Paper
Engineering

A RotoVision book
Published and distributed by RotoVision SA
Route Suisse 9
CH-1295 Mies
Switzerland

RotoVision SA
Sales & Editorial Office
Sheridan House
114 Western Road
Hove, East Sussex
BN3 1DD, UK

Tel: +44 (0)1273 727268
Fax: +44 (0)1273 727269
www.rotovision.com

10 9 8 7 6 5 4 3 2 1
ISBN 978-2-88893-049-5

Reprographics in Singapore by ProVision Pte.
Tel: +65 6334 7720
Fax: +65 6334 7721

Printed in Singapore by Star Standard Industries (Pte) Ltd

Paper Engineering

3-D design techniques
for a 2-D material

Natalie Avella

RotoVision

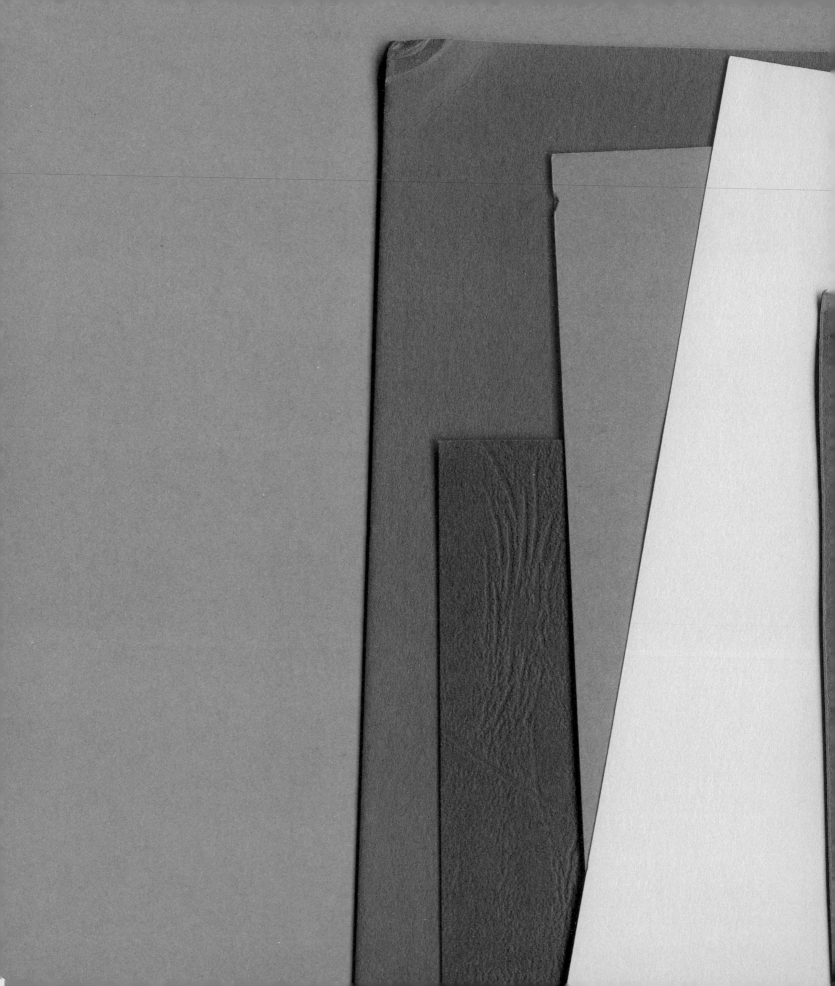

Contents

Introduction
Introduzione
Introduccion
Einleitung
序

We rarely pass a day without holding a piece—in fact many pieces—of paper. Flat, rectangular sheets of the substance pass intermittently through our hands. From the newspaper at breakfast, the phone bill on the door mat, the page of a novel on the train in to work, a meeting agenda casually dropped on the desk or the restaurant menu at lunch. Paper is mostly just a surface on which to carry and store information—a servile agent to words and images. It's there but it's not there, seen but not observed… the text and image so busy vying for attention that the substance behind the print takes a silent back seat. But even when its tactile possibilities are ignored, paper is an inadvertent component of the typography and image. Unless the ink completely conceals the page, it is the imperative blank space that bridges (or separates) typographic characters or frames a picture. It's simply the white space that's so desirable to many designers. But of course, images and text are no longer dependent on paper alone—we can print on numerous substances such as textiles, plastic, or glass. Or, we need not print at all, experiencing the visuals as a light projected on a building, and more commonly than not, behind a screen as a complex and, to many, inexplicable, combination of dots and zeros.

The possibilities of the digital world are proving to be endless, but there are still many things that the computer's body, on which the digital image depends, cannot do. You cannot fold a screen in two, three, or four, crumple it into a ball, tear it in half or hold it up to a window so that the light shines through between the words. Neither can you rub it between your fingers and experience different tactile qualities (well, one keyboard feels pretty much the same as another). As the screen on which information is displayed is getting slimmer and slimmer, no doubt it won't be long until it has the same weight and flexibility as a 200 gsm piece of paper. Until then, in terms of holding and ltooping visual information, there's still nothing quite so accessible, universal, intimate and unique as a simple piece of paper.

Graphic design is usually thought of as an activity that takes place in two dimensions but, in fact, everything more complex than a single poster functions in three dimensions. This book looks at the effects that can be achieved by graphic designers when the fibers of a normally flat sheet of paper are carefully violated—either fractured with a fold, sliced with a cut or ripped with a tear. Using recent material collated from international design agencies, it will look at the three-dimensional potential of paper in graphic design.

As well as collating different examples of work from design agencies around the world, four paper engineers, Rob Ryan, Ron van der Meer, Kate Farley, and Ed Hutchins are profiled. Popular British artist Rob Ryan creates highly decorative handmade paper cut pieces. His work, which has often graced the covers of books, records, and magazines, often reflects a romantic and whimsical world, littered with flowers, birds, leaves, and silhouetted lovers. Van der Meer is well known throughout the world for his flamboyant pop-up books, designed to appeal to adults as well as children. His books are made in collaboration with experts on subjects such as architecture, sailing boats and music, and are hand-assembled by hundreds of workers in far-flung places such as Colombia and China. Kate Farley and Ed Hutchins work on a much smaller scale, creating books in small editions, by hand and more often than not printing and binding in their own small studios. They are artists whose miniature books play with our perceptions and reveal new surface possibilities. Graphic designers usually work within the limits of tight budgets and time scales, so either hand-manufacturing by others or by designers themselves in the studio, is often a luxury (or burden) out of bounds, but all four designers reveal to the graphic designer further possibilities of paper in design.

So how does a three-dimensional piece of graphic design influence a reader?

Interactivity

Paper-engineered work often involves an element of reader participation. Many designers featured in this book believe that design involving reader interactivity tends to be more memorable and the information conveyed more absorbed than work that is simply looked at on flat sheets.

In the Western world the closest that many adults get to interacting three-dimensionally with paper is folding a letter to fit in an envelope or wrapping a birthday present. Only on rare occasions do we emotionally interact with it—like symbolically tearing the photo of a broken relationship in half or crumpling the pages of a late night dissertation gone wrong. Regularly we turn the leaves of books, brochures, and journals but we do so like blinkered horses following a well trodden path and reading is often little more than a process of absorption rather than of interaction with a page. The vast majority of books are manufactured in the traditional Western codex format—planes of flat, rectangular, same-sized paper, bound together

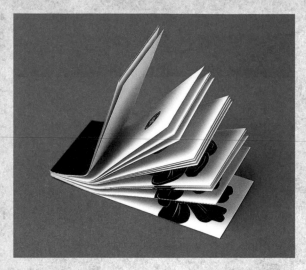

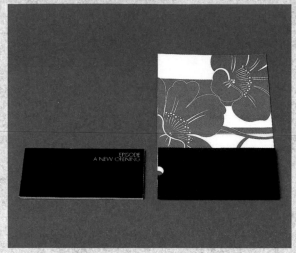

with each layer working in a planned, predictable way. Bookshops worldwide are filled with books of this format and because it works so well, format is very much taken for granted.

Paper engineers, such as pop-up or book artists, seek new potentials in format. They rebel against or adapt traditional structures such as the codex or folio (one sheet folded in half to create four pages), exploring dimensional possibilities by adding new layers, cuts and shapes. A paper-engineered book or card is more than a surface to support content and the reader of an engineered book is no longer a passive audience to image and text. Reading becomes an immersive experience. The reading of the work gives way to the notion of experiencing the work and this allows more possibilities for individual interpretation. A turning of the page or pulling of a tab reveals new dimensions or layers, often creating surprise and opens up for us new perceptual modes. This design does not function without participation.

In the process of looking at a paper-engineered object, the reader does not just absorb the work but is complicit with the designer in making it happen. You could even say that the reader becomes part designer and part performer of the piece. Part performer because the reader's kinetic energy creates the movement that brings the piece to life. Part designer because the reader's imagination and common sense is needed for the design to reach its full potential.

Sometimes directions must be followed such as "pull here," "lift this" or "cut around the dotted line." In such cases paper engineering also depends on good surface design because, however abstract the design is, if the reader is not intrigued enough in the first instance to pull the tab, then the design just hasn't worked and is null. The cleverest pieces

of design are often the most conceptual: where the template is just enough. The instructions are there, but you need not comply. The invitation to interact alone could be a metaphor showing that this is a company that believes your say is important. You are more than just a number—you are a collaborator.

Time and space

The use of innovative cuts or folds makes a paper-engineered work's relation to time and space more dynamic than that of a flat sheet of paper. Keith Smith, an eminent book-binder, believes that the "ultimate realization" of creating a book is not about sewing or gluing but about creating "a conceptual ordering of both space and time." The single sheet, explains Smith in *Books Without Paste or Glue*, has a narrow sense of time because it allows an overall view of everything. Once a page is folded to produce four pages they "cannot be seen simultaneously, they are experienced in time, like a play in four acts, a symphony in four movements. Time and movement are a necessary part of this format." He believes that "any art form revealed in time must be paced." And pacing is achieved not by content alone, or structure alone, but through the perfect balancing of each.

In her essay 'On The Margins of Time,' Joanna Hoffman, a Polish artist who creates books with unusual formats, explores the notion of time and space in the process of reading: "The content of a book speaks through its form... Structural inventions such as arrangement and differentiation of pages, tearing, folding, cuts, etc. introduce rhythmical values and make the object become an orchestration of some definite fragment of space and time. Hence the reader of a book acquires one more dimension: the history of its

performances. It is based on repetitions which have nothing to do with sameness but induce an activation of time and space, motif and content, animation and metamorphosis."

When a piece of paper is folded in half a secret internal space is created. Before we turn the page there is a moment of anticipation—a pause that could not be achieved when the reader looks at the single-sheet format. The new edges that have been created are like horizons to other planes. When more complicated folds are added the experience of time and space is diversified.

"Since this format exists in space, it is nearer to sculpture than painting. Since it exists in time, it has more properties of cinema than the still-photography it might contain," says Smith. An obvious example of the cinematic qualities of an engineered piece is the flick-book invitation (opposite, top) to the opening of a new branch of clothes shop Episode. Designed by Multistorey, this graphic design borrows from the world of animation.

Here content and structure have been balanced perfectly. The design has carefully taken into consideration existing elements of the shop's campaign. The flick book, showing the petals of a flower unfurling, symbolizes the opening of the shop. But it is also the same flower used on one of Episode's skirts and their press pack. A perforated sleeve to be torn off and taken for entry to the opening is attached to the book. "As designers we are really interested in appealing to more senses than just sight," says Multistorey's Harry Woodrow. The choice of paper was an important part of the design process.

The book was printed on Chromomatt for its smoothness and low friction, and the sleeve was printed on Fedrigoni's Sirio Black/White, a chalky-feeling black-backed white board. The floral pattern is printed in a complementary dusky pink on the front and the details of the event are foil-printed on the black side in white gloss foil.

This piece of design certainly projects itself into time and space. The reader will look at the object more than once; probably watching the petals unfurl at different speeds each time. The Episode branding on this piece is subtle, making this a small, attractive object that could be saved.

"To treat a book as no more than a stack of sheets would be denial of inherent movement as fronts evolve into backs," says Keith Smith. "A codex is more than a group... such a structure is linked,

each successive idea dependent upon the previous. The key is not to "add" in the sense of treating the book as an empty vessel into which things might be stuck. Rather, learn to see the blank book for its power and potential."

The examples of paper engineering that follow tap into the power and potential of the many formats common to graphic designers such as brochures, books, leaflets, invitations, and flyers. We will start by looking at the simplest of folds on everyday pieces of graphic design such as leaflets through to more complicated pieces that borrow from the art of origami and others that add further dimensions by mixing in interesting cuts to the folds. From folds with cuts we will move on to die cutting and later to pieces created by paper glued together to create pop-ups and innovative binding.

FOLD
PLIER
PIEGARE
PLEGAR
FALTEN
χ刀刀る

Fold

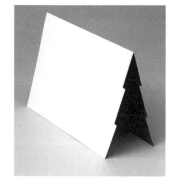

In Silvie Turner's *The Book of Fine Paper* she quotes papermaker Joel Fischer: "I make a sheet of paper. There in my hands is a totally new space emerging from the water and there for an instant the possibilities of the world expand."

Fold the piece of paper in half and these "possibilities" quadruple, as four sides—four spaces —emerge. The creasing of fibers has resulted in a hinge connecting two planes. Removed from the single-sheet format, we now have a folio: four pages made from two leaves. The hinge creates a backbone, or a gutter, and resultant planes are able to move separately in space. Depending on which way this folded sheet is held, the backbone could symbolize a mountain peak or the gutter of a valley. In the example shown, Richard Johnson at Ogilvy Singapore has used the simple fold (enhanced by some die cutting along one edge) to create this Christmas tree-shaped card.

When an object is closed by folding, an intimate, interior space is created. By unfolding the object the surface that once was on the interior can then be exposed as the exterior space. During the activity of folding, the space around the object becomes dynamic. Richard Johnson's card inventively uses both the interior and exterior spaces created by the fold. The act of folding and unfolding has been suspended midway.

Folding objects express a negation of materiality, as a three-dimensional volume can become a two-dimensional flat surface. This is the ideal format for a graphic designer. When the three-dimensional object is received it is unimposing. The recipient is less encumbered by the piece when it arrives and after being coaxed into making it into more of a 'thing,' can easily return it to its less 'thingness' through the simple act of folding it back again.

In the following pages we will look at a number of pieces by graphic designers that use innovative folding techniques. There are throw-outs and throw-ups, French folds, dos-à-dos cover folds, origami-style folds, concertinas, and parallel folds. These pages aim to prove that even the most basic folds can be adapted in numerous ways to create diverse effects. First of all, we will look at the folded material we encounter the most… leaflets.

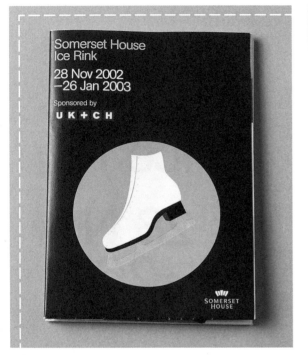

Design: **Wink Media**

Client: **Somerset House Ice Rink**

Project: **Promotional leaflet**

Every Christmas, Somerset House, a grand building by the Thames in London, hosts an ice-skating rink in its courtyard that is open to the public. For the past couple of years this event was sponsored by *Wallpaper** magazine. When founder and chief-editor Tyler Brûlé left *Wallpaper** to start a Swiss-based design and advertising agency, Wink Media, he thankfully kept hold of the ice-rink's reins and his new company continues to support the event. Hence the event has this beautifully illustrated promotional leaflet, designed by Wink Creative. Made with three vertical folds and two horizontal folds down the middle, this leaflet creates 18 potential panels of information. When folded it can be read as a booklet and when all the folds are opened out there is a poster with a very cool (no pun intended) illustration on one side and on the other an illustrated guide on how to keep warm, safe and, most importantly, upright.

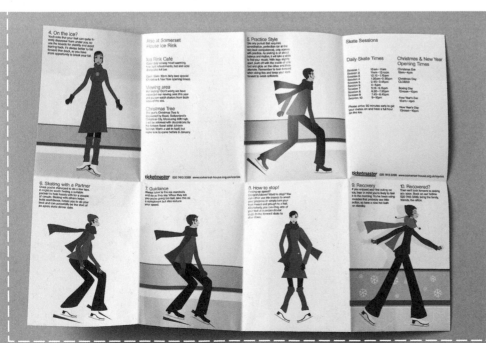

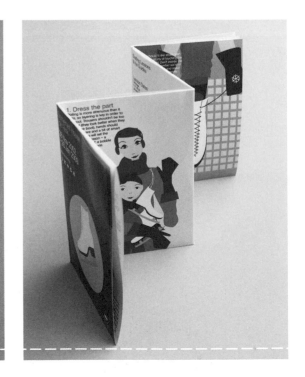

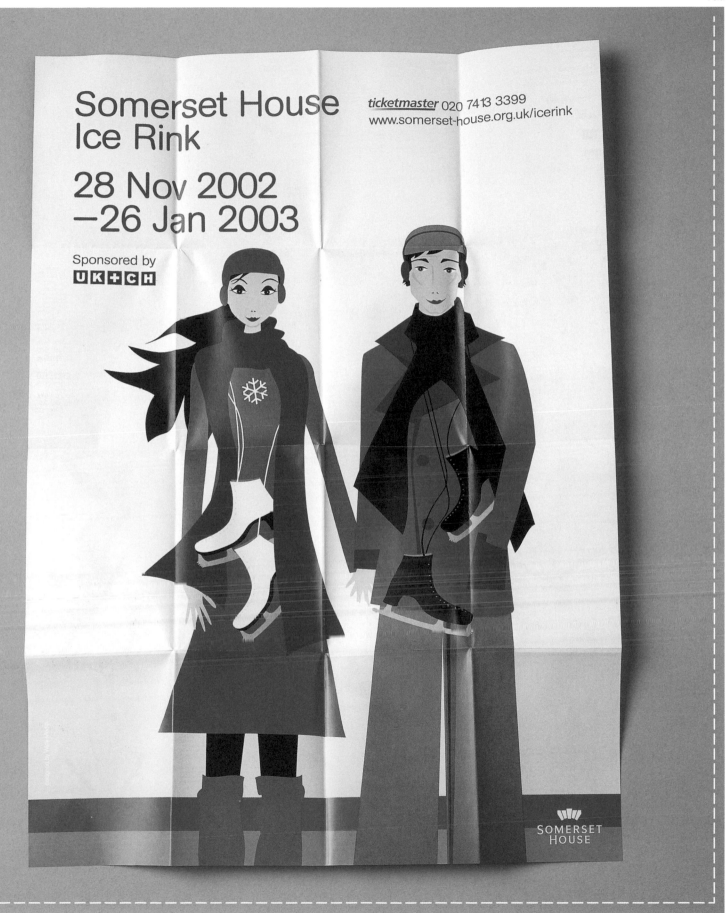

Design: **StudioThomson**

Client: **Liberty department store**

Project: **Press booklet**

Housed in a Tudor revival arts and crafts building and tucked down a back street away from the corporate banners and steel and glass monotony of the main retail thoroughfares is the subtly stylish, yet constantly cutting-edge, department store Liberty. StudioThomson created a press preview booklet for its Christmas season that speaks of the store's seemingly innate sophistication and quiet glamor. There are no brash typographical statements on the silky silver cover, simply an embossed chandelier. Lift this cover and inside you'll find a seven-page booklet that folds out to reveal beautifully photographed images of some of the eclectic products the department store has to offer. Unaccompanied by type, and without the slightest mention of retail costs, the elegance is purely visual and tactile. Accompanying the booklet is an embossed white press invite to the preview.

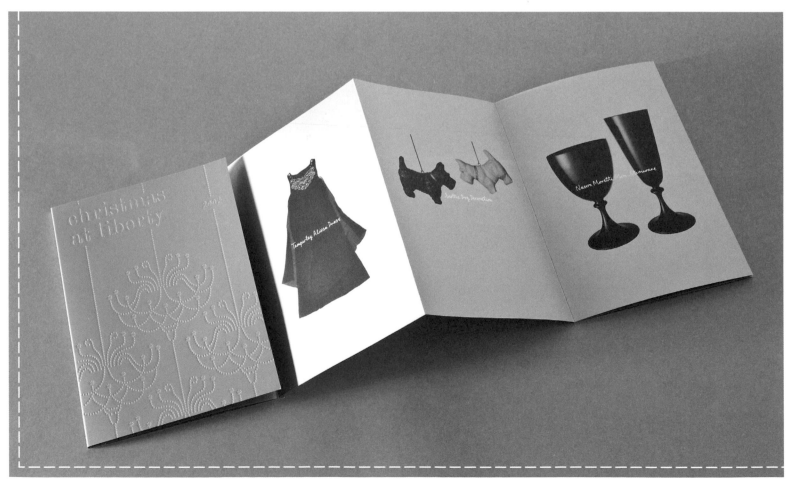

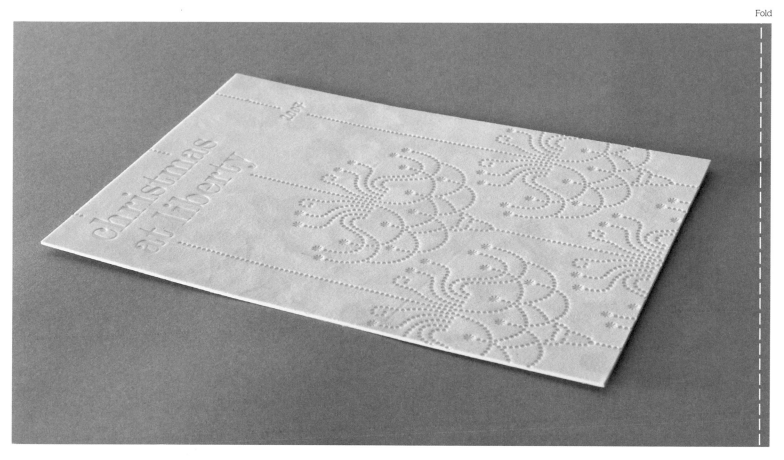

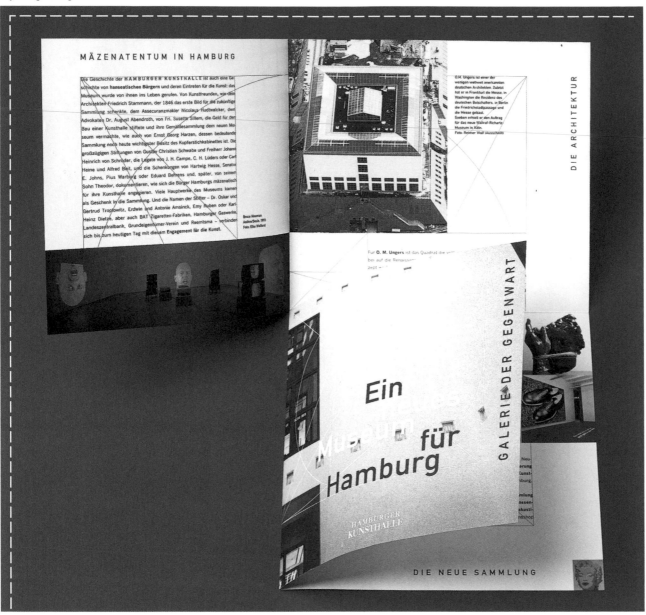

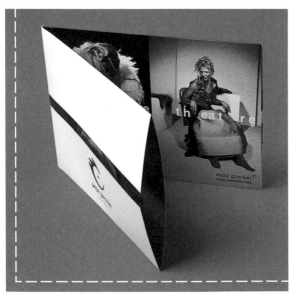

Design: **Birgit Eggers, Eggers + Diaper**
Clients: **Anja Gockel and Hamburger Kunsthalle**
Project: **Promotional leaflets/brochures**

The leaflets shown on the previous pages all have vertical and horizontal folds that are neatly proportioned so that, when folded, the panels align along the edges. The edges of these pieces, designed by Birgit Eggers, are aligned so that gaps reveal part of the page tucked behind, giving a new dimensional quality to a simple piece. The brochure for Hamburger Kunsthalle (above) uses die-cut and folds to reflect the museum's architecture, which is based rigorously on squares. The fold and cuts allow the square Andy Warhol to continuously be viewed. The Hamburger Kunsthalle piece was designed by Eggers while at design agency Büro Hamburg. The unusual napkin-style fold of the leaflet for Anja Gockel (left) gives the viewer a glimpse of the fashion designer's clothing before it is opened.

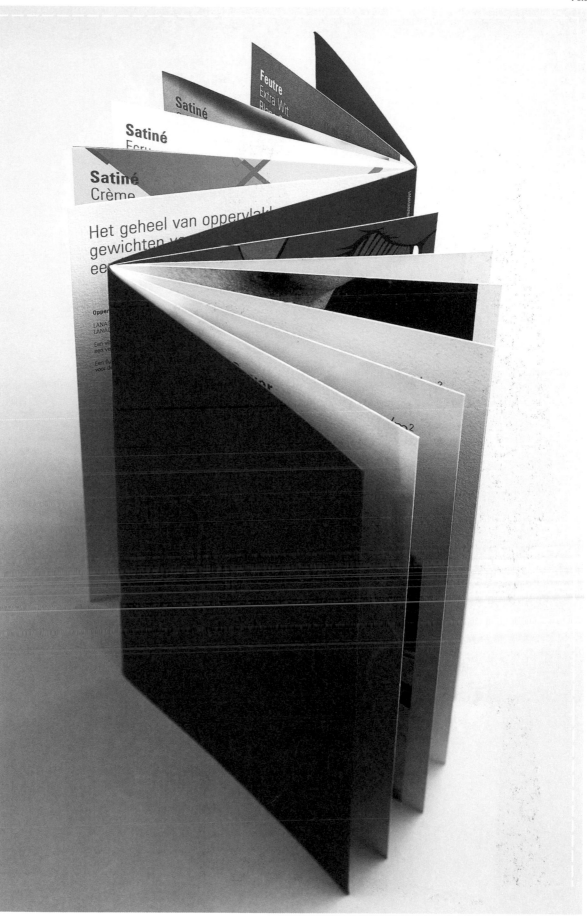

Design: **Roundel**
Client: **Zanders**
Project: **Lanagraphic catalog**

Two books attached by a single cover are referred to in bookbinding as a dos-à-dos (translated from French this means 'back to back'). By making two alternating folds, two reverse-facing interior spaces are created in which two separately bound texts are then attached. Since they are back to back they cannot be viewed simultaneously and the front cover of one book faces the viewer while the other one does not. This format was popular in the last two centuries for binding together related books such as, for instance, the Old and New Testaments, and *The Iliad and The Odyssey*. After viewing the first volume you must turn the object over to begin the second. The first page of each book is on the outside and both volumes end in the middle of the object. Roundel has used this format for the European promotional brochure of Zanders' Lanagraphic papers. The theme is 'inside and outside' so there are two books named accordingly. Images, such as a pair of slippers and an egg in a frying pan expressing the 'inside,' appear in one book and the other book, 'outside,' is illustrated with outdoor images such as a bench and a dustbin. The format is ideal for showing the strength and texture of the Lanagraphic cover paper which covers and links the two books.

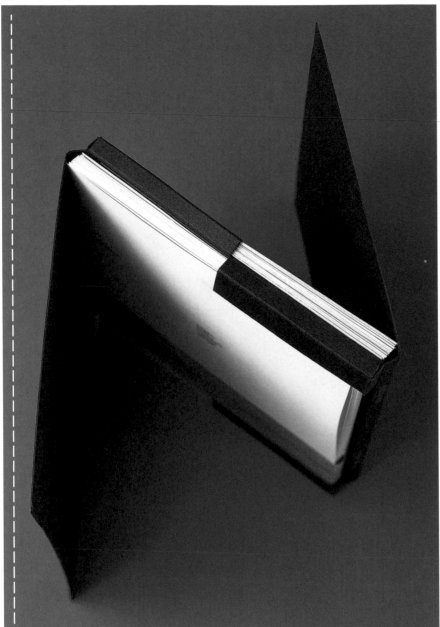

Design: **FL@33**
Project: **Own project**

Tomi Vollauschek of FL@33 used a variation of the dos-à-dos to create the cover of this poetry collection. Here, each of the two poetry collections are not bound into the gutters of the two folds; instead, the separate leaves of each sit inside two pockets created by paper which has been folded round and pasted to form pockets at the bottom of the alternate (and opposite) sides.

This complicated cover concept was produced using just a single piece of paper, meaning that the initial piece of paper must have been cut into a shape allowing for the intricate pocket sections. Containing the collections of poetry 'coup de grace' and 'zwischenstation,' this book was published in Frankfurt in 1998 in a limited edition of 100. The embossed cover was produced by hand.

Design: **Zuan Club**
Client: **Java Live**
Project: **Invitation**

As you open this card which works as a flyer and invitation to Japanese nightclub and restaurant Java Live (a place with, it seems, a Caribbean theme), dancing characters pop up. The energy of the paper and folds really makes the page come alive and conveys the party vibe and spirit of the place.

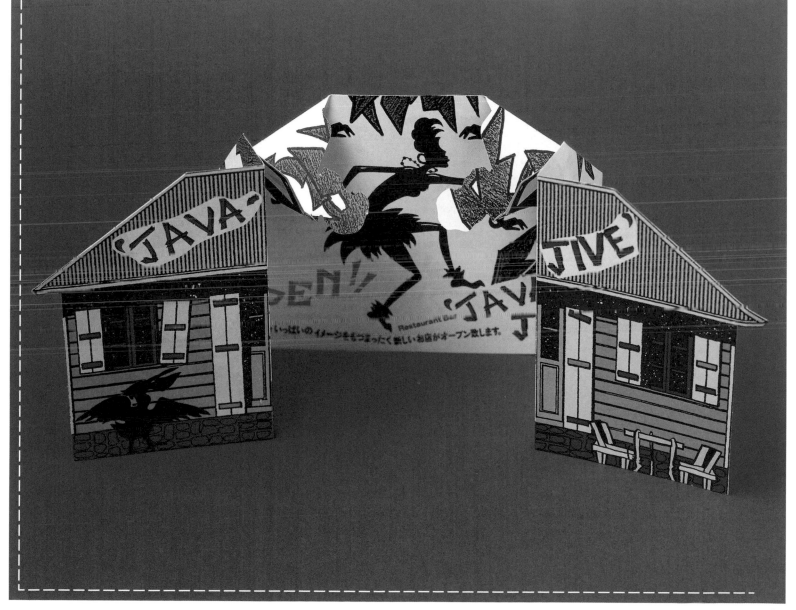

Design: **Shaz Madani**
Project: **Self-initiated**

This self-initiated project, by London College of Communication student Shaz Madani, is almost sculptural in quality. It was created as a promotional campaign for an ecologically minded paper company.

Layers of paper were pasted together and then cut into the shapes of letters or leaves. The shapes were positioned above the negatives of these cut-outs to be photographed. As the paper has been hand-cut, it does not align

absolutely perfectly, and so retains the charm of a crafted object. There is no print, and images are created purely by light and shade that manifest on the cut sides and spaces.

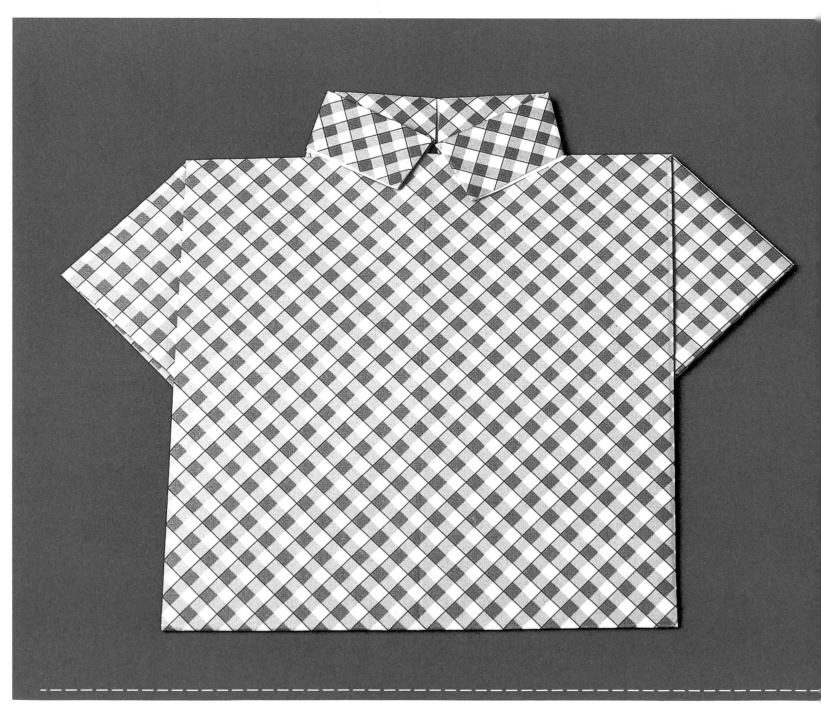

Design: **Multistorey**
Client: **Simon Carter**
Project: **Press day invitation**

Here the folds of one sheet of paper become more complicated. Multistorey duo Harry Woodrow and Rhonda Drakeford hand-folded 200 of these origami invitations for the launch of menswear designer Simon Carter's Spring/Summer 2002 collection. The shirt-shaped invitation is constructed from one sheet printed with pink gingham on the bias—a key seasonal pattern from the collection. The shirt sits in a pinstripe gray envelope, which helps emphasize that this season the range extends to include tailored suits. They worked out the position to print the invitation text on the paper so that, when folded, the text was displayed on the reverse of the shirt. The text was layered on the bias to emphasize this detail and to increase its legibility. A linen-embossed paper, Zanders Zeta Linen, added to the cloth effect. Stock used for the envelope was Fedrigoni Saville Row Pinstripe.

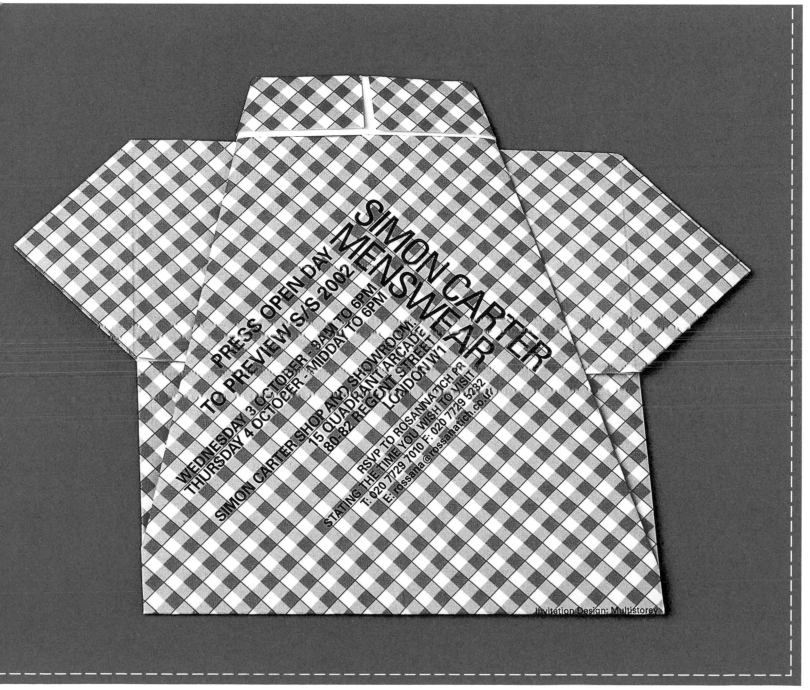

Design: **salterbaxter**
Client: **Discovery Networks Europe**
Project: **Mailer**

This mailer for Discovery Networks Europe uses a double-gatefold effect, whereby two folded panels on either side of one longer central panel, fold in symmetrically to meet at the middle of this longer panel. 'Bigger Catch,' designed by salterbaxter, attempts to lure advertisers by tapping into the wildlife theme that features strongly in the corporation's broadcasting. As you pull the leaves of the folds open with both hands, the two hands printed on the front open to reveal the secret inside... a fish that gets larger and larger. This animation-like piece cleverly shows how time and space can carefully be manipulated with a good combination of innovative format and clear print design.

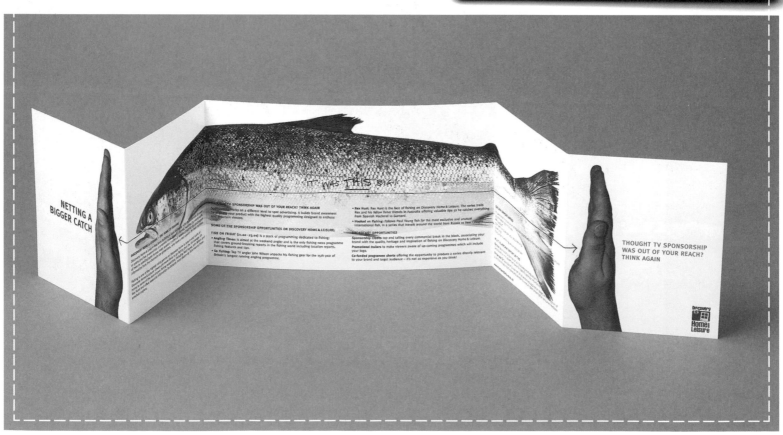

okay, pull up here

Design: **Roundel**

Client: **Doric**

Project: **Promotional brochure**

Doric is an established signage manufacturer whose traditional market was the railway industry. Roundel's campaign aimed to change perceptions of the company and show them as more contemporary and approachable. Common colloquial expressions for directions—for example, 'over there' or 'second on the right'—were used as the key concept behind the new identity and promotional campaign for Doric. This colloquial signage was applied to stationery, vans, and buildings to guide you to the logo or page by page through the brochures. The first brochure, 'this way,' encourages people to start reading from the middle by cutting the first section of pages (half of the brochure) shorter than the second. From the center you can 'turn left' to images of Doric signs used in stations, airports and institutions or 'turn right' following signs to a page of text about the company's philosophy. Roundel followed the theme into the second brochure, 'turn to,' two years later. This time the instructions led you from the front cover all the way through to the back cover. Small fold-outs and one large throw-out lead you in, under and over the pages. Such an interactive use of pages makes the user think about the way we use signs to navigate and interact with our everyday landscapes.

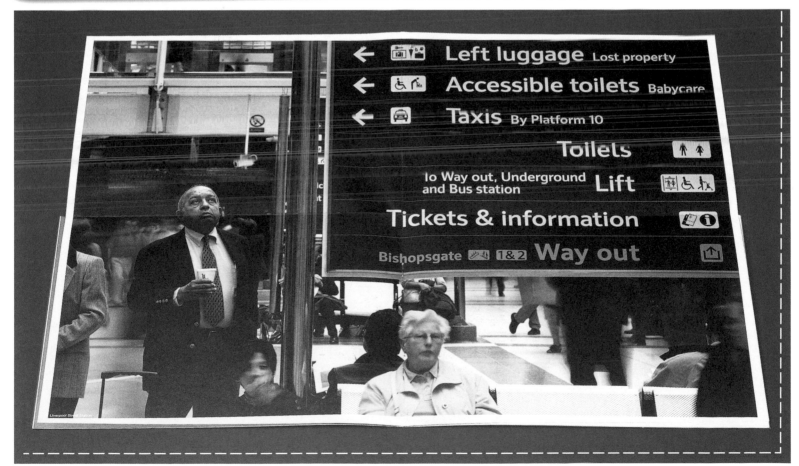

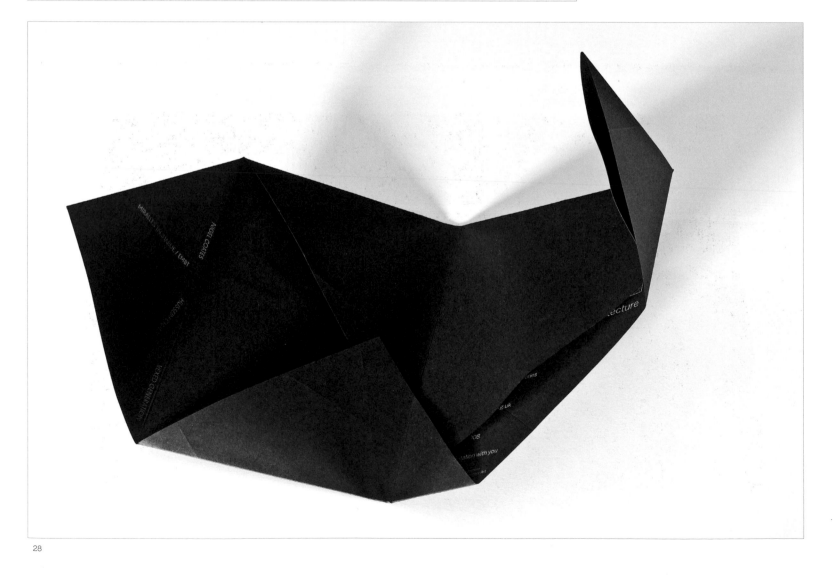

Design: **Multistorey**
Client: **Somerset House, London**
Project: **Exhibition preview invite**

An element of paper engineering was the ideal solution for this exhibition invite, as the content of the show—examining the relationship between fashion and architecture—meant the designers felt an exaggerated structural feel was required. The invitation was for Skin + Bones, an exhibition exploring how fashion and architecture have influenced each other since the 1980s, and how the two industries use similar processes and materials, often just at different scales. Innovative folding turns this invitation into more of a structural object and visually conveys the concepts behind the show more than a page of printed card would. Printed across the black chalky paper are thin glossy lines, which evoke the actual physicality of sitting at a table designing—of working with blades, pens, and paper—a quiet practice that designers and architects alike do when freed from the computer.

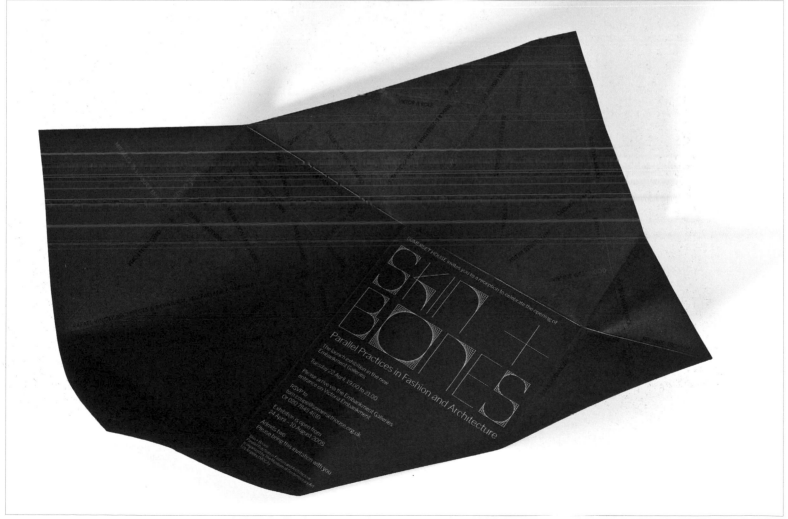

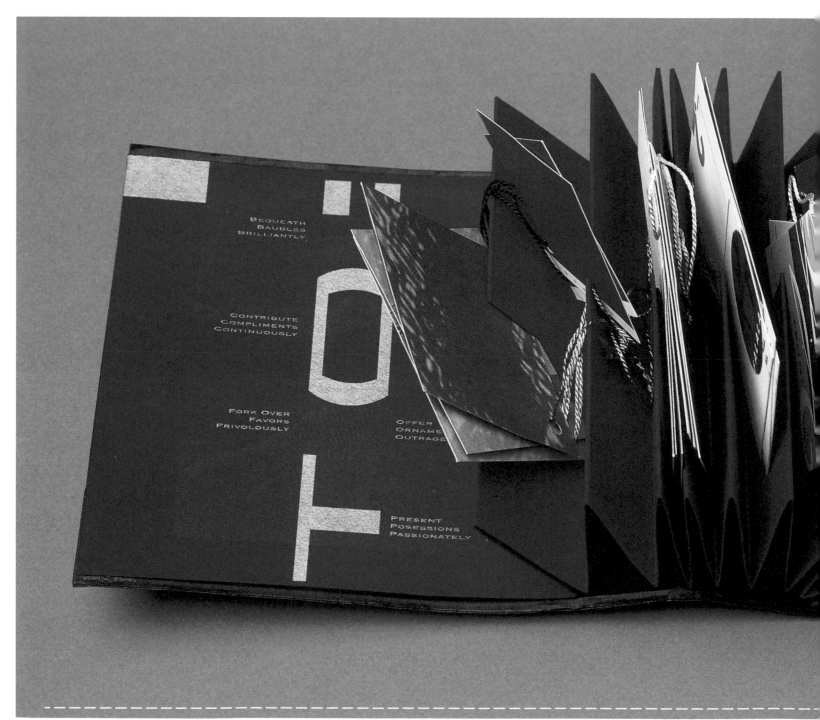

Design: **Vrontikis Design Office**
Project: **Gift tag holiday gift**

More a greetings package than a greetings card, this Japanese-style envelope promises much and doesn't disappoint. It arrives as a simple envelope of corrugated black card bound with a thin piece of red ribbon. Once opened, the center piece springs open, with more exuberance than a Christmas cracker. Concertina folds in the middle are each cut with a single slit, and grasped in each of these is a selection of gift tags. This package of creative gift tags was fourth in a series of five that Vrontikis Design Office used as holiday gifts for clients and friends. Petrula Vrontikis says, "Our sources of art were eclectic and ranged from old engravings to unused art from on-going projects. We 'tag' the card designs on to the extra room on press sheets for jobs that run throughout the year, resulting in a variety of color schemes and papers. Our inspiration here ranged from pop-up books to the classic publication *How to Wrap Five Eggs* by Hideyuki Oka."

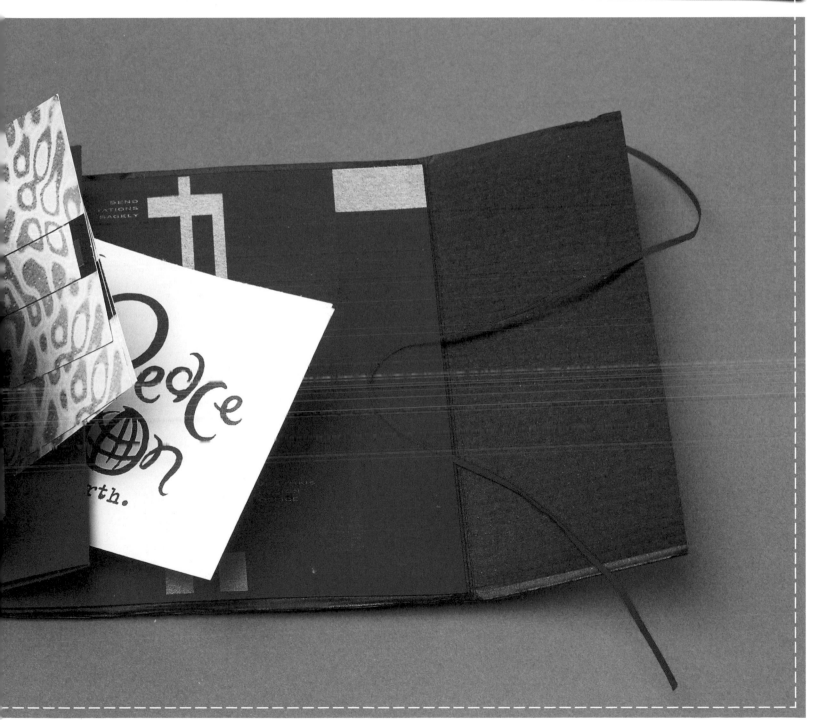

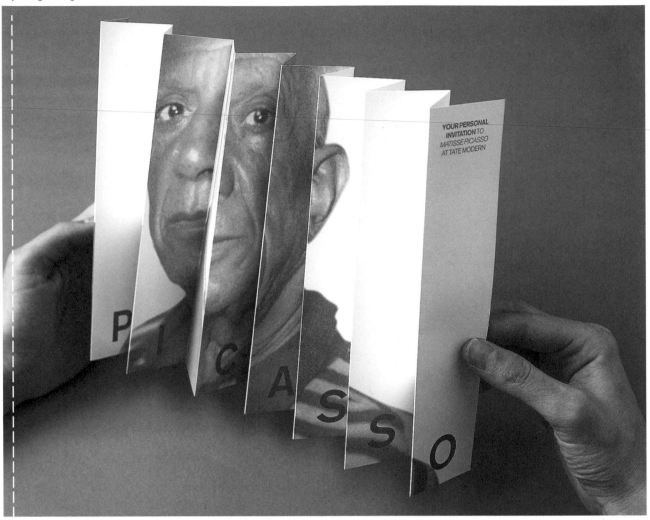

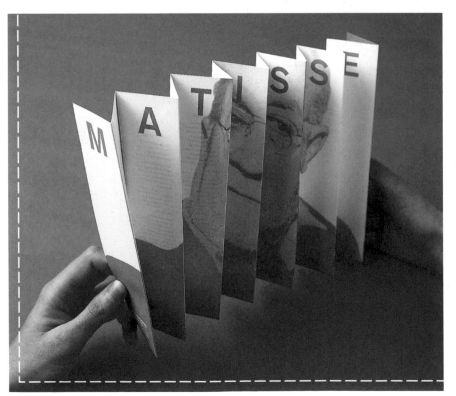

Design: **salterbaxter**
Client: **Tate Modern**
Project: **Invitation to exhibition party**

The MatissePicasso exhibition was held at London's Tate Modern in 2002. The exhibition examined the relationship between two of the last century's most prolific painters and aimed to show that, through their art, the connection between Matisse and Picasso was much closer and more complex than has been recognized before. Design agency salterbaxter was asked to design an invitation to a dinner for sponsors Ernst & Young marking the opening of the exhibition.

Their solution was to use this concertina-style folded paper with the faces of the two artists cut up and spliced together. The individual faces appear only when it is held up and the folds are viewed obliquely. Salterbaxter created the visual style and all supporting materials to accompany Ernst & Young's sponsorship of this exhibition. They also designed a huge backdrop which was hung in the Turbine Hall at the Tate.

Design: **Multistorey**
Client: **Bryan Morel PR**
Project: **Invitation**

This invitation to a PR company's press day is as neatly folded as a well-to-do gentleman's handkerchief in his suit's upper pocket. When folded, all you read is Bryan Morel PR, but once the folds are opened the navy blue letters that made up these three horizontal lines are neatly scattered in vertical columns among several lines of pale navy lettered words that make up Bryan Morel PR's client list. The names had to be carefully aligned so that when folded it would work in such a tidy way. The details of the press day are given on the final page. The folded invitation was sent out placed in a belt-like buckle—created by two diagonal slits—on a rectangular piece of navy card. The card not only keeps the folds neatly in place—showing the clever use of Bryan Morel PR on the front—but when turned over, the invitation details are seen through the die-cut on the back. It looks very tidy and organized, as all the best PR people are. It's a witty piece of design—a piece that you definitely would not drop in the trash once the press day was over.

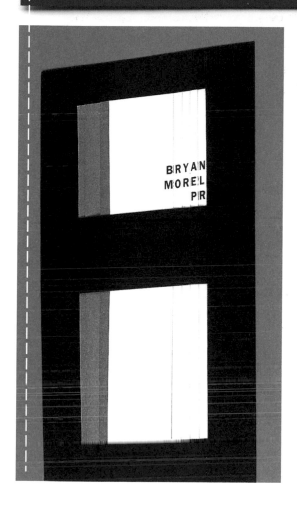

Design: **Zuan Club**
Client: **Bingo Bongo Club**
Project: **Invitation**

This invitation to the launch of a new Japanese nightclub and restaurant has been made extra luxurious by the use of fine paper, ribbon, and fabulous folds. Not only does the paper feel wonderfully strong and textured, but the reader has to open a silky ribbon before looking inside.

When opened, there are two reverse folds close to the middle. The extra folds enhance the piece and give the structure additional strength so that it would easily and attractively sit on a shelf or desk.

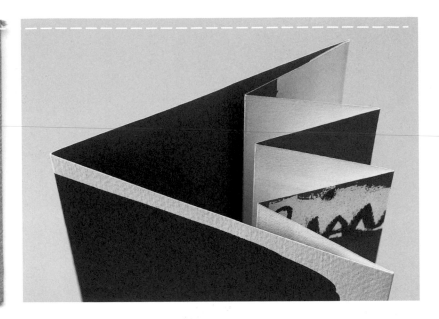

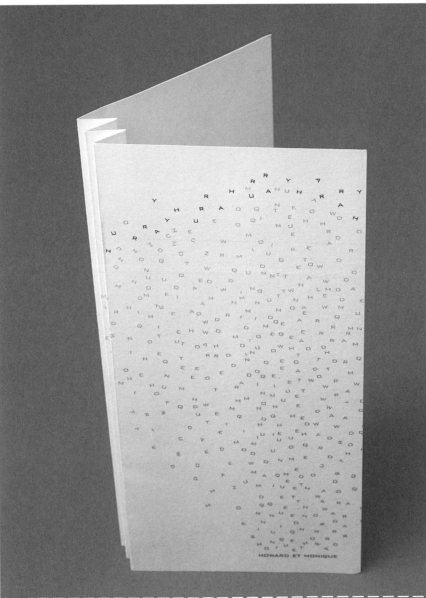

Design: **Lawrence Garwood and Etu Odi**
Clients: **Howard and Monique**
Project: **Wedding invitation**

The two leaves of this attractive wedding invitation, are joined not by just one hinge created by a fold, but by several small folds drawn together in a concertina effect. From the side it looks like the uncovered spine of a pleated book. It is a simple idea, with a very elegant effect befitting a card for such an occasion. The card was designed by fold enthusiast Lawrence Garwood from design agency Etu Odi.

Design: **KesselsKramer**
Project: **Self-initiated**

Missing Links is a miniature book in a concertina format with cardboard covers, the first with a hologram foil-blocked title on the front. Each page features a selected Polaroid from a collection of several hundred taken over a period of ten years by Erik Kessels. An introductory page explains: "Elements on their own often have little or no relevance until they are put together and juxtaposed with something else. Then there is a reference, a visual foil in which to feel context. For how can you tell what is beautiful until you know what not beautiful is?" There is also an explanatory sticker on the back of the plastic wrapping in which the concertina is at first contained (this wrapping is reminiscent of that containing sticker collections of movie and soccer themes found in cereal packs). It reads: "Polaroids are a medium for instant glimpses of a world as it stands still for a moment, and then passes. A link to a moment. Only later when the large number could be reviewed, did the photographer and editor apply a theme, or logic. Finding missing links thus creates a new way for seeing and associating instants, or remembering the past, and thus heightening moments that link in many different ways and, for everyone, a different reason Do Link." The 18 Polaroids are best looked at in pairs, opened up like double-page spreads of a more conventionally bound book. If the concertina is opened as a whole, the links seem almost disbanded.

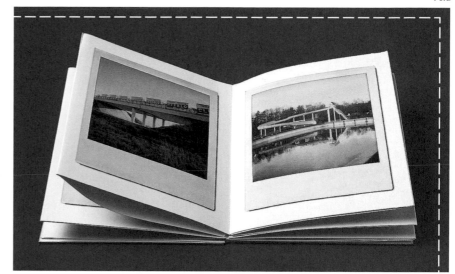

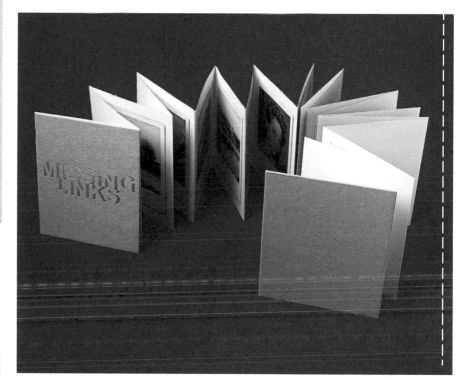

Design: **Lippa Pearce**
Project: **Christmas card**

This concertina Christmas card with cardboard covers sent out by design agency Lippa Pearce folds out to read a cryptic message which, when deciphered, is a line from an old Christmas record.

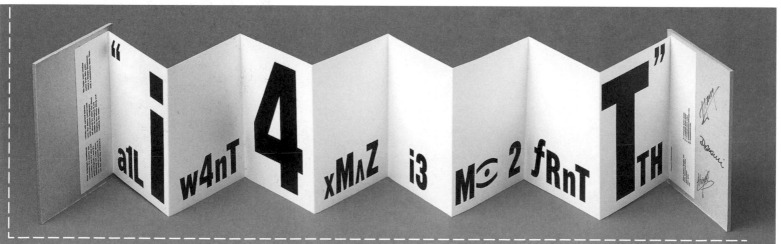

Design: **William Hall**

Client: **The London College of Fashion**

Project: **Centenary book**

A limited edition poster, printed in lustrous gold and black ink, folds around the launch copies of this book in such a way as to give a glimpse of what is contained inside. *The Measure Book* was created to celebrate the centenary year of the London College of Fashion and features articles and commentaries by such fashion luminaries as Jimmy Choo, Giles Deacon, Zandra Rhodes, Paul Smith, Mario Testino and Vivienne Westwood. The book asks each contributor to reflect on the effect London has had on contemporary culture—and specifically fashion—over the last century. The images (right hand page) and text (left hand page) are strictly separated, allowing an already image-rich book to be read purely as a visual essay. This demarcation is exaggerated by placing the image page at right angles. The index and contents page are combined in a fold out back cover. The position of each entry relates both to the page number and the tape measure positioned alongside.

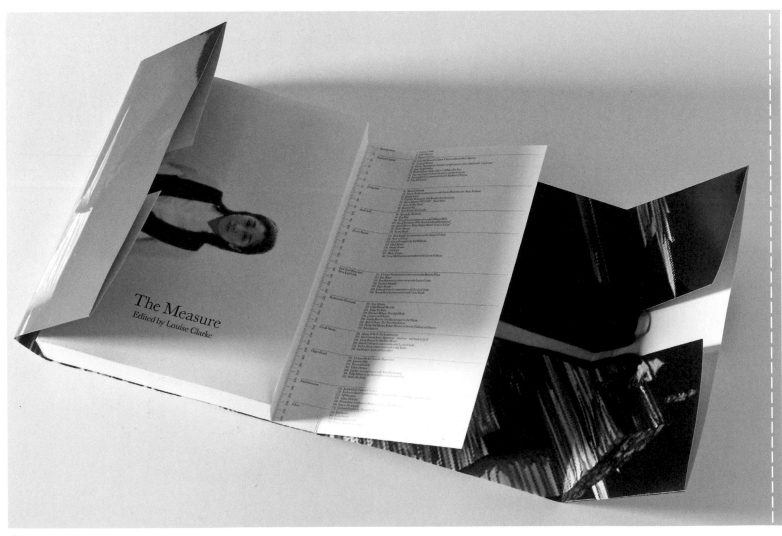

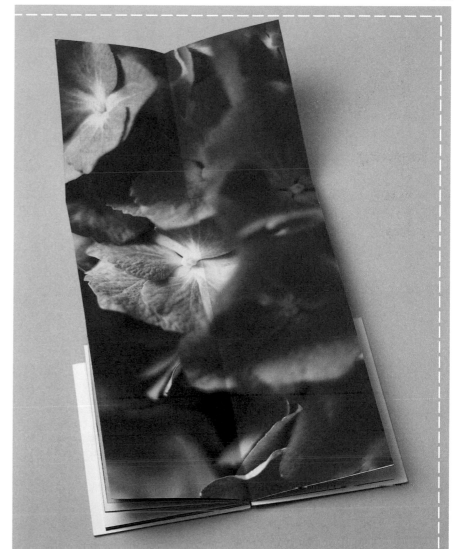

Design: **Iris Associates**
Client: **Plantology**
Project: **Promotional book**

The pages of this attractive promotional book, designed by Iris Associates for florists Plantology, feature double throw-ups on each page, which, when opened, are three panels in total. The book discusses how flowers can be explosions of color, and this is experienced perfectly as the white pages fold out to reveal vivid and evocative close-up images of flowers. Each three-paneled page is folded down to the size of one page and attached to the other pages with glue. The spine of the book is uncovered so that the neatly gathered folds are exposed and together look like a folded concertina. Two white pieces of board are used for the front and back cover and an intricate illustration of a flower is foil-blocked, along with the company's name, onto the front.

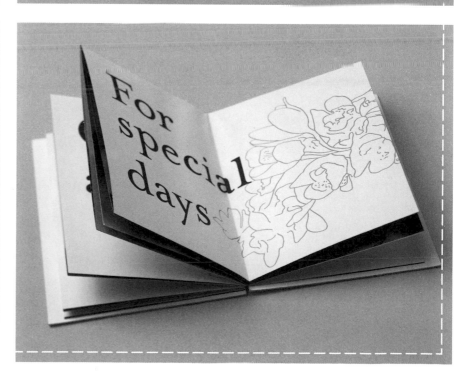

Kate Farley

"Each time I teach a group about book art and begin showing the basic sewn structures and folds, I feel as if I'm introducing the students to a secret world," says Kate Farley, a book artist who also teaches her craft. Her books, handmade in limited editions normally of 20, often lie flat in a book-like way until opened. Once you try to lift the front cover you realize two hands are needed, that the book must be lifted from surface level, the covers prized apart and the pages, rather than turned one at a time must, more often than not, be unravelled. "Concealing and revealing" are the words that Farley encourages her students to think about, and are a perfect way of describing her work. For Farley, creating a book

is about "producing something that involves many different considerations that need to come together in an organized manner." She explains: "It's not about sticking images into a book structure, it's about considering all the features a book offers. Sequence, narrative, time, as well as structural and visual content." When the perfect combination of structure and visual content is achieved, then you've got a good book. 'Totality,' a concertina that on one side follows the shapes of a solar eclipse and on the other a lunar eclipse, is a good example. Content, structure, and material seem to have evolved so perfectly into a whole that it is hard to imagine which conceptual component came first. "I initially planned to print this until it occurred to me that as it's a book about light being obscured it ought to be made by obscuring light and hence the photograms. I had to research photographic paper which enabled me to fold it, and even then I had to do that while each book was wet." The project was done in her bathroom—a make-shift darkroom—in the middle of the night.

Farley approaches each piece in a different way. "Sometimes I start with a series of drawings, sometimes it's the structure. I have spent many days simply folding paper at my desk. This sort of play can result in several other options before I am sure I have the perfect visual/structural content partnership. Neither one is more important; it's a balance." '360°' is a concertina of four planes, each showing a north, south, east, and west perspective of a landscape through semi-circles that have been cut around the circumference and folded back into the uncut part of the full circle. For this the structure came to her fairly easily but she spent "days drawing variations of the views as diagrams, changing my mind about how

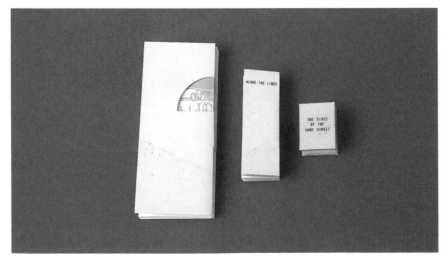

much of the landscape to show and working out the four quarters of the circle before committing it to the printing block."

Farley became interested in book art as a student, then studying Printed Textiles and Surfaces. Her final dissertation was on the artist's book and so it was a natural progression to do an MA in Book Art. "After my training in textiles when I always thought in terms of widths of fabric and dyeing the fabric, it was strange to then think in terms of grain direction," she says. The paper she mostly uses is Fabriana Artistica 200 or 300 gsm, normally 200 gsm for folding. "I love the energy you get from these folds," she says, as she pulls open the concertina book Two Sides Of The Same Street. "Every fold appears to have a store of energy. And it's almost like it needs to be contained and released."

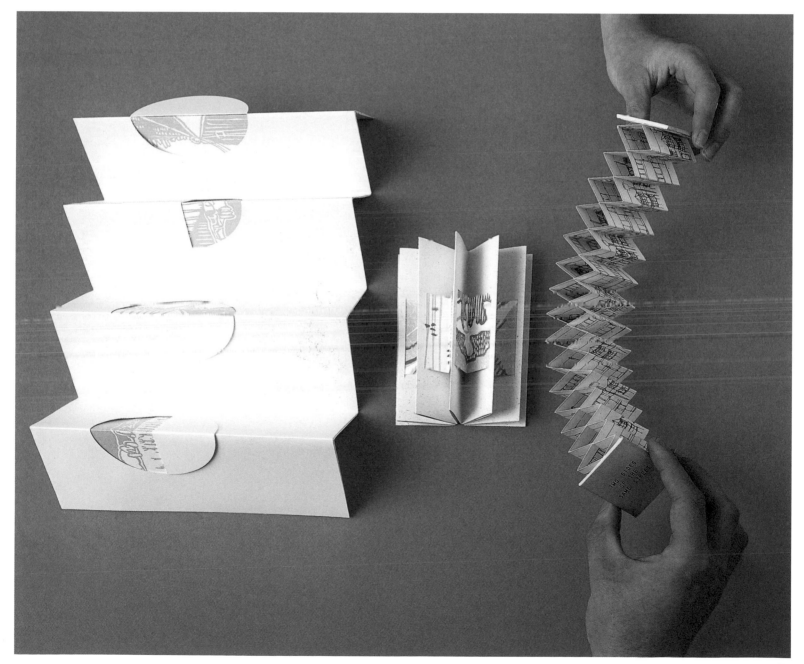

Farley's early works explored issues of place and home. Within Four Walls is a screenprinted folded structure highlighting the value of 'home' as a familiar secure place in a large city. When four loose flaps are pulled out at four right angles, a rigid structure with a square at the centre is revealed which contains the illustrated interior of Farley's room. Two Sides of the Same Street explores the contrasts of taste and of living standards in London. Farley was struck by this when she was living in a "grim apartment that looked out across the road to a row of beautiful terraced houses." This double, interlocked

concertina, which opens to reveal apartments and houses in sequence, perfectly reveals the dichotomy between the vastly different habitats that really do exist side by side in cities.

Other themes she has explored are journeys and landscapes. She often draws the landscapes that race past while on long train journeys. "My drawings have become patterns, capturing an essence of a place rather than a formal landscape study. A memento." She uses little text in her pieces. "I don't feel comfortable using much text and I'm not an

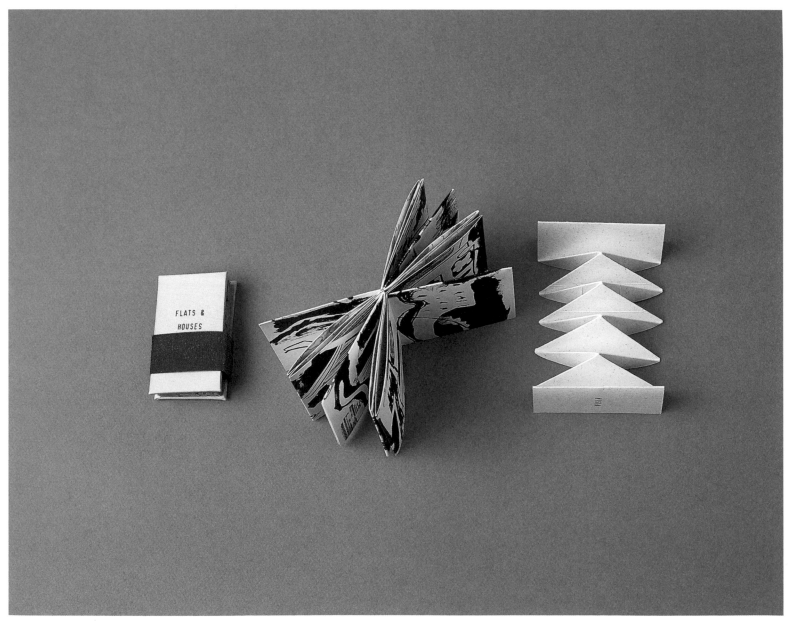

illustrator. The words I choose for titles are enough for me. They offer clues to the subject but also keep secrets."

Farley believes that "making it is as much of the process as designing it" when it comes to artist books. "By the time you get to the end you know it so well—you're so intimate with the piece," she says. Rather than one book at a time she works on the edition in stages, normally printing, then cutting, scoring, folding and constructing. It appeals to her how easy and accessible these books are to create,

that she can set herself up and make a book wherever she pleases. "All I need to make a book is a set square, knife and bone folder—I can carry the tools around with me and can make a book anywhere."

Making books appeals to Farley far more than creating paintings, prints, or sculptures—works normally on singular planes or surfaces that could be described as constantly open, more publicly displayed and hence a shared experience. "The book in your hand seems so much more intimate and personal," she says. "I was often making fine-art prints and I didn't

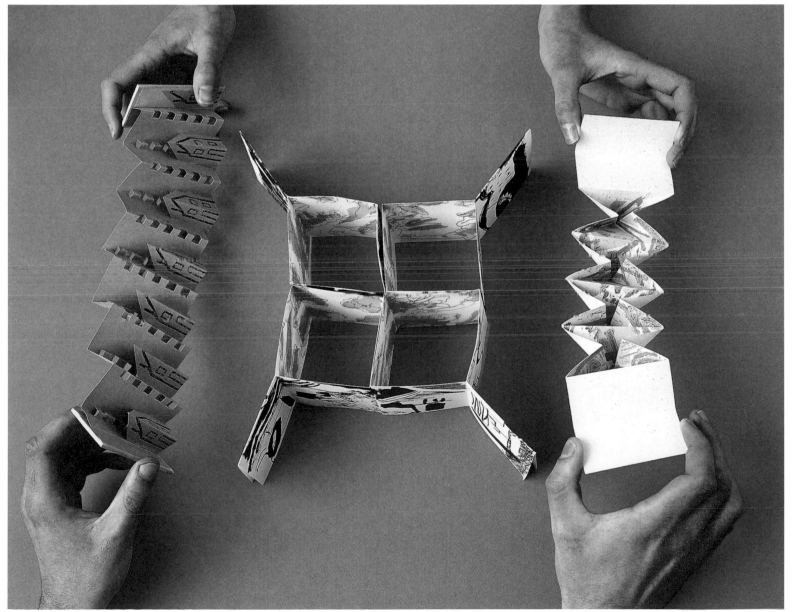

feel comfortable with the gallery experience. The book suited a private encounter. People can own it and do what they like with it and it doesn't cost a lot of money." It's important to Farley that her books, which are normally sold at artist book fairs, are affordable. It doesn't concern her that the prices far from reflect the time taken because she never wanted it to become a commercial enterprise. "The artists at a book fair come in all shapes and sizes with a vast range of interests and I'm sure a range of reasons as to why they make books," she says. "There isn't one mold for a book artist, although I think most people seem pretty happy to be making books and that tends to show. It could be something about the paper, the control over the production and publication—I doubt it's the money!"

"Moving from initial ideas to production can be an infuriating struggle at times, and at others, so obvious. I believe the printing, folding and construction is all part of the mental process as well as the physical production. Looking back on a completed edition of books it is easy to forget the trials. At times I feel that each book is my last, until I find myself folding again, nurturing the next edition."

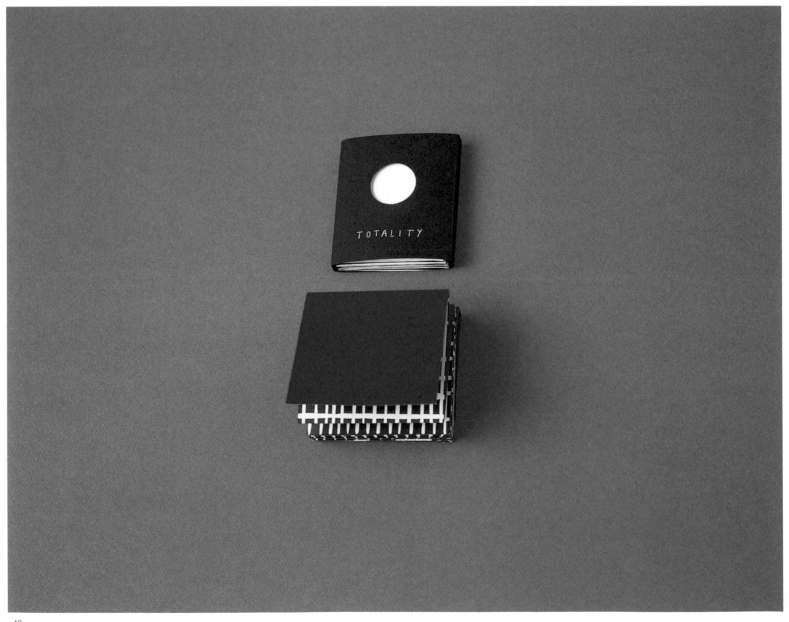

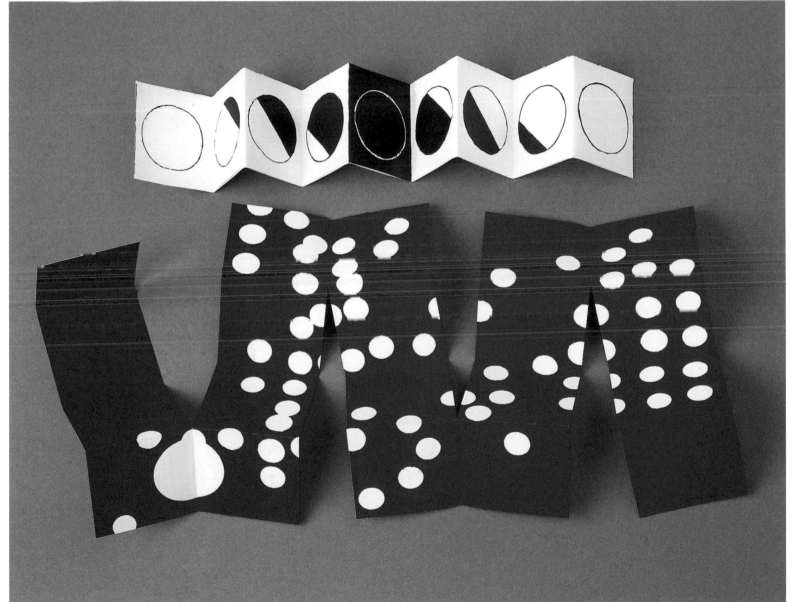

Design: **Carter Wong Tomlin**
Client: **Royal Horticultural Society**
Project: **Press conference invitation**

Here a parallel fold creates a topiary hedge for, appropriately, the Royal Horticultural Society. "Prior to our involvement with the Royal Horticultural Society, the organization had run with a pretty conventional piece of design, the expected few lines of copy topped off by the organization's logo on a single card," says Carter Wong Tomlin partner, Phil Carter. "We therefore tried to inject a bit of fun, wit, humor... call it what you like, into the annual RHS press conference invitation, our main aim being to make it stand out and be memorable. We adopted the use of suitable imagery with the rendering of an appropriate piece of topiary, the cockerel proving the perfect 'call to action'. By folding the card in a reversed manner at the fold we were able to create a three-dimensional hedge for the cockerel to stand on!" The finishing touch was to add the shears (illustrated leaning up against the hedge) as the device to show recipients where to cut the RSVP part of the invitation. Printed in two colors, with some minor hand-coloring, the 500 invitations proved a great success with the Society's members.

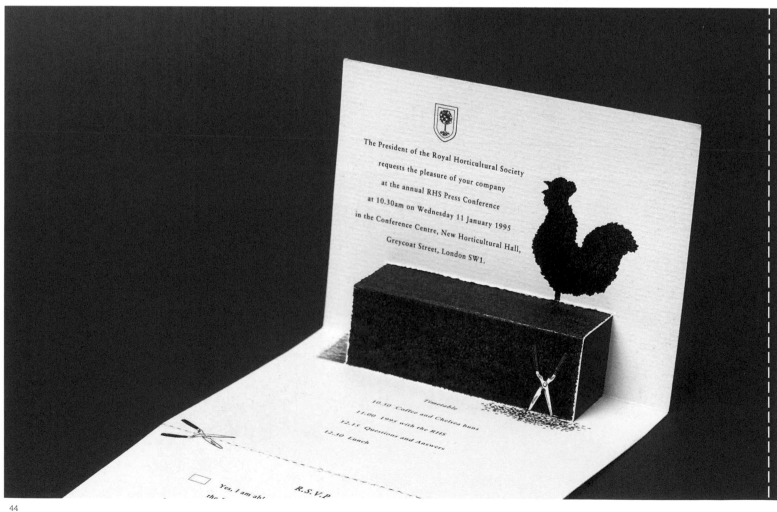

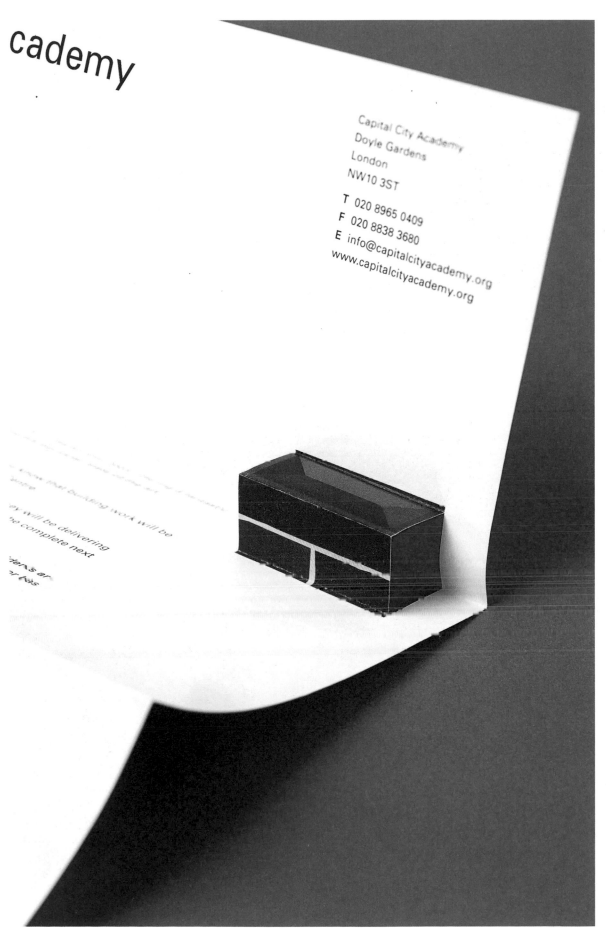

cademy

Capital City Academy
Doyle Gardens
London
NW10 3ST

T 020 8965 0409
F 020 8838 3680
E info@capitalcityacademy.org
www.capitalcityacademy.org

Design: **Carter Wong Tomlin**
Client: **Capital City Academy**
Project: **Stationery**

In this design for Capital City Academy's stationery, Carter Wong Tomlin uses the parallel fold to create the illusion of a brick wall.

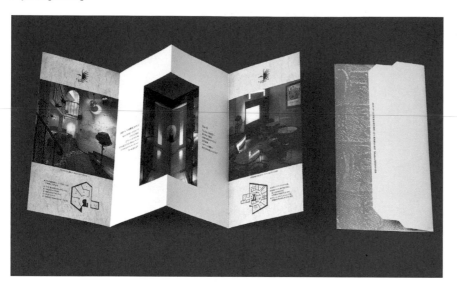

Design: **Zuan Club**
Client: **Karnak Club**
Project: **Promotional flyer and invite**

Whereas Carter Wong Tomlin's design placed the imagery on the outside of the tunnel created by the middle reverse fold, this flyer and invitation to the opening of a bar and restaurant places the imagery on the inside of the fold.

There are no gimmicks here; the design is quite straightforward in what it's trying to achieve… that is, it's showing off the interior of the restaurant and bar and emphasizing this as the venue's main selling point.

Design: **The Riordan Design Group**
Client: **Camp Mini-Yo-We**
Project: **Promotional leaflet**

Further effects can be layered upon the parallel fold. In this example, cuts have been introduced to create truly three-dimensional letters. The reverse folds of this promotional leaflet have been cut with shapes of the three initials of Mini-Yo-We. Mini-Yo-We is an Evangelical Christian children's camp in Canada.

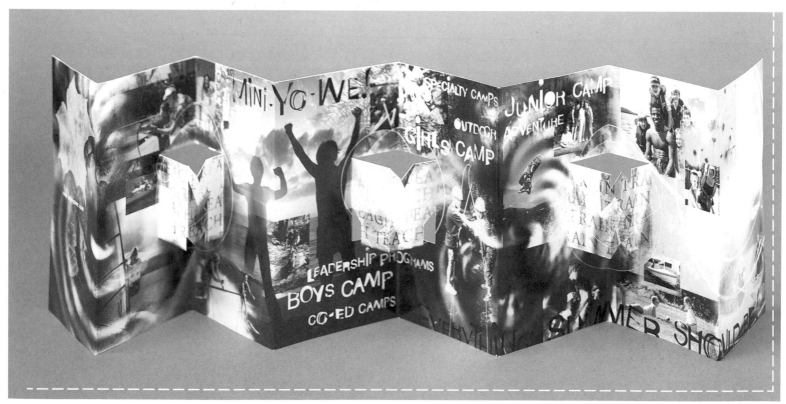

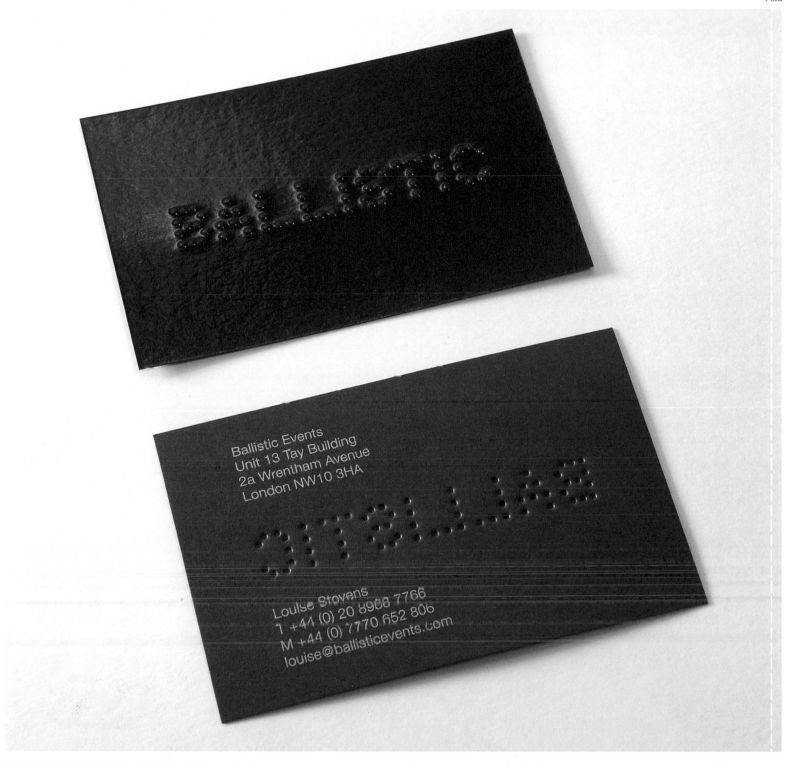

Ballistic Events
Unit 13 Tay Building
2a Wrentham Avenue
London NW10 3HA

Louise Stovens
T +44 (0) 20 8908 7766
M +44 (0) 7770 652 806
louise@ballisticevents.com

Design: **Studio Thomson**

Client: **Ballistic**

Project: **Business cards**

These business cards for communications agency Ballistic are printed on highly glossy burgundy-brown stock with a logo formed by the embossing of dots. The light shines on the raised dots so that they look like little white balls standing out on the page, successfully defining the text, while at the same time cleverly referring to the name of the business.

Design: **Sayles Graphic Design**

Client: **M.C. Ginsberg**

Project: **Holiday invitation**

Created by Sayles Graphic Design, this mail-out's die-cut configuration is deliberately different from the stark layout. Four color photographs of estate and designer jewelry pop out across the page in bold contrast to the solid black boxes of reversed-out type.

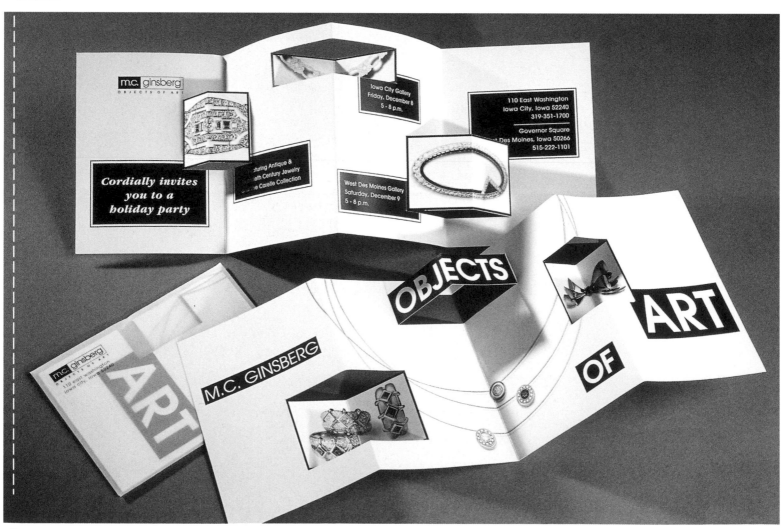

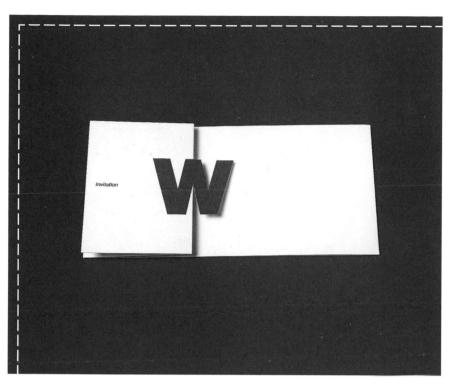

Design: **Zuan Club**
Client: **Wordperfect**
Project: **Leaflet**

Part of a letter printed on a page has been cut around its edges. When the page is folded the cut-out piece of the 'W' pops out and lies on top of another panel created by the fold. Such a clever but simple use of cutting and folding adds a decorative effect and, in this case, emphasizes a letter that is very much part of the visual branding of this company.

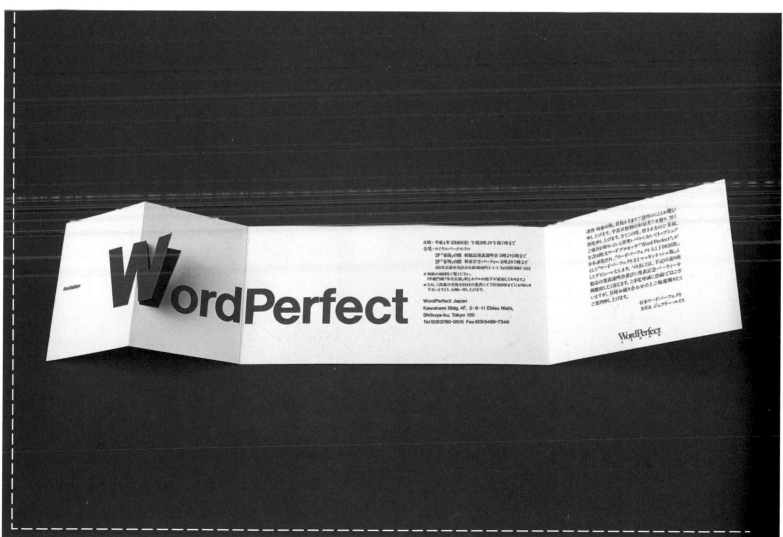

Design: **Marion Bataille**

Project: **Pop-up book**

Letters come to life in this pop-up book, *ABC3D*, created by Paris-based graphic designer Marion Bataille. The letters A and H pull up into square tunnels of paper, C flips over to become D as the motion of the turning page pulls the hidden puppet strings of paper, the lower leg of E pulls back and is hidden revealing an F, and G twists around into shape. To top it all off it is printed in a stylishly simple Japanesque three-color scheme: red, white and black. The book makes an ideal gift for the child of a graphic designer.

Albin Michel Jeunesse and Bloomsbury © 2008

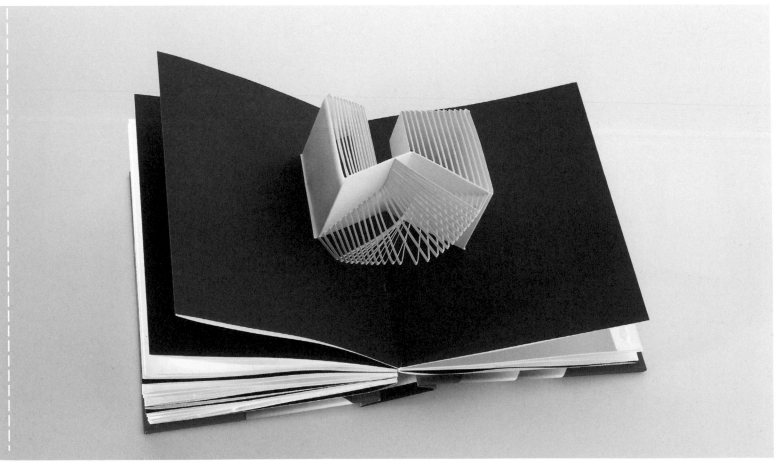

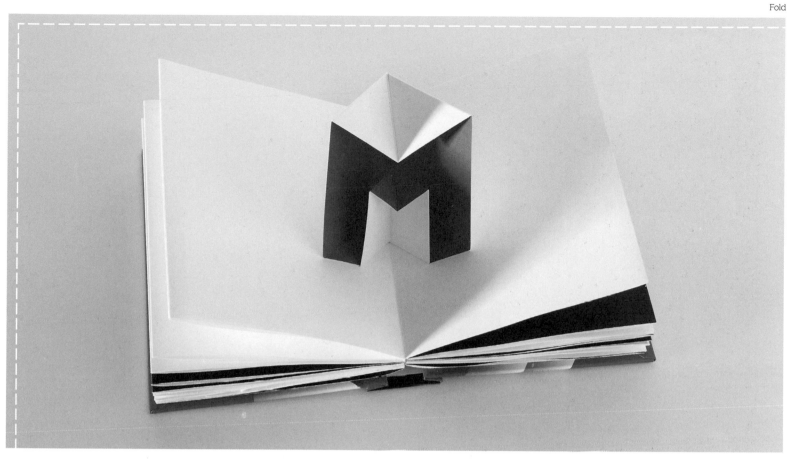

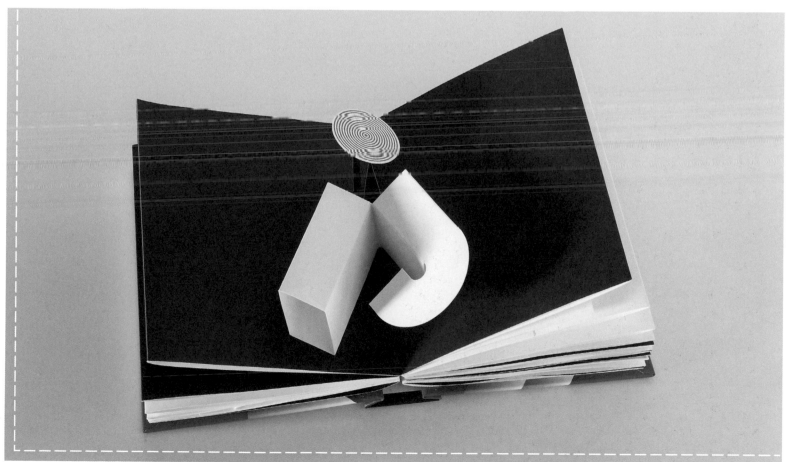

Cut

Couper

Tagliare

Cortar

Schneiden

切片

Cut

Die-cutting can be exploited to create numerous effects. Simple slits can be made to attach pages, insert business cards, or to slot cards together to make three-dimensional shapes. Cut-away edges and shapes can be used to reveal something on the page behind. Shapes cut out or around the page can work in the same way as a printed illustration.

These three pieces of graphic design show how a simple square is used in three very different ways. This simple but strong identity designed by Arizona's After Hours Creative for client Blue Space involves the use of a die-cut square either on blue paper or on white against blue as shown here. The only way of reading this brochure is to tear it apart from the middle. The question "what are you afraid of?" prompts the reader. Ironically this 'think outside the box' and 'empowerment through interaction' statement seems to be anti-design as it encourages the reader to violate the artwork in order to get to the content within.

In the stationery for photographic agency Quasi the position of the cut-out square changes depending on what page the viewer receives. When the folded page is opened, inside there is a printed row of images, one from each photographer represented by the agency. When folded, a cut-out square on the overlapping half of the page falls upon and reveals just one of these images. The image the viewer sees depends on the point along the row

at which the overlapping square has been cut. Designed by Birgit Eggers of Eggers + Diaper, it is a clever way of showcasing the work of all the photographers while placing special emphasis on the one that the correspondence is about.

The die-cuts in these examples were probably created using the most basic of methods whereby metal strips were bent to create cutting edges and then placed in a block called a forme; this is then inserted on the bed of a converted letterpress machine or a converted cutting-and-creasing machine. More intricate shapes can be created by dies formed by metal plates acid-etched from a photographic image taken from artwork. For extremely intricate patterns such as the Christmas card designed by Trickett & Webb, laser cutting can be used. The Father Christmas image is created from a mosaic of the tiniest of cuts. A diaphanous web of fibers has been left behind leaving an unusual textural effect.

Despite the possibility of stunning results such as this, it's important to remember that laser cutting is an expensive option. When it first came about it was widely hoped that it would become cheaper as it became more popular. Sadly the reverse has happened. There wasn't enough call for such intricacy in design and many printers that offered laser cutting found it uneconomical and had to withdraw the service. If your budget allows for

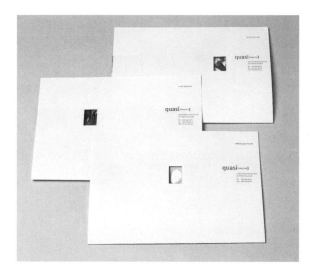
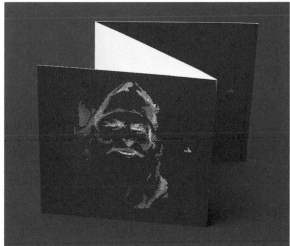

laser cutting and if you manage to find a good printer that can provide or source a laser cutter for you, then there are a few things that need to be taken into account when specifying paper.

Laser beams cut most readily through uncoated paper made from genuine wood pulp or cotton fibers. This is because the beam is made up of minuscule photons of light that find the molecules of purer stock easiest to separate. The photons find it harder and therefore take more time to work their way through cast-coated paper, or through other synthetic products. The weight of the sheet also affects the speed. The laser simply takes longer to cut through a thicker sheet. On heavily coated paper a slight discoloration can appear on the reverse, caused by the burning of the beams. This is not so obvious if it has been printed in a color that will camouflage the burn. Alternatively, the slight yellowing of the edge can be emphasized as part of the design. Whether it's laser cutting or simply metal die cutting it's always worthwhile getting the printer to test on the paper of your choice.

The following pages show some effects that can be achieved when good print design is coupled with some imaginative cuts in the page.

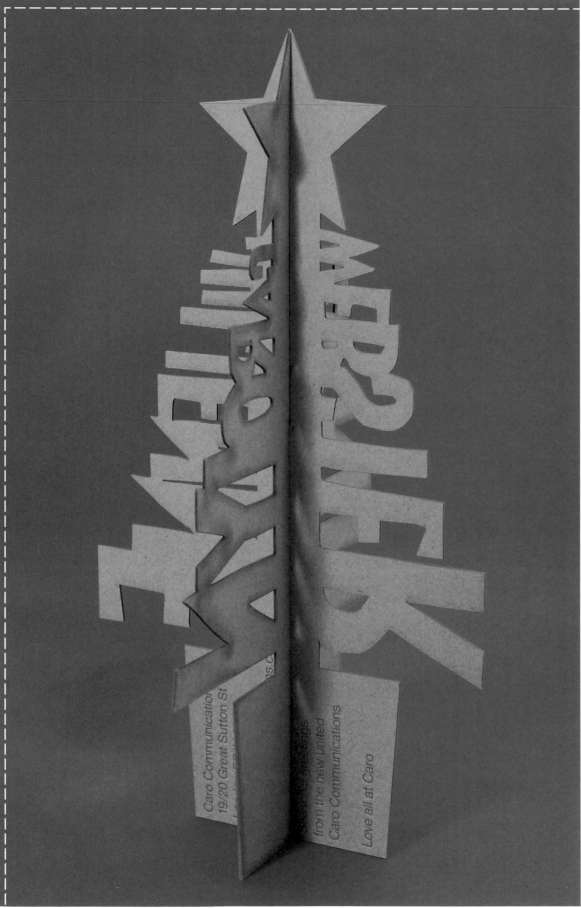

Design: **Multistorey**
Client: **Caro Communications**
Project: **Christmas card**

Businesses rarely use Christmas cards to communicate festive good will alone; they are often opportunely used as a vehicle to pass on other messages. This one, for instance, communicated that there was a new partner in the company. Multistorey made two separate laser-cut Christmas tree shaped cards, each forming the name of the partners. When slotted together they create a freestanding three-dimensional Christmas tree with a festive message block-foiled in hot pink onto the base of one card. The three-dimensionality gives the card a defined presence on a client's shelf, and the interactivity required helps drive the idea of something that works as separate elements, but that becomes complete when combined.

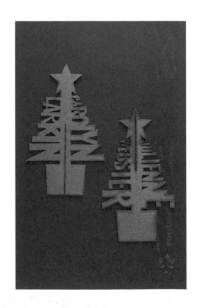

Design: **Wood McGrath**
Client: **The British Council of Art, Architecture and Design**
Project: **Poster design**

Each year a unique framed poster, featuring the same quote by writer George Bernard Shaw, is presented by The British Council of Art, Architecture & Design as an award to the winner of their International Young Design Entrepreneur of the Year competition. Design agency Wood McGrath's interpretation of the quote led them to divide the letter forms in half using a combination of printing, hand cutting, and folding in order to reflect the duality of the statement. This award was presented to the 2007 winner Sigal Cohen of Venezuela at a ceremony held at 100% Design in London in September.

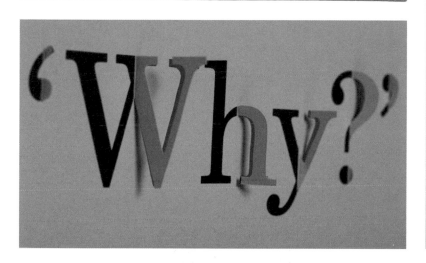

You see things; and you say 'Why?'

But I dream things that never were; and I say 'Why not?'

Sigal Cohen, Venezuela

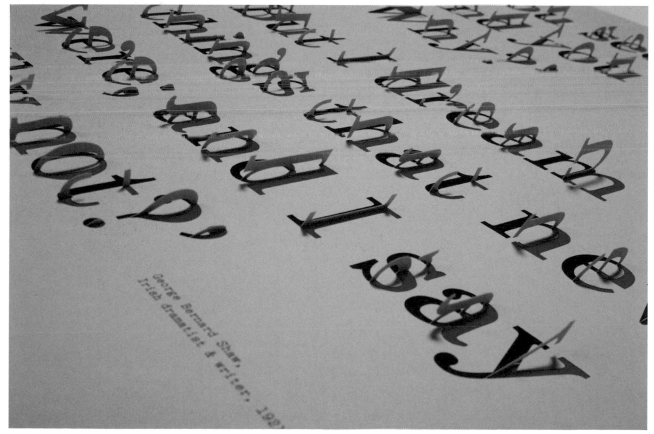

Design: **Metalli Lindberg**
Project: **Self-promotional cards**

This set of 12 promotional slot cards was created to celebrate the new studio space of Italian design team Metalli Lindberg. The commercial studio is in a barn in the stunning countryside near Treviso. With the involvement of the whole studio an identity was created which is based on elements that characterize the space in which they work. The result is this presentation pack of 12 cards with their 're:' theme—re:think, re:ward, re:studio. A party was organized at which the cards were made available to guests to make their own constructions and groupings. A sealed complete pack of cards was then given out to those present as a souvenir of the event and sent out to those who were unable to attend.

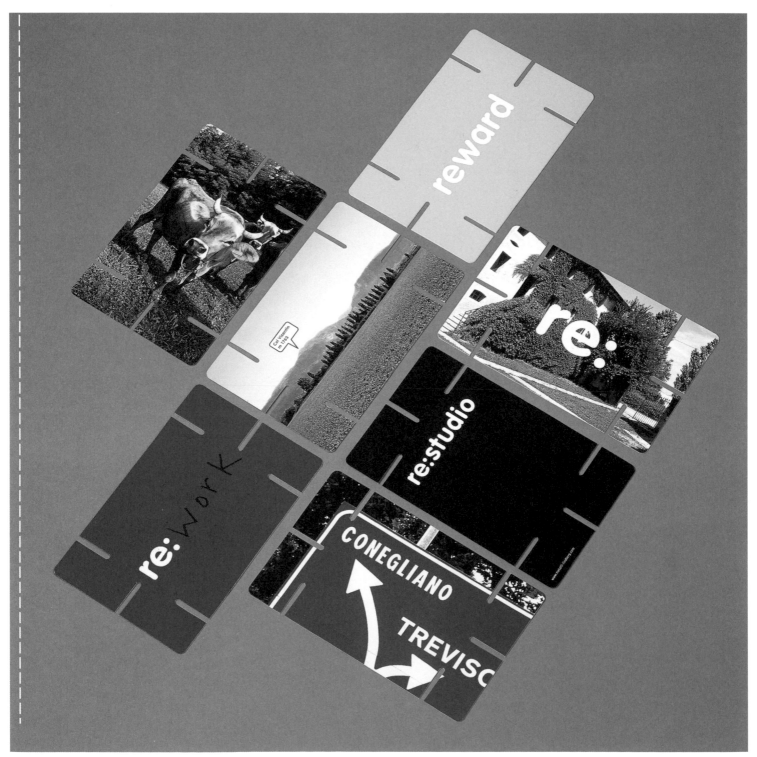

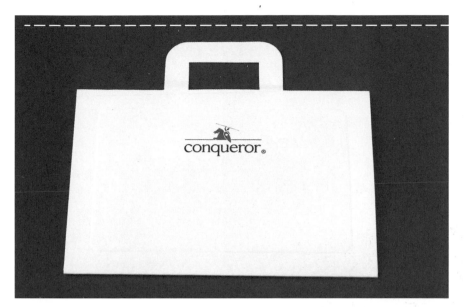

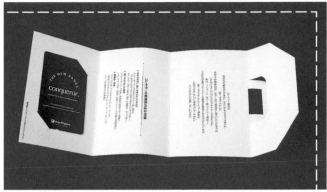

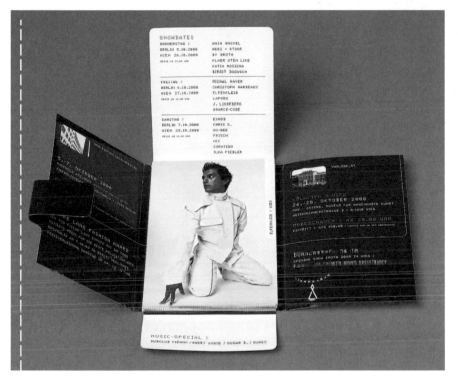

Design: **Zuan Club**

Client: **Arjo Wiggins**

Project: **Sample**

Here one piece of paper is die-cut and folded to slot into the shape of a suitcase. The suitcase works as a pocket to hold a payphone card. This gift from Arjo Wiggins doubles up as a business card-sized panel of information about their Conqueror range of paper. The suitcase itself is a sample of the paper, showing how strong and agile the stock is and therefore ideal for cutting and folding projects.

Design: **Birgit Eggers, Eggers + Diaper**

Client: **IMOTA**

Project: **Folder and postcards**

This collection of postcards, used to promote a fashion show, was held together by a die-cut cover which includes a tongue-in-cheek reference to a belt. Designed by Birgit Eggers, the cover shows that you don't have to use staples, clips, or a separate folder to hold pieces of card or paper together: by cleverly manipulating cuts and folds, cover stock can be made strong enough to work as a folder or container in itself.

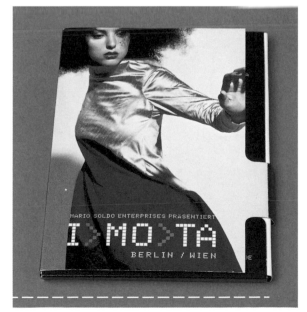

Design: **Eggers + Diaper**
Client: **Jewish Museum, Berlin**
Project: **Leaflet**

It's amazing how much use can be made of just one image thanks to die-cutting. This leaflet for the Jewish Museum in Berlin is cleverly die-cut so that each right-side edge falls in a different place. Along each edge is part of a picture that has been sliced up. When all the pages are closed only the pieces of the picture are exposed, together forming the complete picture. Good editing means that each page alone does not look discordant, but the visual language of the piece as a whole flows because all the pages are tied by one image. This puzzle-like effect gives a clever, modern twist to what would otherwise be a fairly traditional-looking museum leaflet.

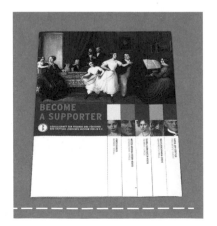

Design: **HGV**
Client: **Bailhache Labesse**
Project: **Brochure**

The aim of this brochure was to impress readers with the quality of the Jersey law firm's staff and their team spirit without compromising an air of professionalism. "HGV wanted to communicate in an unexpected way that the staff of Bailhache Labesse work as a team to deliver expertise and quality," says creative director Pierre Vermeir. Eight faces were used, one on each page, but cut in a different place so that when the brochure is closed they come together to form a completely new face and personality. It would be amusing to try out HGV's design using your own pictures of friends and family. The paper used was Consort Silk 250 gsm for the cover and Consort Silk 170 gsm for the inside and the printer was Gavin Martin. The client was delighted with the result and the annual review provoked positive comments from existing and potential clients.

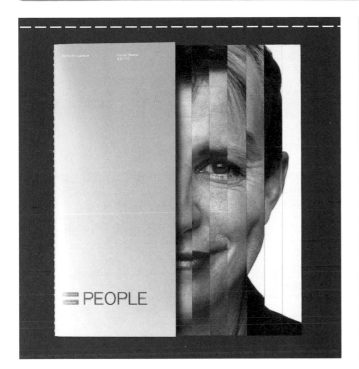

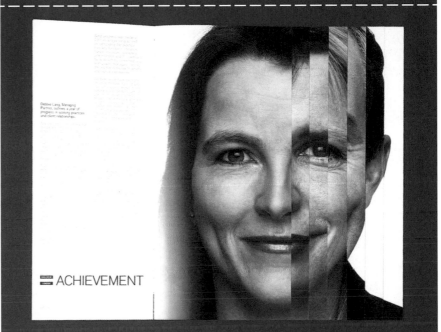

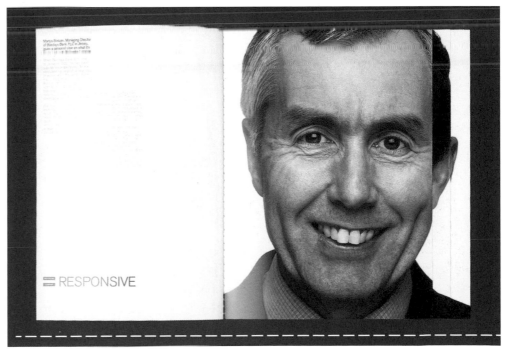

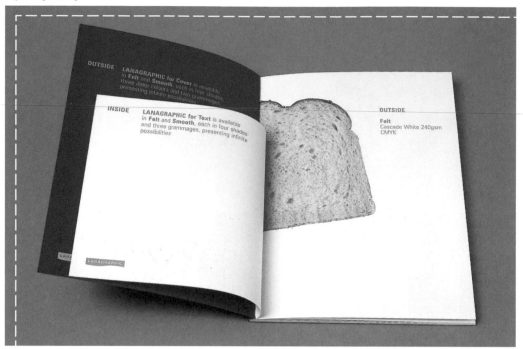

Design: **Roundel**

Client: **Zanders**

Project: **Promotional brochures for Lanagraphic**

On page 19 we looked at Roundel's European version of the 'Inside and Outside' brochure, bound in a dos-à-dos format to promote Lanagraphic, a range of paper by Zanders FinePapers. For the UK version, the design agency used pages that are die-cut in certain places so that an image on one page links and matches with the one behind.

Images include a piece of bread, which, once the page is turned, becomes a piece of toast, and another in which a couple sitting in a convertible car are then sitting on a sofa when the page is turned. The changing images encourage the user to think about texture, to touch and feel the page and consider the 'infinite possibilities' of the product.

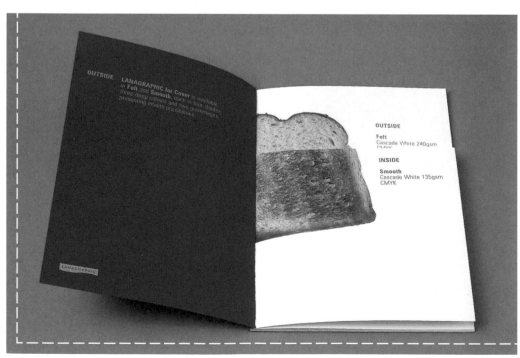

Design: **Multistorey**
Client: **Nokia**
Project: **Marketing brochure**

Multistorey looked at what inspired the designers behind a new Nokia cell phone when asked to design the phone's marketing brochure. Themes such as a flouro color palette, glossy material, geometric architecture, and faceted jewel-like motifs were then conveyed in photographic imagery, paper-engineered typography, and folded pop-up pages. Keywords that describe the phone's design evolution were made from hand-cut and folded paper. These were photographed and overlaid on the geometric images to increase the level of three-dimensionality. The brochure was laid out as one long strip of photographs that bisect each other like shards of glass, and the pages were french-folded. The center spread of the brochure features a pop-up element, where the edge of the pages pop up to represent the angular lines of the phone.

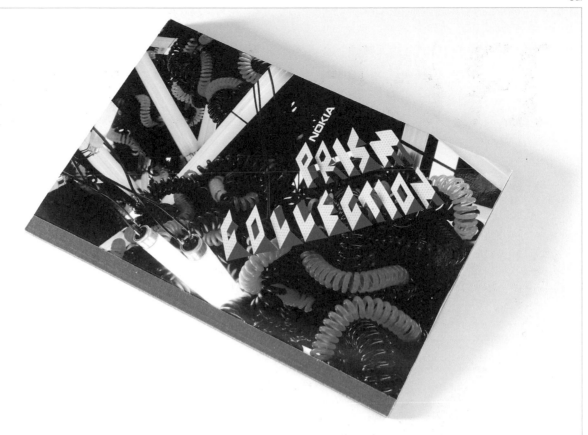

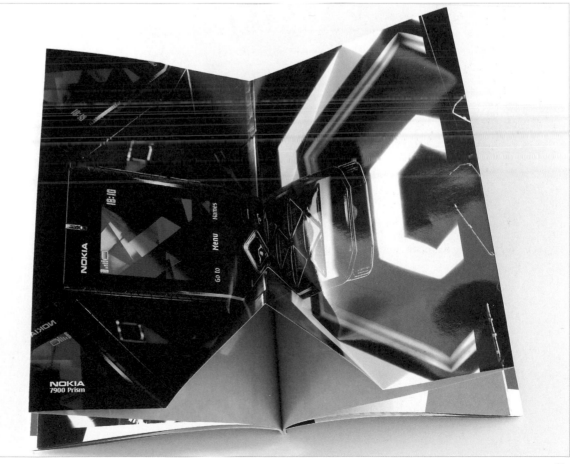

Rob Ryan

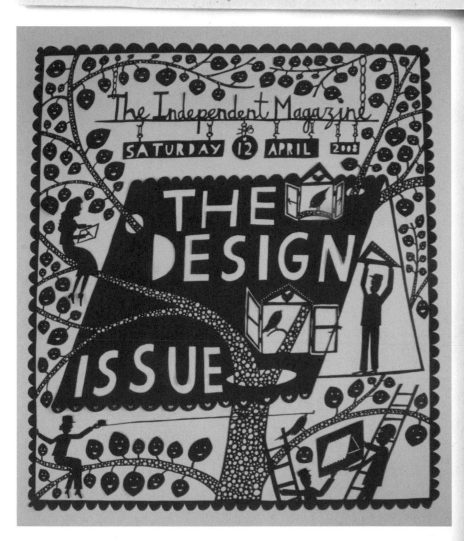

Paper cutting, the art of creating patterns on paper with scissors or scalpels, has been a longstanding traditional folk craft in many countries around the world. In the West it has largely been the pursuit of hobbyists and crafters, but in the past few years there has been a growing number of professional illustrators and graphic designers discovering the charms of such imagery, and you may have noticed the numerous book covers and record albums adorned with the silhouette-like world of the paper cut image.

Riding, or perhaps even driving, the trend for this handmade and highly decorative imagery is British artist Rob Ryan. Ryan found his true niche in paper cutting more than a decade after achieving a degree in fine art at Nottingham Trent Polytechnic and an MA in printmaking at the Royal College of Art in London. In an interview with the *Independent* newspaper, he described how his work has become "more accessible, easier to digest," since he became a paper cutter. "I could do a painting that could be heart-wrenching, throwing my guts on the gallery wall, and it would just hang there. And then I could do a paper cut, a little flowery thing, saying the same thing, with the same imagery, and people can swallow it."

Ryan's success has very much been a result of tuning into the current taste for the more decorative and crafty. There has been a shift away from the angular lines and neutrality of minimalism and a desire for imagery, even in the most corporate and unexpected settings, to look handmade, sometimes to the point of seeming childlike and naïve. It's as if the printed image needs to provide escapism from the screen-based, pixelated world behind which many of us spend our days.

Ryan describes his inspiration as coming from "anything and everything, but particularly being alone. Sadness, introspection, city parks, people behaving well in a poorly behaved world. Children who are lonely and wise." Despite being an urban man—he lives in south London with his wife and two daughters and commutes by bike each day to his east London studio—his paper cuts often feature a romantic world where birds and lovers sit among the trees, or where boys and girls walk hand in hand through dreamy meadows. Along with the return of the handmade, pastoral narratives have also been making a comeback. Just as in wider society, where the urban bourgeoisie have ditched vacation villas for tents and simple wooden cabins so that their children can experience the great outdoors, and city dwellers have been taking their shovels to once deserted allotments to get back to nature and a sense of self-sufficiency, there is also a return in the world of visual imagery to whimsical countryside themes.

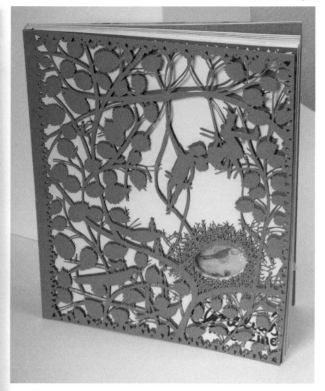

Much of Ryan's imagery has strong roots in folk tradition. For instance, the hearts and phrases declaring love and longing that feature strongly in his work have long been a feature of scherenschnitte, a style of German paper cutting that was imported to the United States in the late eighteenth century and was practiced by the Pennsylvanian Dutch. Created by young men and presented to their sweethearts as tokens of affection, the handcrafted love letters (liebesbriefe) incorporated hearts and flowers. They sometimes had a delicate, lace-like quality, and were embellished with painted watercolors including sentimental inscriptions.

Alongside the dreamy imagery, Ryan's work also contains quaint and sentimental phrases about love and longing. For example, a paper cut greeting card features a couple sitting on a branch among the words, "You were in my head but now you are in my heart stay there forever." An image of underwear is printed on a tile with the words, "I would wait for you as long as it takes I said I would and I will." Some would even go as far as to say that Ryan is as much of a writer or poet as an artist or illustrator. So do the words or the imagery come first? He responds, "I work mainly in sketchbooks so they come from there. Sometimes the words come first, sometimes the pictures. There is no set path." Ryan has even had a book published, *This Is for You*, which is a dreamy tale of a lonesome boy who has lost his place in the world, and who embarks on a magical paper cut journey to rediscover his sense of belonging.

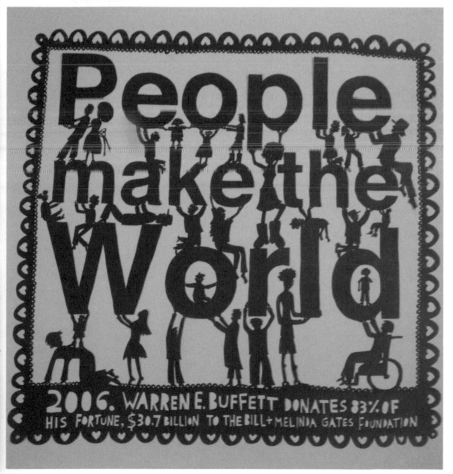

Many of Ryan's pieces convey a sense of melancholy; of loss and loneliness. It is this melancholy, combined with whimsical imagery, that somehow creates the otherworldly feeling of the fairytale. Just as Ryan is a paper cutter who writes, the famous fairy tale writer Hans Christian Andersen was known in his time for his wonderful paper cuttings. Andersen's work was mainly made with scissors, cutting into white paper that was then mounted on black. Many of his cuttings were intended as gifts in return for hospitality, and would be cut at speed and in public as part of an evening's entertainment. Some were simple figures cut out in a few seconds, others were more elaborate pieces made by folding and cutting, then re-folding and re-cutting, creating evermore complicated symmetries.

In many ways, paper cutting is similar to sculpture; it's what is removed that forms the image. You wonder what happens when mistakes are made—do you have to start all over again? "No," says Ryan. "If you make mistakes they are generally very small and can be corrected. It is easy to cut paper and easy to color. The paper I use is an 80-gram book endpaper. When it comes to cutting I use Swann-Morton, 10A blades with a number 3 handle." Ryan creates a pencil drawing, and then every tiny detail of the illustration is cut out with a scalpel and sprayed with color. Ryan is fortunate to have an assistant to help. "You just strip things down," he says. "And because everything is cut from one sheet of paper, that forces a form of decorative pattern. Everything has to link together. Hence you get the trees and foliage linking together, and it all kind of develops."

Ryan's intricate works are not only commissioned as illustrations for numerous books, record covers, and magazine articles, but also for use on textiles, tiles, and even old, odd-shaped glasses found in thrift stores. His venture into creating these products has proved so popular that Ryan has opened his own store where he sells these items alongside his original paper cut pieces.

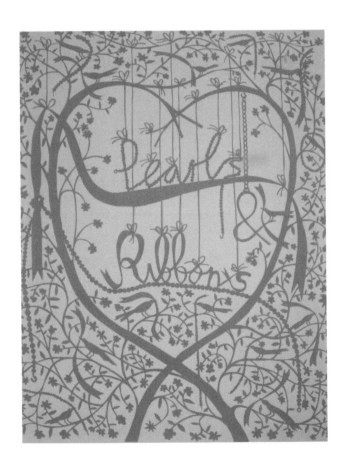

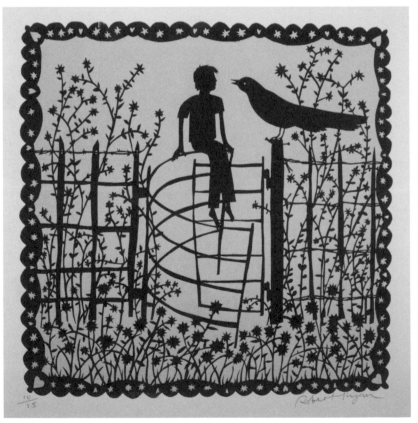

Ryan has managed to become extremely successful despite having no agent, and his popularity has spread simply by word of mouth. Many other designers have been keen to collaborate with him—accessory maker Tatty Devine has worked on a line of jewelry with him, and fashion designer Paul Smith has displayed a screen print exhibition in his Milan store. Ryan has even made a fairy tale paper gown for *Vogue*. It would be hard to get accolades more fashionable than this.

The popularity of paper cut imagery will come and go, but there is no doubt that for many people this style of design will continue to delight. After all, the craft has crossed numerous borders and charmed for many centuries. Its appeal has been universal.

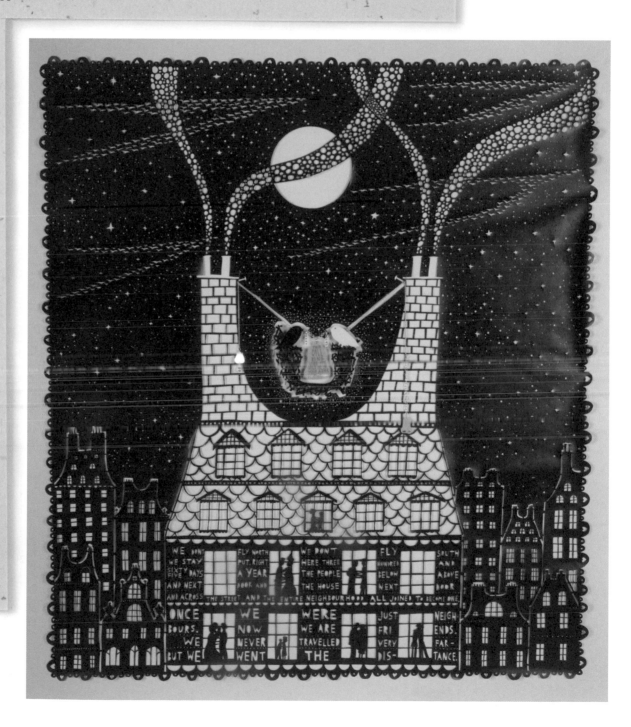

Design: **Ally (now Allies)**
Project: **Change–of–address card**

When design agencies move into new studios they rarely send out standard change-of-address cards or emails. A 'we're moving' notification for a design agency can also double as a platform on which to remind you of their creativity, and emphasize their design ethos. People aren't keen on promotional mailers but here any flaunting is forgivable. When Ally (now Allies) moved studio they sent out this card, which works like a flip-book, using die-cut. It has an auto-cad feel to it; a sense of moving through three-dimensional space achieved by an attractive partnership of illustration and die-cuts at different angles, shapes, and sizes. The whiteness, the simple lines merely gesturing shapes, the Japanese-style bowl... it's all very stylish and sophisticated. Zen, some might say. As you turn the pages you can almost imagine a pair of pretty bare feet padding along the floor, perhaps preceded by the tail of a sleek Burmese slipping around the corner. "We wanted to convey the size and labyrinthine quality of our new home," says Allies designer Susanna Cook. A lovely card... perhaps Allies should move more often.

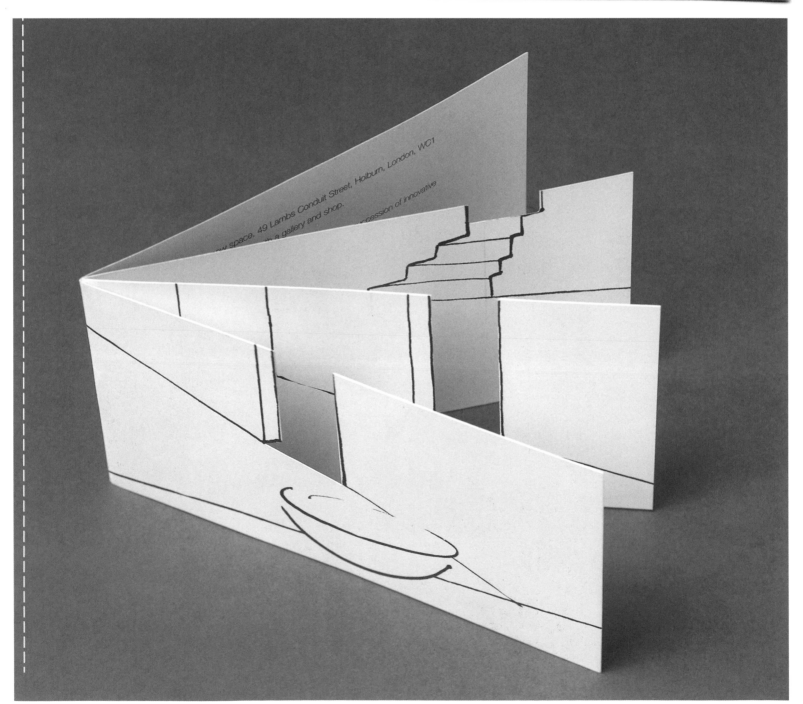

Design: **KesselsKramer**
Client: **ONVZ**
Project: **Annual report**

In KesselsKramer's annual report for ONVZ Health Insurance there are the normal statistics, figures, and plenty of corporate gray, but pull the perforated pages apart and you'll find glossy photographic spreads following the life of a man named Dirk Spits. Could this be an employee? I'm not sure but it's certainly not the chief exec—as these photos aren't glamour spreads and Dirk is no 'it' boy. He's a hairy, red-faced man in need of a gym and a trim, and photographed by Bertien van Manen sleeping, shaving, showering, eating toast, having a curry, or blowing his nose. Even though Dirk is seen in a cricket sweater, Umbro socks, tracksuit and climbing out of a pool, he's certainly not wearing well. This is a somewhat bizarre portrayal of the healthy for a company dealing in health insurance. But it's typical KesselsKramer, whose humor often goes beyond ironic to touch upon anarchic.

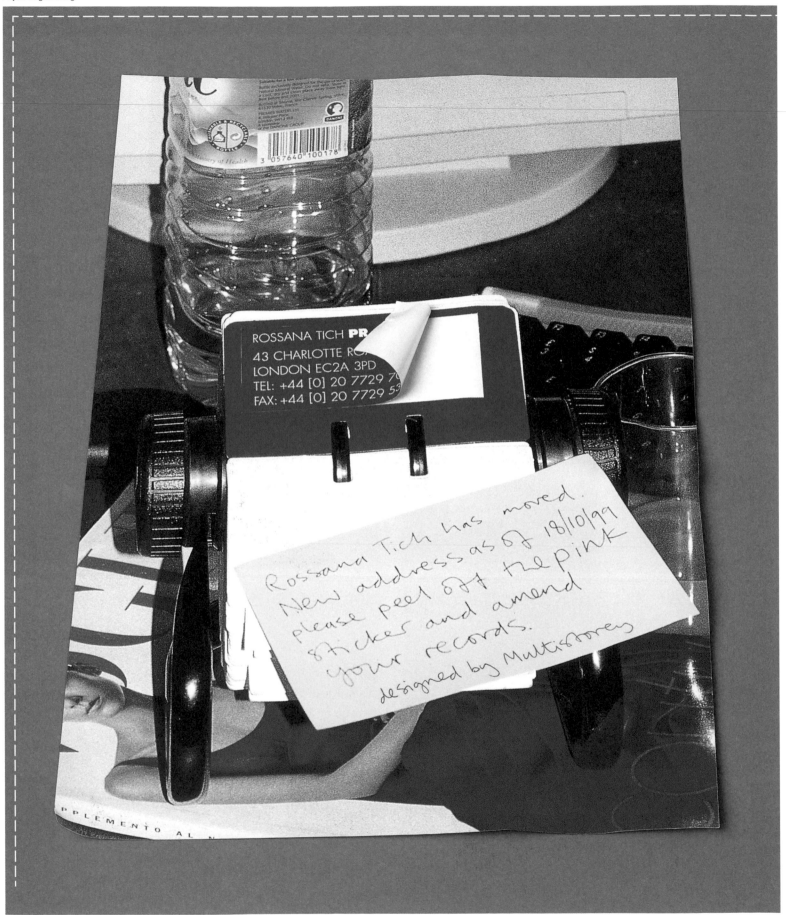

Design: **Multistorey**
Client: **Rosanna Tich PR/Multistorey**
Project: **Change–of–address cards**

Moving offices during the Christmas period seems like an idea guaranteed to drive up the blood-pressure. Fortunately design team Multistorey helped one aspect of this move go more smoothly for PR consultant Rosanna Tich by doubling up the change-of-address notice with her Christmas card (bottom right). A large card is perforated in the middle on both leaves so that a smaller card that shares the same fold can be pushed out. The larger surrounding Christmas card is illustrated with rows of lofty alpine trees and the smaller moving notification card is illustrated with images of removal vans. This combination of trees and trucks may at first fool you into thinking you've received a card from a lumber company, but open it up and all is revealed... the smaller card's interior carries the new address details. Once Christmas is over you can push out the card and retain it for your records. This concept is not only

a visually attractive solution but is clever because of its efficiency—saving on paper, stamps, time, and design fees. Fortunately for Multistorey, Rosanna Tich decided to move two years in a row and approached them both times. The other change-of-address card (this move not at Christmas) didn't use perforation but a sticker (opposite page). One sheet of paper with a colorful photograph of a rotating wheel for storing business cards was sent out. The wheel is opened at a card showing Tich's new address. This part is actually a sticker that can be peeled out and stuck by the client or contact over Tich's former business card. Multistorey's own change-of-address card (above right) also uses the business card wheel theme. The shape of a new business card for such a wheel has been stamped so that you can push it out and just add it in. All three solutions are witty and attractive and facilitate easy end use.

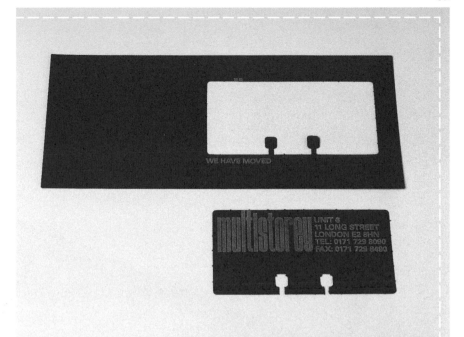

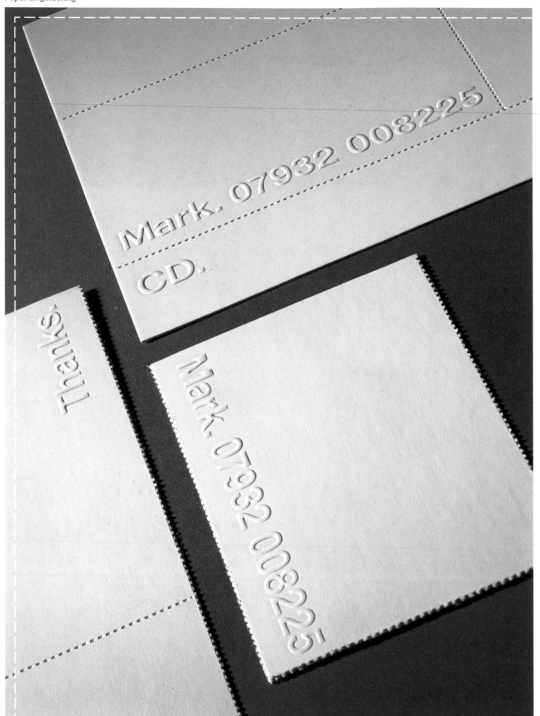

Design: **Rodney Fitch**
Client: **Mark Harper**
Project: **Stationery**

Thanks to perforation this simple piece of card can be used as a business card, compliments slip or CD cover. If it is sent as a compliments slip or CD cover, then the recipient can tear off the business card section to keep. The information is conveyed through embossing, creating a stylish white-on-white effect.

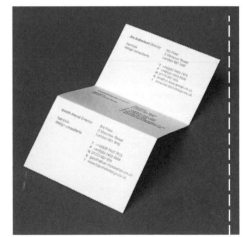

Design: **hat-trick**
Project: **Business cards**

hat-trick is a design-agency led by three partners. Their three business cards are attached together by perforation and can be folded into one card. The use of lighter stock means that when concertina-folded it is not bulkier than the usual single cards. By giving out the three cards together it means that clients have access to them all and also the partners have equal access to the clients. None of the trio can be accused of enticing favoritism here, but if the client likes, he or she can pull the cards apart and keep only one.

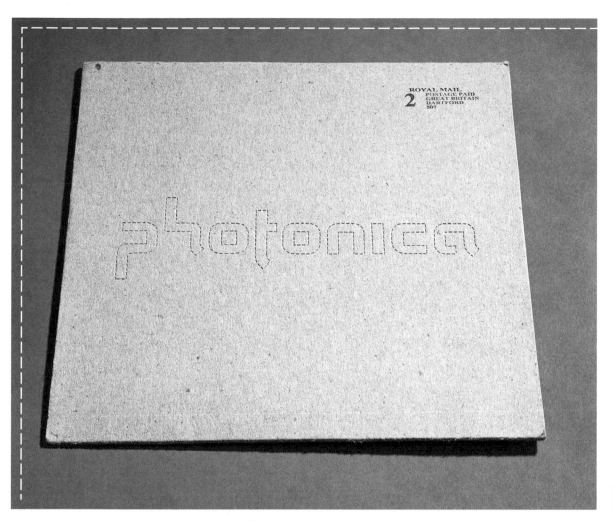

Kiss cutting is a process by which a die-rule or laser is controlled with utmost precision so that it penetrates material but does not cut straight through it. Sticker labels are a good example of kiss cutting: the outline of the label is cut without cutting the release (backing) material. Here kiss cutting penetrates into the surface of a piece of board to create a decorative effect—in this case the outline of the Photonica logo.

Design: **Frost**
Client: **Nike**
Project: **Invitation**

Nike (UK) invited young filmmakers to write a short film giving a fresh perspective on sport. The three finalists were given £7000 to turn their treatment into a three-minute film. For the invitations to the Nike Young Directors Awards, design agency Frost borrowed from the visual language of film. The perforated strip that must be pulled open to get to the invitation details inside is positioned so that the pocket resembles a clapper board.

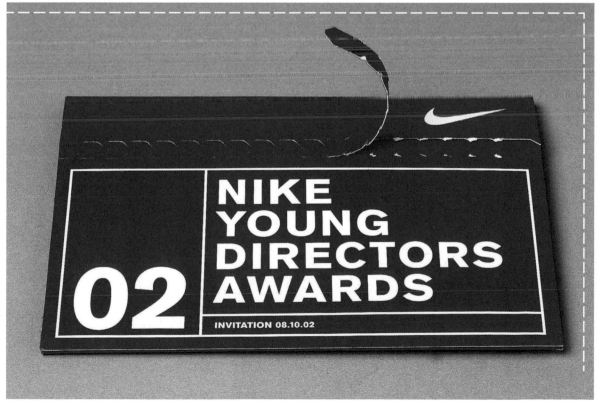

Design: **Origin**
Client: **National Centre for Business & Sustainability**
Project: **Brochure**

This brochure is made from 100 percent recycled, chlorine-free board, features no ink and is debossed throughout. Designed by Origin, this award-winning piece of design is for the National Centre for Business & Sustainability, a consultancy set up by

The Co-Operative Bank, which helps organizations to assist and improve the impact of their business on the environment and society. According to Origin's Paul Hartley, the brochure 'conveys the NCBS's brand values perfectly, and uses the brochure as an opportunity

for the client to 'practice what they preach.' This piece is a perfect example of our 'thinking beyond the ordinary' approach, and represents exactly what Origin is all about."

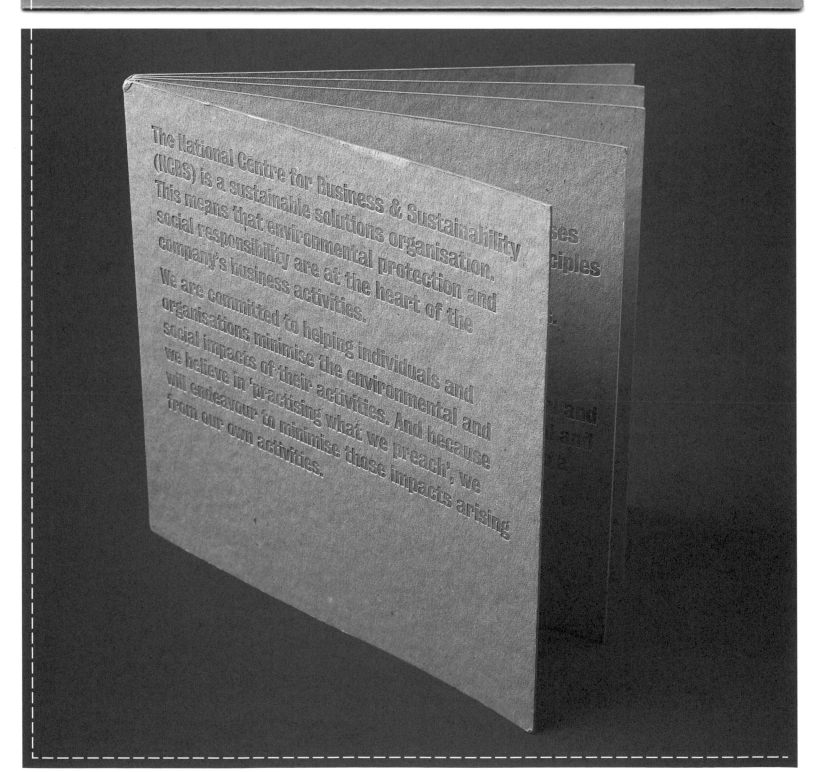

Design: **William Hall**
Client: **We Not I**
Project: **Stationery**

Architectural practice We Not I react against the vogue of architect-as-celebrity by aspiring to anonymity and operating in a 'virtual' manner. Each employee of the agency, including the directors, have chosen to remain totally anonymous, and their central London office only contains a state-of-the-art computer server and internet connection from which the globally located architects download and upload files to work on. When William Hall was asked to design their identity and business stationery, this anonymity rendered conventional business cards unacceptable. The solution was to create stationery that had no printing whatsoever. Instead, there are notebooks with the logo punctured into the center on a business card size page. The architects can add their contact details by hand when required. William Hall explains, "Since the puncturing displaces, rather than removes, the paper (as it would had we chosen laser-cutting or die-cutting), the design has become an architectonic solution, asserting space and encouraging interaction by touch. It also has an enticing visual quality because the voids allow light to filter through."

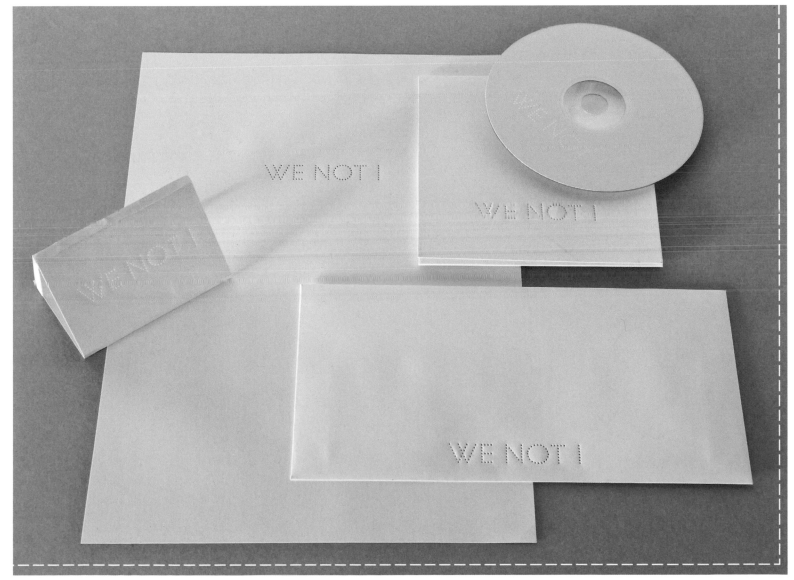

Design: **Airside**

Client: **Another Late Night**

Project: **Beer mats**

'Another Late Night' is a continuing series of compilation albums, each one put together by a different contemporary producer such as Groove Armada, Howie B, Rae and Christian, and Zero 7. Airside was commissioned to design a set of CD and LP sleeves for the series, as well as beer mats and stencils, posters and ads.

For the imagery, the design agency tuned into that very weird time when you are heading home so late that the sun is coming up and people are starting to go about their daily business. There's a different character on each album cover—a girl walking her dog, a jogger, a park-keeper and a milkman —and together the sleeves make up a panoramic view of a park at dawn. The four characters are drawn on their journey through the park. Each of these brightly colored beer mats has been die-stamped with an outline impression of a character. When not pushed out, the indented shape works much like a simple line drawing.

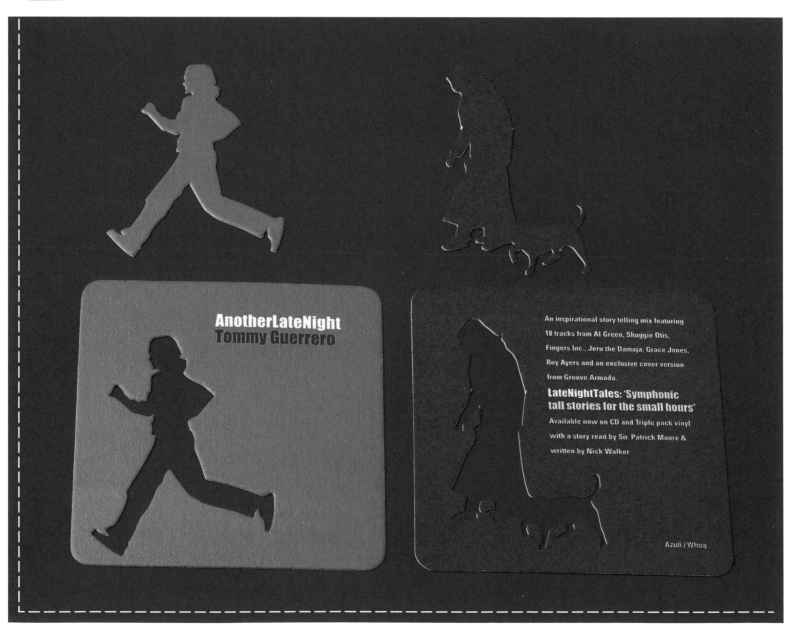

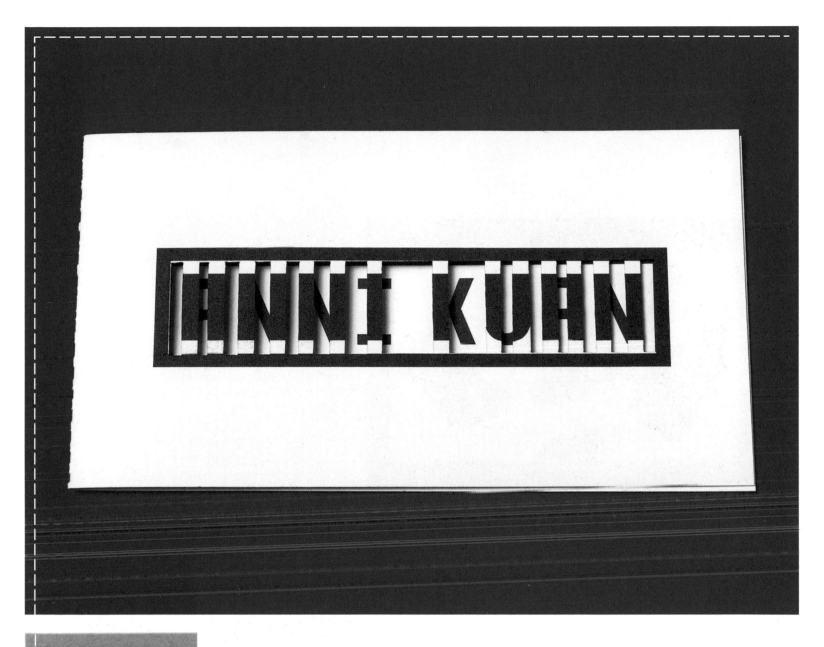

Design: **Sagmeister Inc.**
Client: **Anni Kuan**
Project: **Business card**

Anni Kuan is an Asian
fashion designer working in
New York. On this business
card designed for Kuan by
Stefan Sagmeister and Hjalti
Karlsson, different abstract
elements come together to
form the distinctive Anni
Kuan logo.

Design: **Rodney Fitch**
Client: **Smiths of Smithfield**
Project: **Invitation**

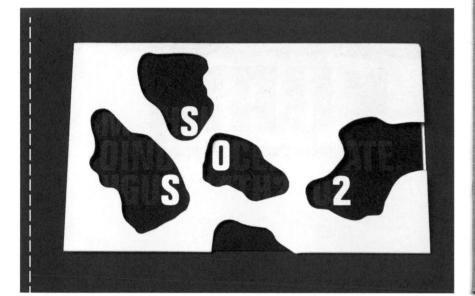

Clerkenwell is one of the hippest parts of London in which to live, work, and play. During the day it is buzzing with young creatives from the design and advertising industries, and by night it's a magnet for the trendiest clubbers and restaurant goers. But the really interesting hours are just before dawn when, at its heart, the beautiful Victorian halls that house Smithfield's meat market are bustling with men in white hair nets and blood-stained white coats heaving carcasses around. Fashionable restaurant Smiths of Smithfield overlooks the meat market. Celebrity

chef John Torode asked design agency Rodney Fitch to create an identity for the restaurant—one that tuned into the area's heritage and environment... hence the 'cow' theme. The identity can be found on menus, packaging, invitations, promotional items and signage. This second-year birthday invitation to the restaurant uses a die-cut cowhide device to reveal the SOS 2 information. The inner invitation then slides out and formally invites you to the party. The sleeve paper stock—Robert Horne's 'Curious Touch Whipped Cream'—even has a leathery feel to it.

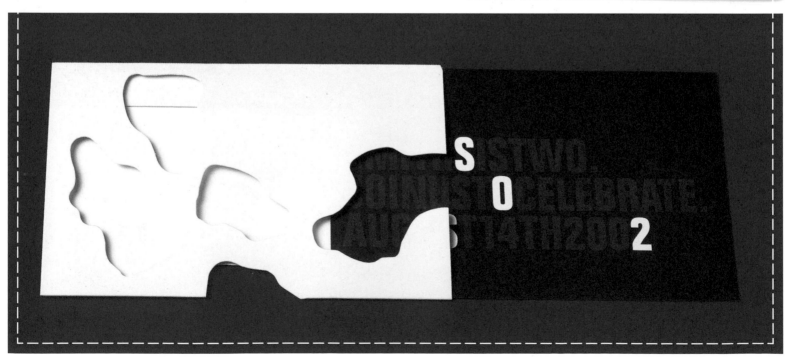

Design: **Yorgo Tloupas**
Client: **Eurostar**
Project: **Promotional packaging**

The channel tunnel opened up whole new worlds of possibility for red-eyed revellers in Paris and London. Eurostar, which runs trains between the two cities, offers great deals for those who have enough energy to leave one city on a Saturday evening, spend the night out in the other, and return home first thing in the morning. To promote the great deals on offer this little package featuring a CD and a booklet was sent out to young Parisians. The CD and booklet are packaged in a slip-case, designed by Yorgo Tloupas, which is die-cut to look like a red London double-decker. A panoramic London nightscape is seen through the windows. The CD contains some new dance-floor tunes and the booklet is a guide to London districts, clubs, drinking holes, cheap eats and includes comments from well-known DJs about their favorite London hang-outs. The whole piece is attractive and well-produced, and unlike many promotional objects is far from disposable... au contraire, it surely has pride of place on the CD shelves of many Paris pads.

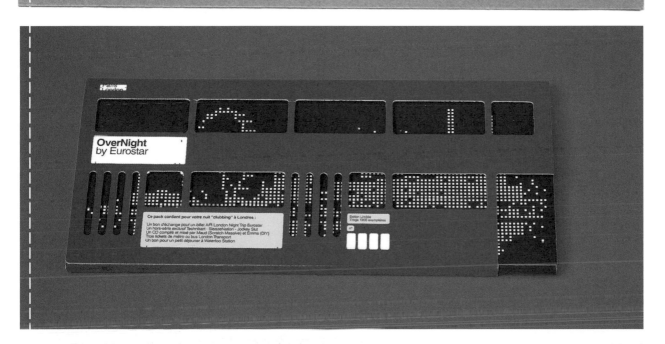

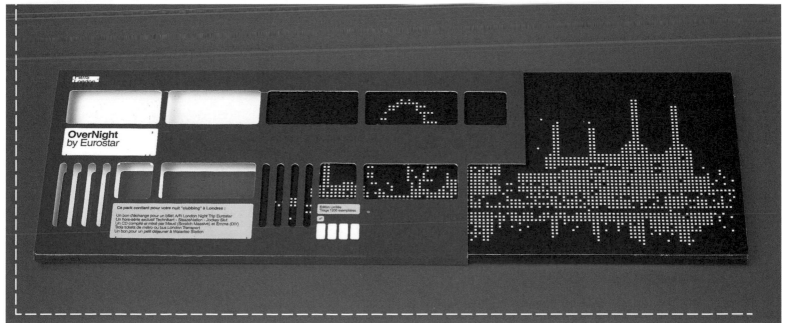

Design: **Yorgo Tloupas**
Client: **Shu Uemura**
Project: **Press release folder**

The concentric oval cut-outs of this beautiful folder perfectly emphasize the elegant nail shapes and lovely varnish colors available from cosmetics company Shu Uemura's Nail Shop. "It's also a reference to the way Japanese Zen Gardens are made (neatly groomed gravel), and to architectural models," says designer Yorgo Tloupas. "The subtlety, excellence and quality of the brand was also an important part of the brief, as was the Japanese heritage. Paper cutting and folding is a secular tradition in Japan, so this fitted in well."

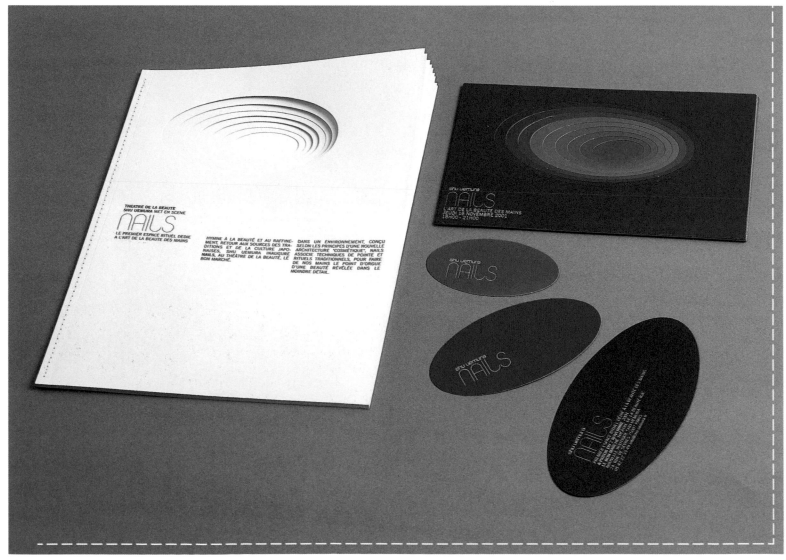

Design: **hat—trick**
Client: **Newslink**
Project: **Mailout cards**

The media is often accused of mixing up messages and messing with our heads. Well, here's the evidence to prove it. Newslink, managed by Capital Radio Advertising, needed to communicate to media buyers the opportunity of using time within commercial radio news bulletins to advertise. Newslink claims that, according to research,

listeners are most receptive during news broadcasting (as they listen to the news more attentively). The idea behind this direct-mail vehicle was to demonstrate media proliferation through cutting. The cut-out pieces are used as metaphors to get Newslink's message across and to represent getting the advertiser's message across. For instance, the cut-out

shape of the keyhole represents "the key to 40 percent higher recall of your campaign?" and a fold-out door represents the concept of access in the quote "newslink allows access to an unprecedented 24 million listeners each week." The response rate of six percent was the best that Capital Radio had ever achieved through a direct mail piece.

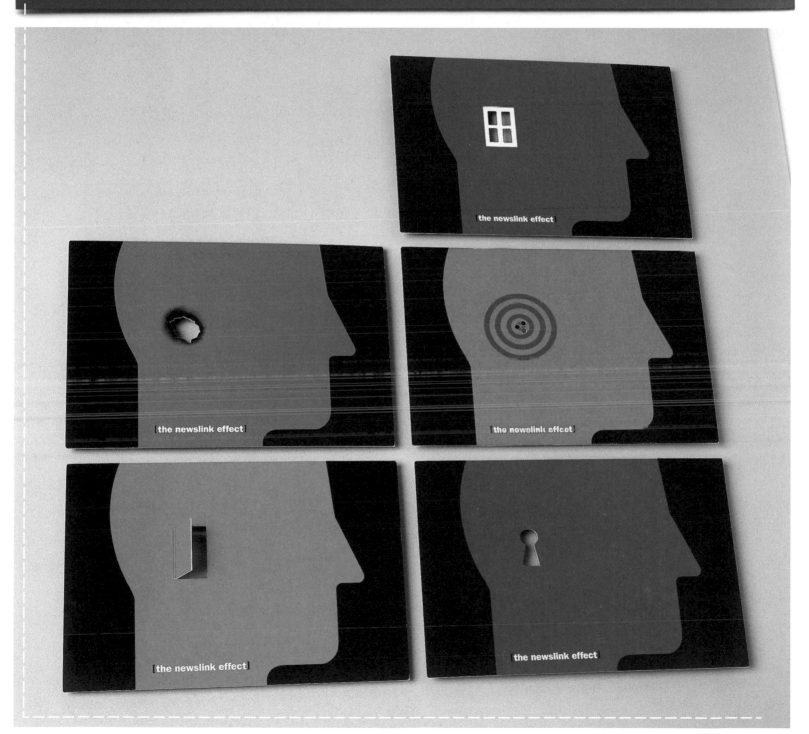

Design: **Bisqit**
Client: **Adidas**
Project: **Press information folder**

Long gone are the days when a press kit was simply a few bits of photocopied paper stapled together and contained, if you were really trying hard, in a folder or slipcase straight from the office stationery cupboard. Nowadays, as well as being lavishly courted with freebies and champagne receptions, fashion and other consumer-product journalists are presented with printed information as beautifully or imaginatively designed in itself as packaging for the end consumer. This folder for Adidas was designed to hold the printed press information for a new soccer boot—Predator Precision— a shoe for which soccer star and hero David Beckham was paid millions just to be associated. A main feature of the shoe is its rubber elements 'strategically placed to increase control, swerve and power." The folder, designed by Bisqit, emphasizes this quality with die-cutting in the places where the studs should be.

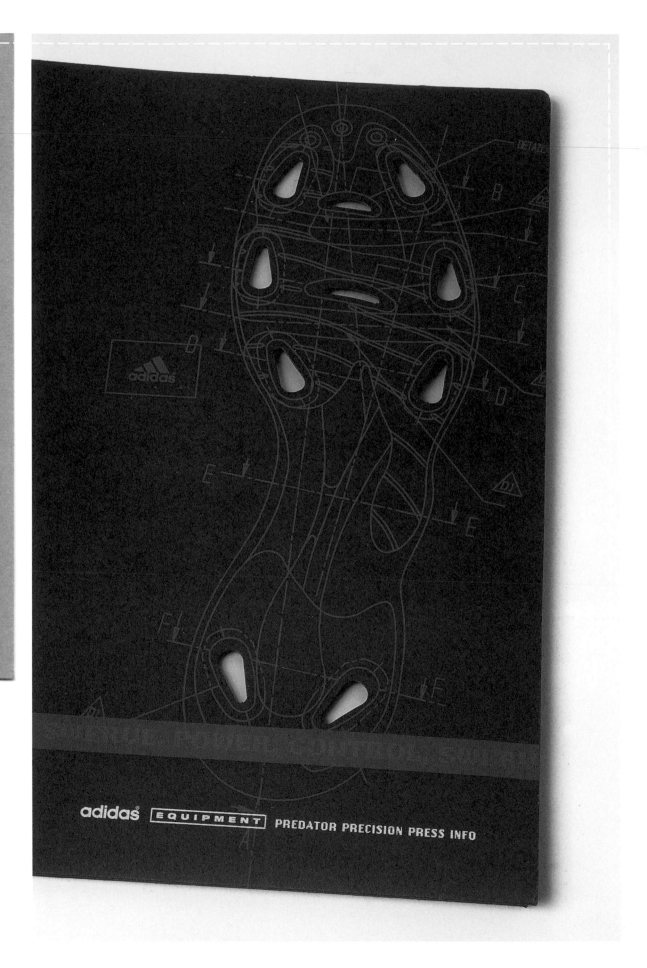

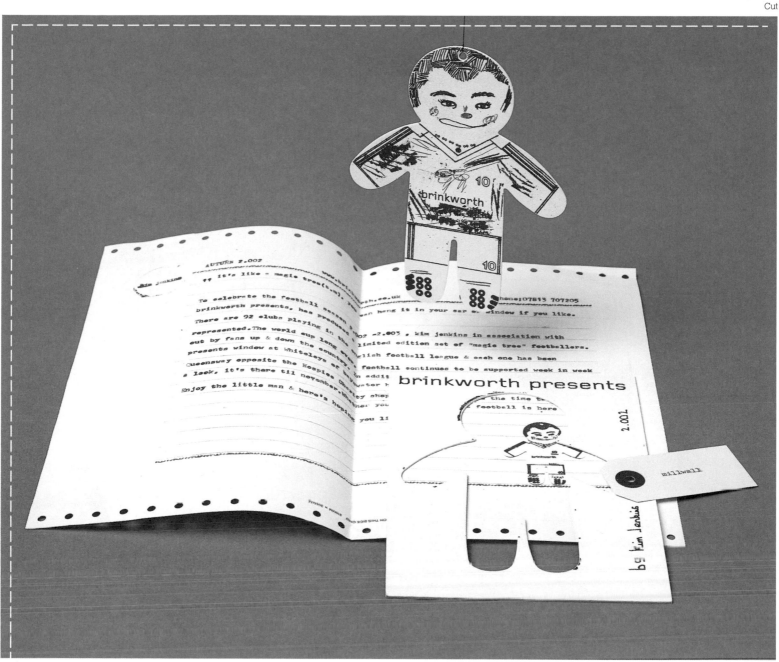

Design: **Kim Jenkins**
Client: **Brinkworth Presents**
Project: **Art installation**

To celebrate the soccer season 2002–2003, Brinkworth, an interior design and architectural agency, commissioned Kim Jenkins to produce a limited-edition set of 'magic tree' players to be hung in car rear-view mirrors or in windows. There were 92 clubs playing in the English soccer league and each was represented by one of these trees. These individual art works were then sent out to 92 lucky people. In addition to the magic tree soccer player, Kim Jenkins created an art installation in the Brinkworth window in Whiteley shopping mall in Bayswater, London. This was not a one-off for Brinkworth—Brinkworth regularly curates artist installations in the window of this popular shopping mall.

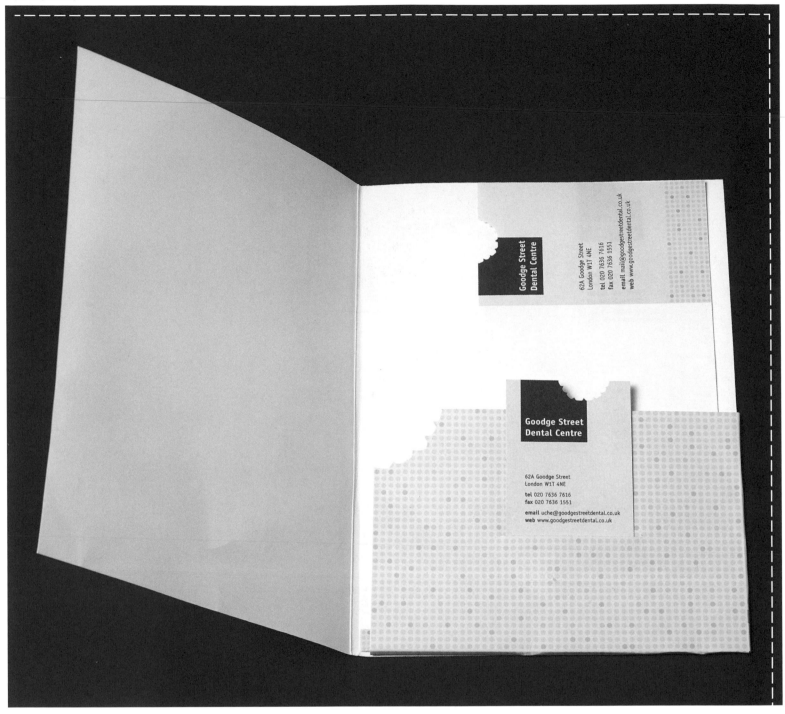

Design: **Etu Odi**
Client: **Goodge Street Dental Centre**
Project: **Stationery**

The corner of each piece of stationery for Goodge Street Dental Centre in London has been die-cut with bite marks. It's rare to find a dental practice that sees the value of good design, but this one certainly does. It hired Etu Odi to design not only its stationery but also a very attractive website. Etu Odi explains: "GSDC is a private dental practice based in the heart of London's Soho media village. It's offering was aimed squarely at the design savvy clientele in the area and provides a range of services over and above what you would expect from a traditional dental surgery."

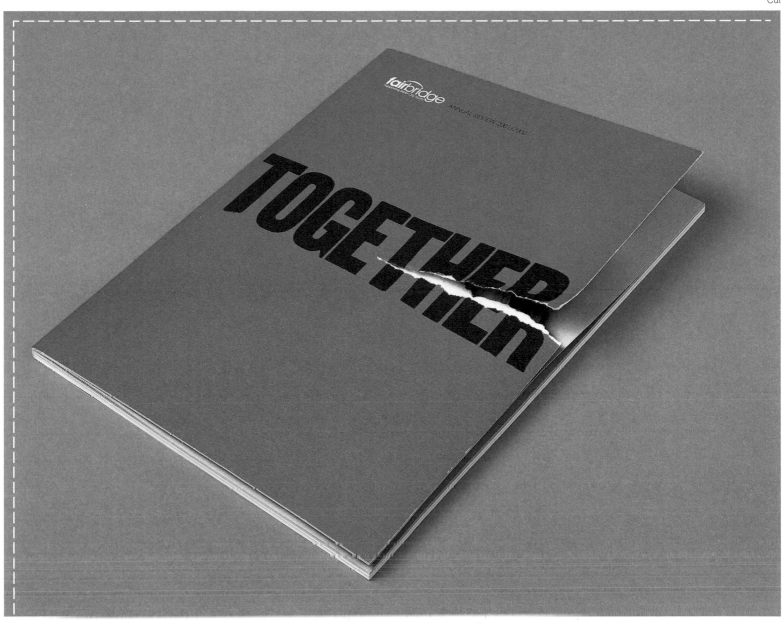

Design: **hat-trick**
Client: **Fairbridge**
Project: **Annual report**

Not much technical know-how was needed to create the simple but very effective finishing on this annual report's cover. Nine thousand covers were simply hand-torn to create an image that works as a metaphor for lives torn apart. Working with 12- to 24-year-olds in some of the most disadvantaged areas in the country, Fairbridge is an organization that puts these young people's lives back together by changing what they expect from life and giving them a chance to put things right. Throughout the rest of the annual report the analogy of sticky tape is used to illustrate how Fairbridge helps them put things back together. A series of photographs and images were torn, then put back together again with sticky tape. These images also illustrate how Fairbridge works together with other government agencies. To create this effect, hat-trick had to do various tests to find a relatively uncoated stock that would take the spot UV varnish for the tape. The paper used was Command Matt from McNaughton and printing was by Boss Print.

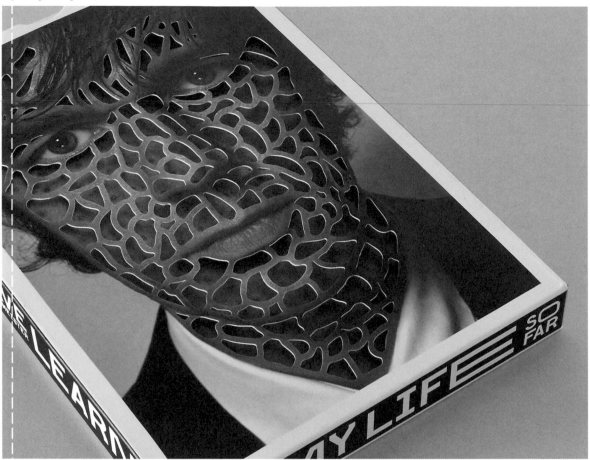

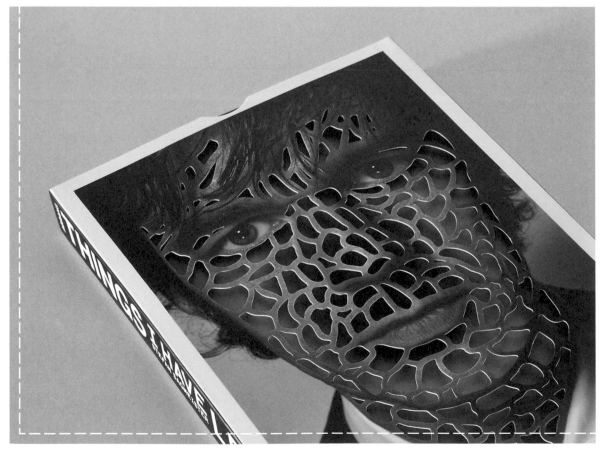

Stefan Sagmeister is known for making a spectacle out of himself. He has previously incised words onto his body with a razor blade, eaten twice his weight in junk food for posters, and documented himself urinating words in the air on Wall Street. The cover of his book, *Things I Have Learned In My Life So Far*, is no exception. The book consists of 15 pamphlets contained within a slipcase showing Sagmeister's face covered with a maze of die-cut spaces. If you're not so keen on the teenage-like pimples that the spaces reveal on the first pamphlet, then you can shift the others around in the slipcase for an alternative, perhaps prettier, graphic experience of the designer. Each pamphlet documents typographical experiments using the words of simple maxims gathered from a diary that he kept during a yearlong, client-free sabbatical. "Worrying solves nothing" is written out in black and white clothes hangers, and "Keeping a diary supports personal development" is created from bamboo scaffolding. All these typographical experiments were photo-graphed in settings beyond the usual printed page or art gallery.

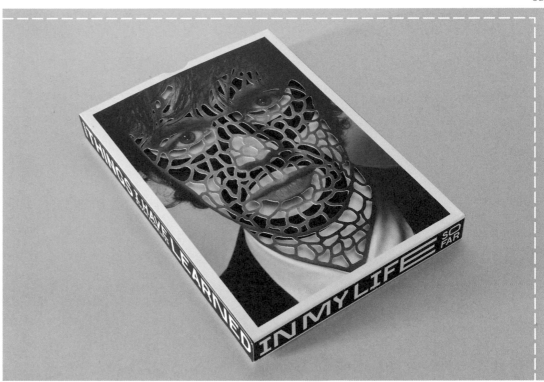

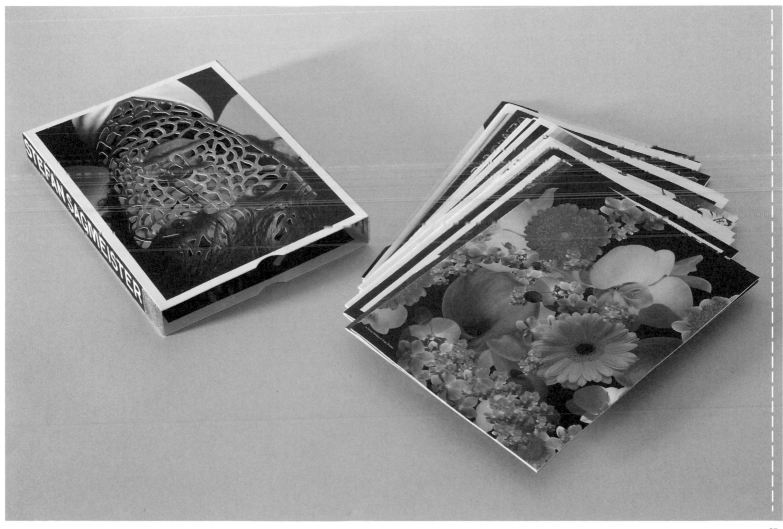

Design: **Stefan Sagmeister**

Project: **Gallery installation**

Accompanying graphic designer Stefan Sagmeister's book, *Things I Have Learned in My Life So Far* (see previous page), was a multimedia exhibition of works at Deitch Projects in New York's SoHo. The title of the exhibition was incorporated into a wall of open notebooks. Pencils hung from the ceiling close to the notebooks, encouraging visitors to write their own "things they have learned in their lives."

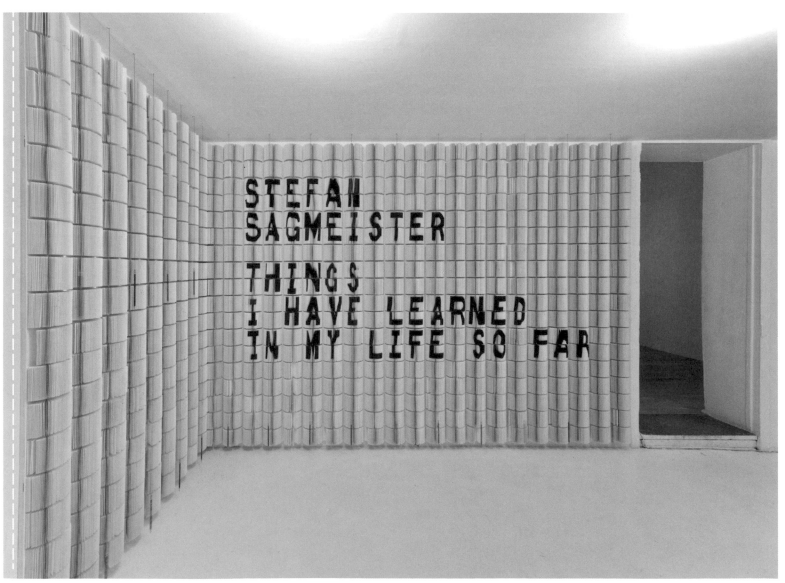

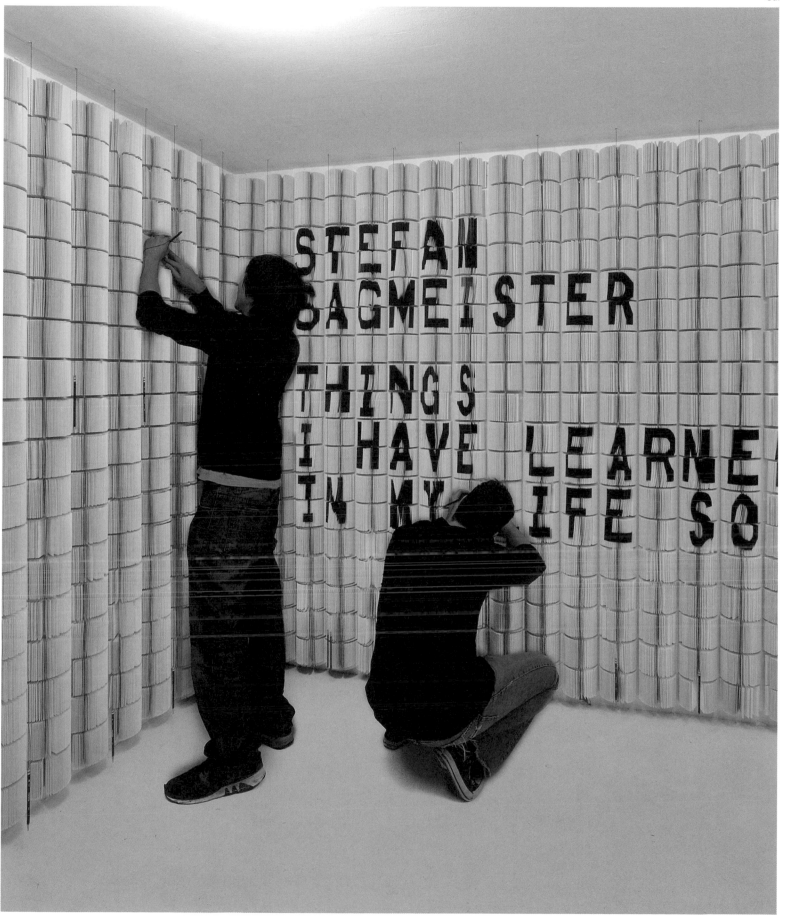

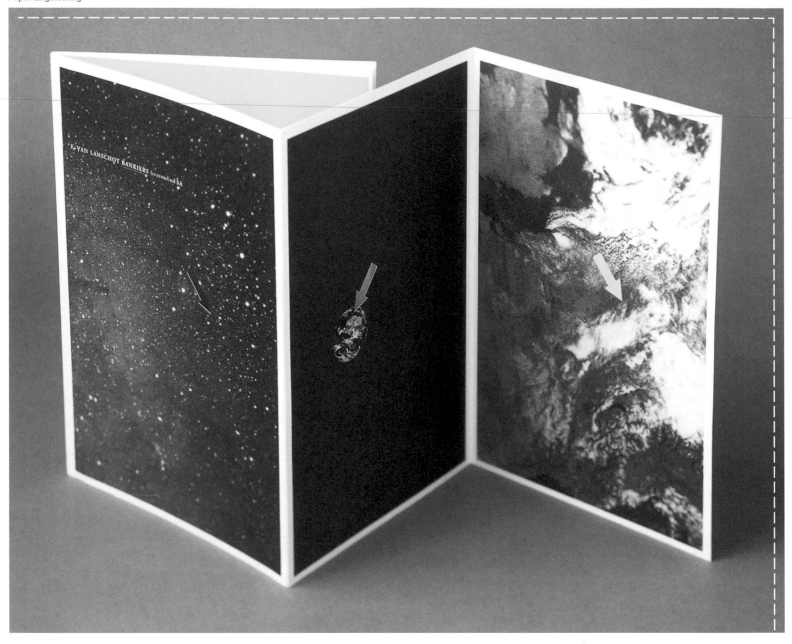

Design: **Mark Diaper and Will de L'Ecluse, UNA**
Client: **F. van Lanschot Bankiers**
Project: **Annual report**

"For this Luxembourg bank, the idea of stability is crucial—any change makes their clients and investors nervous," explains former UNA designer, Mark Diaper. "When they moved premises they wanted to make it clear that nothing else had changed. The cover of their annual report shows that they are still in the same place in the universe, still on planet Earth, still in Luxembourg, but when you look on the inside of the cover, the two die-cuts show you that they have moved from one address to another. The rest of the report sets out the facts and figures in a very simple way without illustrations or much use of color—as would be expected from a financial institution where the importance is clarity. But the front cover gives the report a creative edge and puts a message across in a clever and amusing way. What otherwise could have been a dull report has been transformed by wit conveyed through folds and die-cut.

Design: **Trickett & Webb**
Client: **Royal Mail**
Project: **Menus/gifts**

Each year the UK's Royal Mail arranges a Christmas lunch for their Stamp Advisory Committee, which consists of about 20 people from all fields, including designers, doctors and media stars. These are three of a series of menus/gifts for the event that were designed by Trickett & Webb. They always include a set of stamps, often the Christmas set, and because they are produced in a limited edition of 50, they inevitably become collectors' items. "Lickety Stick was based on the toy stamps illustrated by Dan Fern," explains Lynn Trickett. "We created a tiny 'board book' with a Betjaminesque storyline, written by Neil Mattingley. Since the run was only 50, we were able to cut the pages by hand, when cutters would have been prohibitively expensive. Weather Map (top left and right) was based on the Snow stamps by Andrew Davidson. The stamps showed children playing in the snow, so we continued the snow theme by 'burying' the stamps in embossed snowdrifts. The tiny book was wrapped in an elaborately folded weather map, which doubled as the menu. In the year we designed Christmas Trees, (bottom right) the stamps were illustrated by Laura Stoddart and the theme was trees that are related to the Christmas story. We designed a little book where each leaf was literally a leaf from the trees." Laser cutting was used to achieve the cut-out shapes, as such intricacy would have been impossible with conventional dies. The paper was a specially treated watercolor paper that could take printing inks. In all, Trickett & Webb produced nine of these special gifts for Royal Mail.

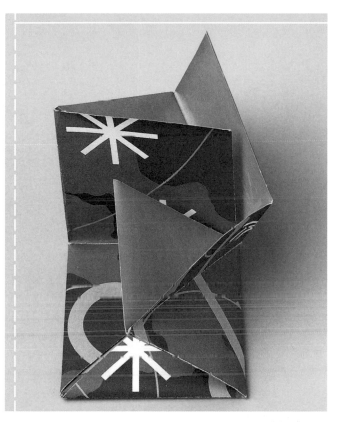

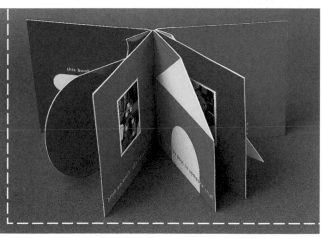

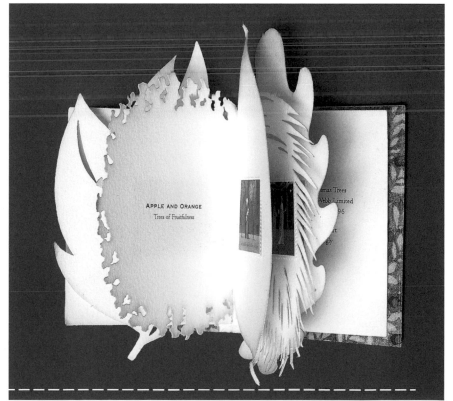

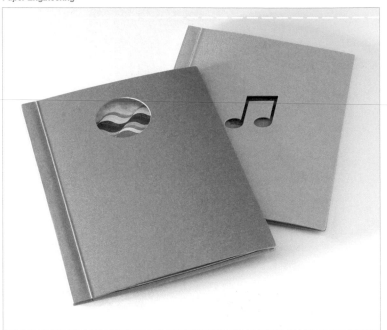

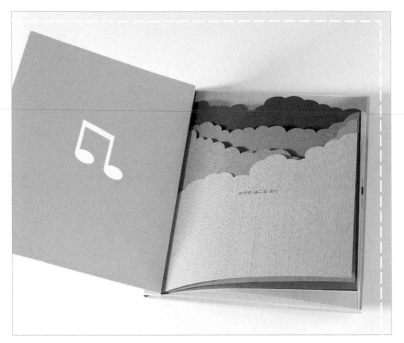

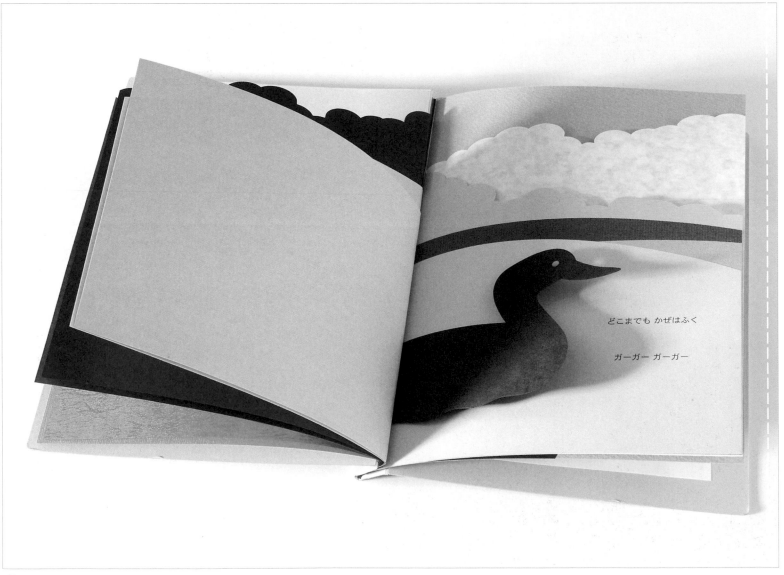

Design: **Katsumi Komagata**
Project: **Picture books for children**

Japanese graphic designer Katsumi Komagata started creating these beautiful paper engineered books for children after the birth of his daughter. Inspired by watching the progress of her development, he created sets of playful card games that enable color and shape to change through the act of folding and unfolding pages and peeking through cut spaces. Komagata then went on to create storybooks such as the ones shown here— *Blue on Blue* and *Sound Carried by the Wind*—that draw the reader into a three-dimensional world through different colors, paper textures, and cut shapes. No two pages are the same in any way, and the books stimulate curiosity and allow for interaction between parent and child. The only problem is that these books are so lovely, would you dare let your child get his or her hands on them? Komagata, who spent five years working as a graphic designer in New York where he won an ADC silver award, runs his own design agency, One Stroke, in Japan.

かぞえきれないほど　ほしは　たくさんある。

こんなはげしい流れは　はじめてだった。
ぐるぐるからだがまわり
息をするのがくるしくなってきた。
「あー　どうしよう」
PACU PACUは考えた

Design: **Gardner Design**
Client: **Aspen Traders**
Project: **Holiday cards**

Gardner Design has been creating holiday cards for Aspen Traders for 15 years. Aspen Traders is a woman's clothes store that specializes in garments and jewelry from around the world. Each year they inform Gardner design about that year's trends, which the design team focuses on for the cards. Bill Gardner says, "We pretty much understand what they and their customers will respond to. Being on Aspen Traders' Christmas mailing list has turned into a symbol of status in the community. There is no doubt that a folded, dimensional piece has a much longer life than a flat piece. They become small treasures. On a monthly basis, someone mentions to me that they have collected every one of the 15+ cards and that they set them up in their home over the Holidays. You can't buy that kind of advertising." The three-dimensional fabrication of the cards has several parameters. The cards have to fold flat and fit into an existing envelope for mailing. When the card is opened, it must not require any additional assembly, and the cards should be self-standing for display. Gardner adds: "Every year we challenge ourselves to try something a little different. Some of the cards have become complicated enough that the folders have come close to revolt." Gardner has always had a fascination with clever folding: "I would see a printed sample of a card and I would cut out little mock-ups to see if I could achieve the same effect. Over the years I have learned enough about folding paper that I can sit down with paper, knife, scoring tools, tape, and rulers and just start whittling away. Now I have gotten to the point where I can see a piece folding in my mind so I sit down at the computer and draft it out on screen." Much of the surface design is applied by Brian Miller, the company's vice president and art director: "He has an amazing ability to take a three-dimensional design and integrate a beautiful surface that ties directly into the shape and theme of the piece," says Gardner. "Designing flat for a piece that will live in 3-D is very challenging."

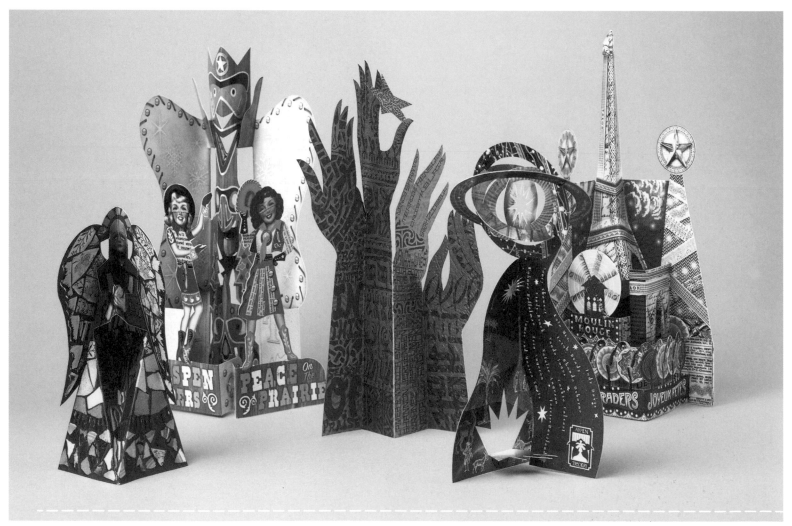

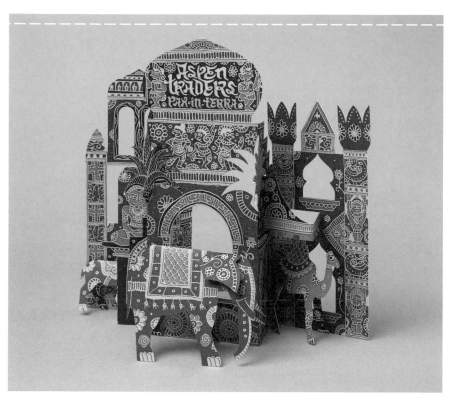

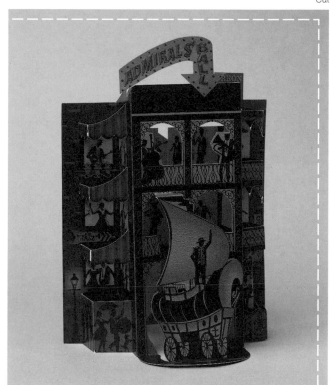

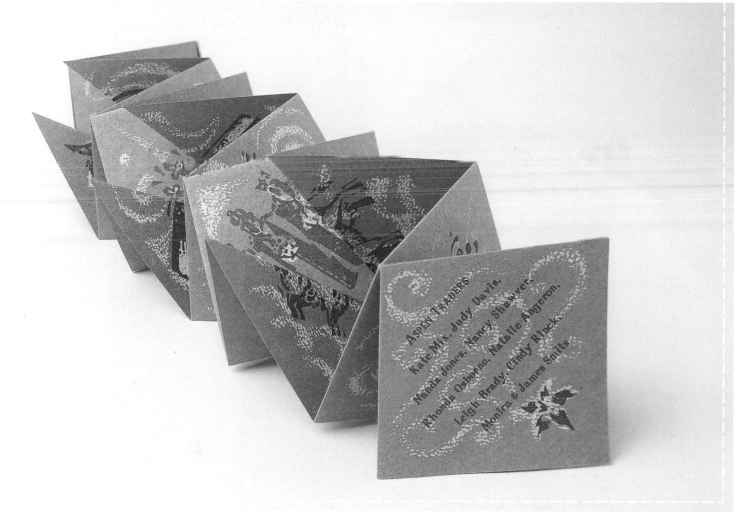

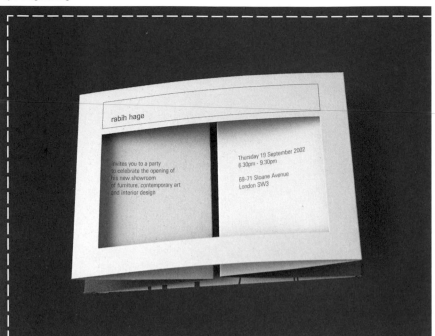

Design: **hat−trick**
Client: **Rabih Hage**
Project: **Identity and promotional items**

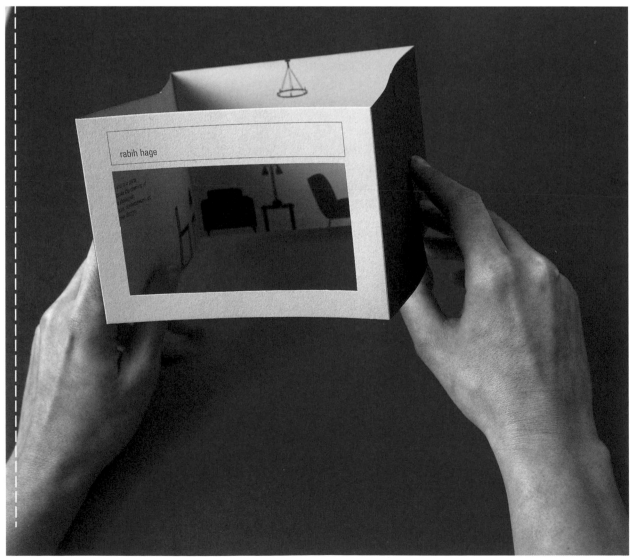

Rabih Hage is an interior design company specializing in contemporary design, furniture, and art. They also 'discover' and represent contemporary furniture designers and artists, which they either use in their interior design service, or sell from their showroom. Rabih Hage turned to hat-trick for a new identity to reflect the nature of their business and establish their own signature style. "We designed a brand mark using the initials rh, with the r hidden in the h, which is then 'discovered,'" explains creative director Jim Sutherland. "It also deals with issues of light, space, and three dimensions, reflecting the nature of their business." The invitation to the opening of the new showroom uses folds and die-cut to open into a shop window format. Looking through the die-cut rectangle you can see examples of work available through silhouetted illustrations. "The stock chosen was Colorplan gray for its color which very much reflected the subtle tones favored by Rabih," says Sutherland. For the 'interior' mailer we used one-sided chromulux so that the outside was uncoated and printed to match the Colorplan whilst the inside photographs were printed on a gloss. A further mailer is the slot cards which show art and design pieces by both renowned and newly discovered artists carefully chosen by the architect and interior designer Hage and contemporary art consultant Annick Lashermes.

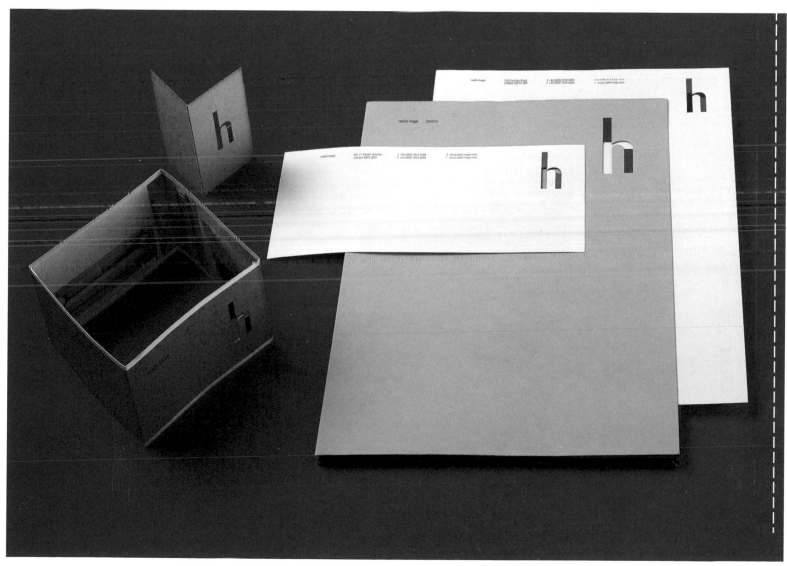

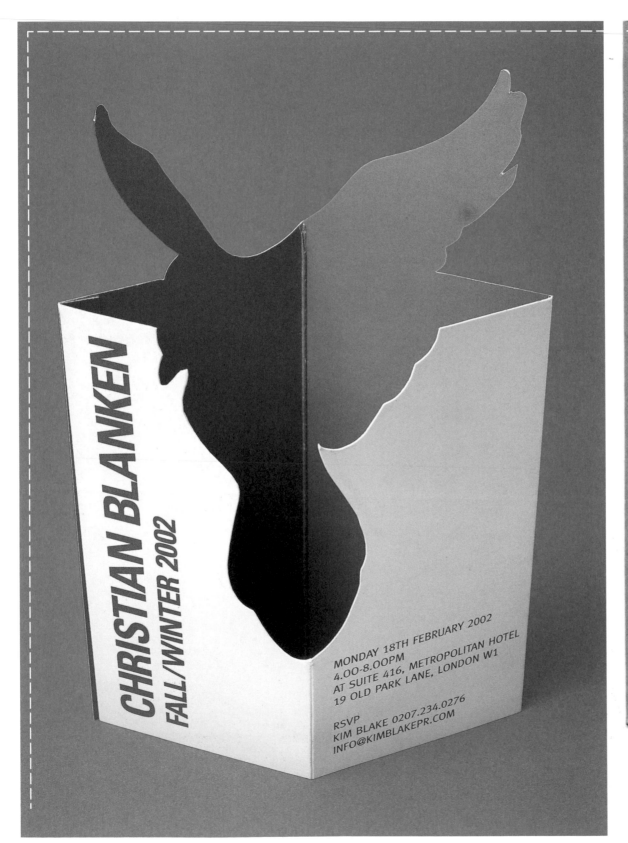

CHRISTIAN BLANKEN
FALL/WINTER 2002

MONDAY 18TH FEBRUARY 2002
4.00-8.00PM
AT SUITE 416, METROPOLITAN HOTEL
19 OLD PARK LANE, LONDON W1

RSVP
KIM BLAKE 0207.234.0276
INFO@KIMBLAKEPR.COM

Design: **Agitprop**
Client: **Christian Blanken**
Project: **Invitation**

The dove was originally created as a textile print for garments designed by Christian Blanken for his Autumn/Winter 2002 collection. The fashion designer asked Jim Holt of design agency Agitprop to create print concepts that referred to the hope for peace rather than war following terrorist attacks in the US. A dove motif was suggested and Holt developed two prints, a flock of flying doves and a camouflage print made up of doves. The structure of this invitation to Blanken's dove-themed show was, according to Holt, an attempt to make a minimal budget go further. "Rather than using just a postcard, which was the original brief, I thought it would be better to create something that would hopefully stay on people's desks for a while instead of being relagated to a pile of other fashion week invites," he explains. "By limiting the printing to a single color I was able to apportion enough of the budget to allow for die cuts and folding."

Design: **Bisqit**
Client: **Hill and Knowlton**
Project: **Christmas card**

Greeting cards don't have to be one piece of rectangular card folded in two. There are other ways to make a structure from one sheet of card, and without using glue, that sits without falling from your desk or shelf. With a bit of pushing and folding, this card, designed by Bisqit, folds into a cartoon shape to sit on your desk. Created for swish communications specialists Hill and Knowlton, this Christmas card is a PR dream… not everyone follows Christ or Allah but everyone the world over goes "aaah" when they see Bambi. Oh, and it's not called Christmas card either, instead it's a "holiday wish" card.

'Holiday-wish-bambi' brought to you by H&K Creative

Design: **Mark Diaper and Hans Bockting, UNA**

Project: **Catalog for art exhibition**

Voices is a book/catalog that accompanied an exhibition looking at the use of voice in fine art. The first section of the book was die-cut with a series of circles that were deliberately offset to mimic the appearance of the larynx/windpipe. "It made sense to start the die-cuts within the book," says designer Mark Diaper, "in the same way that a voice starts within, rather than cutting all the way through the book." The concept behind the exhibition was that for centuries artists have regarded the human voice as one of the most perplexing of subjects—a phenomenon that seems to lie beyond the reach of visual representation. The exhibition and book aimed to show that today, with an increasing number of artists active in the audio-visual field, there are pressing reasons to think anew about the potential of the voice as a metaphor and material within the arts. The exhibition toured The Netherlands, Spain and France.

Design: **Charlie Thomas**

Client: **Great Eastern Hotel**

Project: **Invitation**

This shoe-shaped invitation was designed by Charlie Thomas for The Great Eastern Hotel's millennium night party. As the spine is left intact, the two leaves of the die-cut card look like a pair of splayed feet.

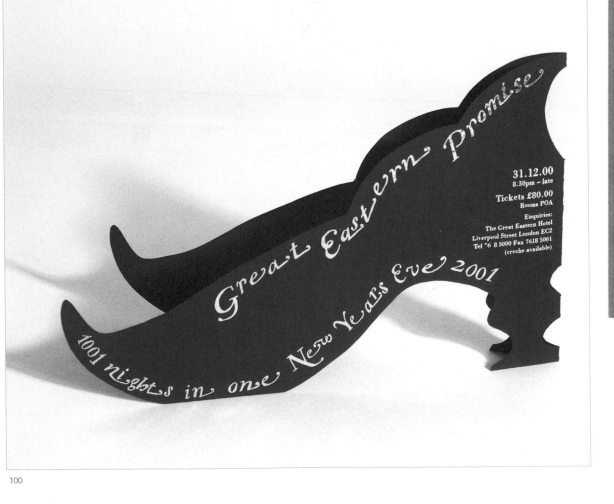

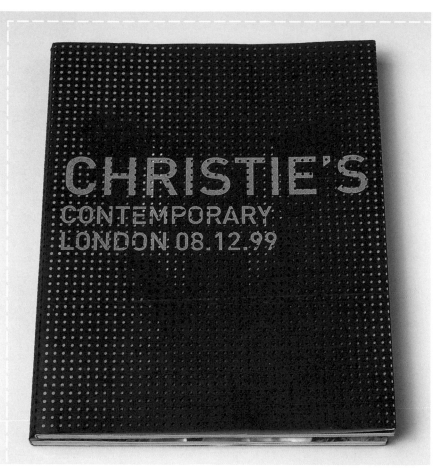

Design:	**Christie's International**
	Media Division
Printer of cover:	**Benwell Sebard**
Project:	**Auction catalog**

Auctioneers Christie's deal with objects and artefacts from every era, and so each auction catalog must be sympathetic in style to the period of the content on sale. We know almost instantly that this catalog with its black cover and bold gray sans serif type will not contain images of Dutch 18th-century masterpieces. Its industrial feel is clearly of the modern age and in this case is for an auction of contemporary London art selling works by such artists as Gilbert and George, Jake and Dinos Chapman, Sarah Lucas and Chris Ofili. The black matt jacket holding the two auction brochures together is covered with hundreds of close but neatly spaced tiny holes. Behind this jacket, through the holes, can be seen a Damien Hirst painted butterfly from In Love—Out of Love (one of the objects up for auction) which is on the cover of the first brochure. As the cover is lifted to reveal the content of the brochure, the front jacket almost seems to shimmer as the color moves inside the black framed holes. Despite the intentional graphic obscurity of the butterfly cover, everything inside is very clear and simply laid out.

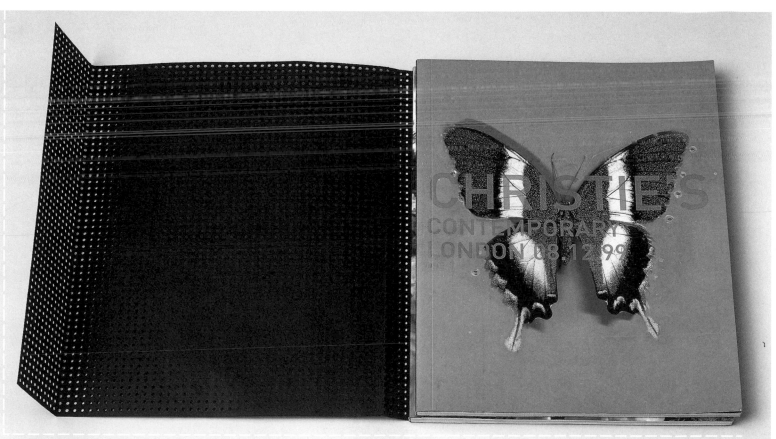

Design: **Carter Wong Tomlin**
Client: **Orange**
Project: **Chinese New Year Card**

This Chinese New Year card for Orange took the theme of a snake, the animal for the Chinese horoscope of that year. "Having designed several of these cards over the years, the constant challenge was to find a creative way of depicting the given animal of the horoscope for the particular year in question," explains Phil Carter. "We discovered from our client that the most successful cards had been the ones that had used paper engineering in some fashion, over and above the more conventional folded greetings card. Given that the card still had to fit into a standard-sized envelope we opted for a circular rendition of a snake, designed as an ever decreasing spiral, punched out of a square-format card."

A cotton thread secured to the snake's head enabled the cut-out to be hung up. Its slow, spiral movement, coupled with the obligatory printed Chinese colors of red, orange and gold blocking, proved to be very eye catching. A print run of 1000 was sent out.

Design: **Fibre**

Client: **Motorola**

Project: **Invitation**

MOBILE was an exhibition from Motorola that followed "the evolution of portable, personal communication from clunky two-way radio to discreet globally ubiquitous object of desire."

This invitation to the private viewing of the exhibition was created not only in the shape, but also the size, of one of the earliest mobile phones. As you can see, it really is the size of a brick.

Ron van der Meer

Diese Darstellung zeigt den durch Erdbeben verursachten Einsturz einer Autobahn-Überführung. So ähnlich sah die Situation an einer Überführung der kalifornischen Autobahn 880 aus.

Ron van der Meer was the first paper engineer to insist that adults could be as fascinated by pop-up books as children. Consequently, his books on specialist subjects such as architecture, music, and psychology have been international best-sellers and are collected by fans throughout the world. As well as bringing the thrills of pop-ups to adults, his ingenious mechanics show graphic designers the full potential of paper engineering. A flat page of a seemingly normal book can be lifted and turned to reveal the three dimensions of a sailing ship, an orchestra, a volcano, or the Sydney Opera House.

Van der Meer's background is in graphic design. At college in the early 1970s he found himself veering towards animation, and specialized in the three-dimensional application of toys. "I was very much into fiddling and cutting and making things up," he says. In 1978 his life was changed by a small book a friend had brought over from California. Created by Ib Penick, this children's pop-up book was simple by today's standards, but at the time such a three-dimensional application to paper had never been seen by many people, including van der Meer. He became hooked: "From then on I started playing around with paper and making pop-ups."

Van der Meer approached UK publishers Hamish Hamilton with his own idea for a book. The publishers had no experience of creating such books and told him to approach Intervisual—packagers based in California who had been involved in inserts for many

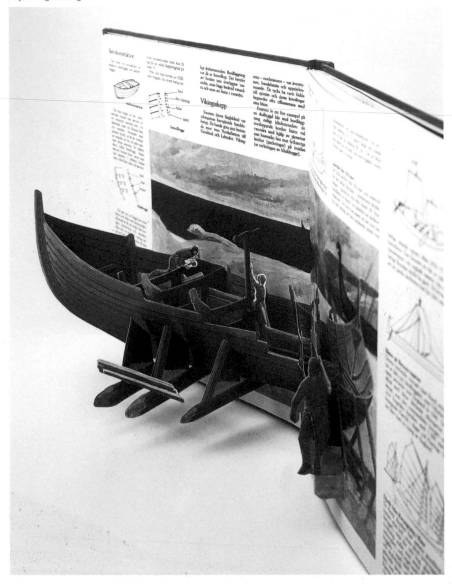

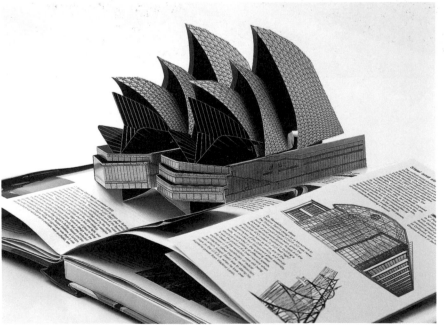

years. Van der Meer visited Intervisual in Los Angeles and they took on his idea for Monster Island, a book that ended up selling 300,000 copies and is still selling today. Monster Island was the first of a whole range of books van der Meer published with Intervisual. The company would have preferred him to work in-house, but van der Meer was adamant to retain some independence and remained based in the UK. "Waldo Hunt at Intervisual is known as the godfather of pop-up books," says van der Meer. "But Wally always wanted to put his stamp on the books—it was all psychological. It was never a paper engineer working on his own—it was always two or three different people. He's very controlling." Despite this, the relationship between Hunt and van der Meer worked well. One project Intervisual wasn't keen to be involved with was Fungus the Bogeyman—a collaboration with Raymond Briggs which went on to sell 150,000 copies. "At that time we could only publish it in Britain. It wasn't published in the States—it was considered too risky."

In 1981 van der Meer approached Intervisual with an idea for a book on sailing ships. "Wally wasn't interested. He told me adults weren't interested in pop-ups—it'd never sell. So I went to an British publisher and they were very interested. So when Wally found out he came back on board. It was the first serious book on sailing throughout the centuries. Over 400,000 copies of Sailing Ships were made and it's still selling—I'm still receiving Royalty cheques. It sells in New York for 600 dollars."

Van der Meer's next adult book was The Art Pack, a beautifully illustrated book filled with pop-ups and pull-outs which provided the first interactive introduction to Western art. He had always worked with writers, but The Art Pack involved his first collaboration with an expert—Professor Christopher Fraley. The Professor and the paper engineer found their approach to the book clashed. "Experts feel they already know what should be in it," says van der Meer. "They can't seem to take a step back and see what should be in it from a consumer point. I myself tend to look from the outside in." He had to convince Fraley that subjects needed to be broken down into smaller sections and that less text was necessary. "The most important part of creating such a book is to break it down into sections and into its pop-up elements. The first thing that puts you off any book is too much text. We managed to break down a text of 80,000 words to 40,000 words." He feels strongly that his work must be accessible to everyone, not just to people with an existing knowledge of the subject. "I want to ask the questions that the general public might ask," he explains.

Van der Meer believes that some of the simplest techniques are the most effective. "I'm not into the big 'showing off' sorts of tricks—mine are much more pragmatic. First of all I look at the subject; secondly I look at it to see if there's anything I can add to it as a designer to make it much more understandable. Thirdly I ask if it's feasible in terms of cost and money." As a designer this 'adding to a subject' is very important to van der Meer. "If you can't add anything to it then leave it alone," he says.

"The paper we use has 16 percent of the strength of a sheet of metal of the same thickness," explains van der Meer. "It consists of short fibers which, when folded, give a sharp edge, and in our case allows the paper 'sculpture' to be folded about a thousand times

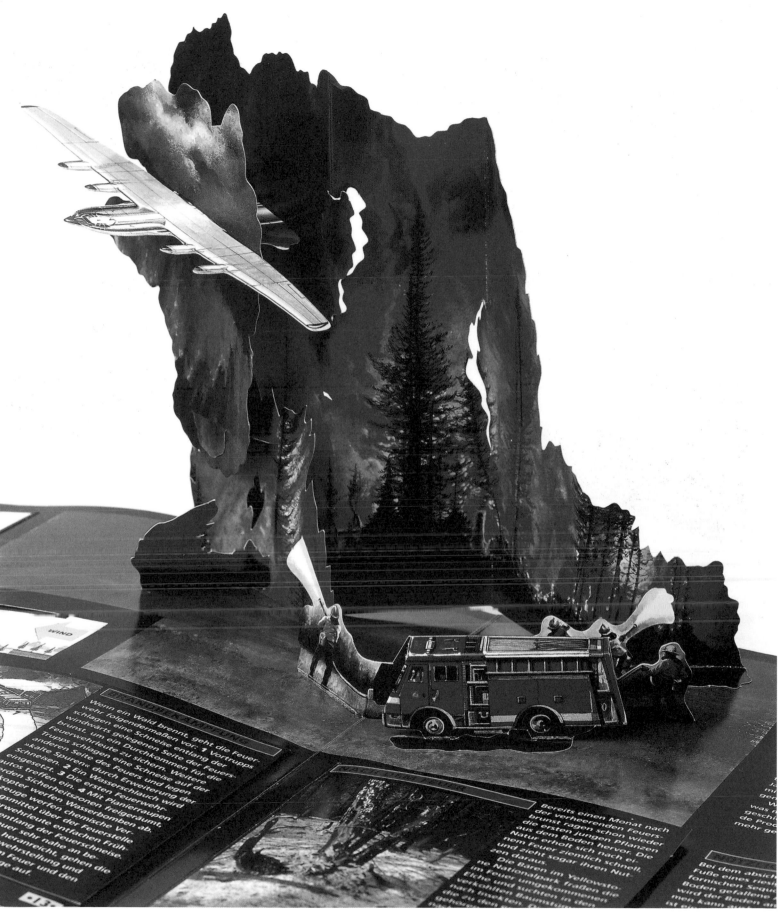

BRANDBEKÄMPFUNG Wenn ein Wald brennt, geht die Feuerwehr folgendermaßen vor: **1** Vortrupps schlagen eine Schneise entlang der windwärts gelegenen Seite des Feuers, um ein Durchkommen für die brunst, um ein Durchkommen für die Feuerwehrleute zu sichern. Weitere Trupps schlagen eine Schneise auf der anderen Seite des Feuers und legen »kalte Spuren« durch Erweiterung der Schneise. **2** Ein Wasserschlauch wird eingesetzt. **3** Die ersten Feuerwehr- autos treffen ein. **4** Mit Planierraupen werden Sicherheitszonen freigeräumt. kopter werfen Wasserbomben ab. zeuge werfen chemische Ver- wehrleute über der Feuerstelle gsmittel über der Feuerschneise. entlang der Feuerschneise. uer sehr nahe an be- wehrstellung, gehen die heranreicht. n Feuer und den ge auf.

Bereits einen Monat nach der verheerenden Feuers- brunst ragen schon wieder die ersten jungen Pflanzen aus dem Feuer nach ei- nen Feuer ziemlich schnell, und zieht sogar ihren Nut- zen daraus. Die Bären im Yellowsto- e Nationalpark. Traßen die n Feuer umgekommenen Elche und flüchten in den wohlten Baumstün- nach Insekten su-

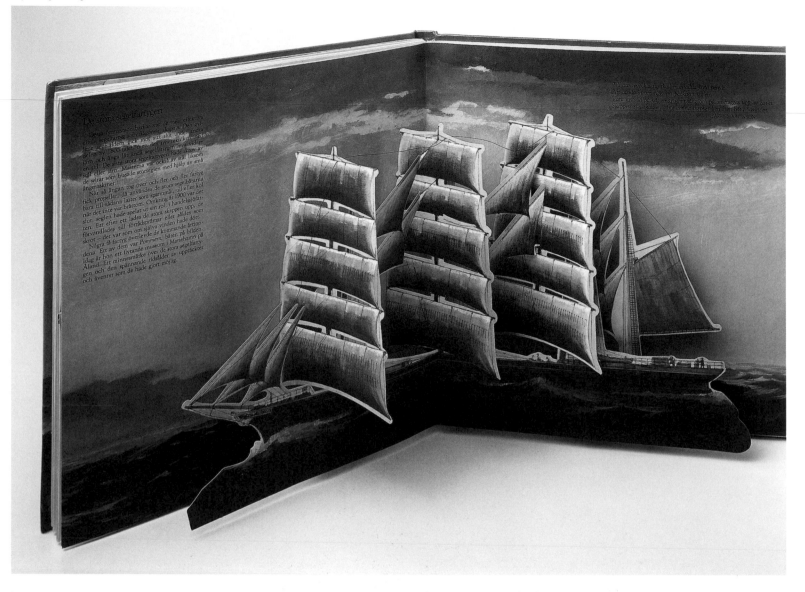

without splitting. For the average pop-up book we use ten-points paper. In other words 220 gsm coated on two sides." The sheet size used is 28 x 40 inches. On these sheets we arrange our book. The individual pieces have to be laid out, or 'nested', next to each other on the sheets in such a way that they take into account the grain of the paper, which helps with the strength of the folds, and also the closeness to the pieces to reduce wasted space, and therefore cost."

Research, carried out by a psychology professor in Amsterdam (van der Meer's ex-brother-in-law) proved that a reader retains 75 percent of all the information in a van der Meer pop-up book compared with 20 percent retained when reading a normal book. "You read the book three times; first you play with the different elements, then you read and then you go through it properly. The most important part as far as your brain is concerned is that you use more senses than just reading. It gets instant interest. Every section works in a different way—every time

you turn the page there is a surprise." He points out that, unlike normal books, this sort of book will be returned to again and again.

His next project involves combining the effectiveness of the pop-up book as an educational tool with the power of the Internet, to create a series of online mathematics tutorials for 3- to 16-year-olds used alongside the books. Unlike some artists who work so much with their hands, van der Meer feels no fear or skepticism about the digital revolution and screen-based entertainment. "It's only another medium, like anything else. Fortunately it's a good one. The potential is enormous," he says.

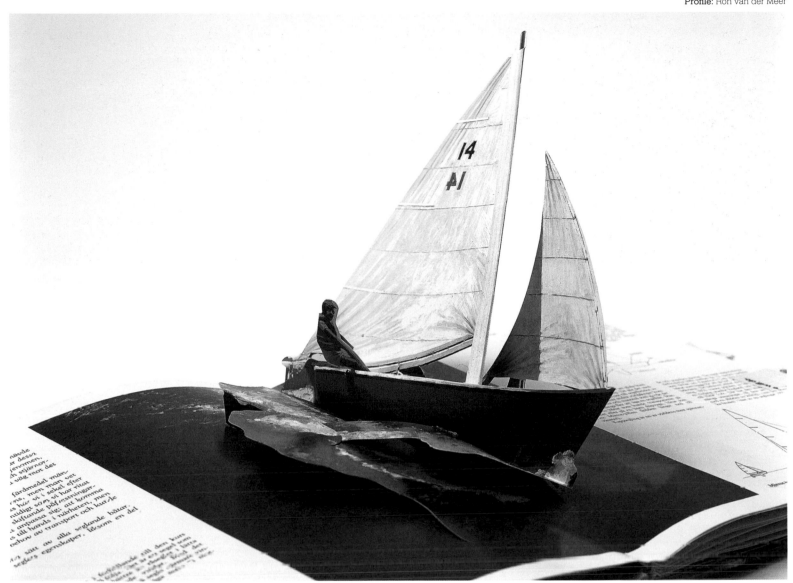

Design: **Corina Fletcher**
Client: **Personal project**

Paper engineer Corina Fletcher has always been keen to show just how effectively paper engineering can be used to communicate. For this personal project, she drew upon her rusty school chemistry. The eight-page folded pamphlet shows how each of the first eight elements of the periodic table—from hydrogen through to oxygen—is constructed. With the clever use of die cuts it is possible to push out and fold back strips of the paper to create a three-dimensional circular image of each element, showing its electrons, protons and neutrons. As the number of electrons and protons increase for each element, so do the number of paper strips that surround the nucleus. "It's ideal because you can't photograph electrons, and diagrams don't work as well," says Fletcher. She used a paper strong enough to take the fine cutting and printed using her college's facilities. A limited edition of 100 were made. If text books were so inspirational, we'd all be somewhere else right now—in labs wearing white coats and goggles.

Design: **Trickett & Webb/Corina Fletcher**
Client: **Royal Society of Arts**
Project: **Calendar**

This pop-up calendar was designed and produced for fellows of the Royal Society of Art in London. Each pop-up was based on a different aspect of the organization's heritage, such as music, fashion and photography. The beauty of this calendar is its minimal use of print; the simplicity allowing the mechanical complexities to work visually to great effect.

Design agency Trickett & Webb worked with paper engineer Corina Fletcher to create this calendar. During her third year as a student she noticed that all her work had a three-dimensional element to it. She went on to specialize in the three-dimensional application of paper and won several awards. Following her MA she was approached by Ron

van der Meer (see his profile, page 104) and was his assistant for several years. Today Fletcher is a consultant paper engineer for various design agencies and also creator of pop-up children's books. She has worked on several projects with Trickett & Webb. This calendar was immensely popular and won many design awards.

January

M	T	W	T	F	S	S
				1	2	3
4	5	6	7	8	9	10
11	12	13	14	15	16	17
18	19	20	21	22	23	24
25	26	27	28	29	30	31

'FASHION IS NOT ART
IT IS INDUSTRY...'

*The late Jean Muir, Master
of the Faculty of Royal
Designers for Industry
(1994/5), felt passionately
that fashion design was as
precise a science as any
engineering process.*

*As early as 1758 the Society
rewarded designs for weavers
as part of their encouragement
of art applied to manufactures.*

February

M	T	W	T	F	S	S
1	2	3	4	5	6	7
8	9	10	11	12	13	14
15	16	17	18	19	20	21
22	23	24	25	26	27	28

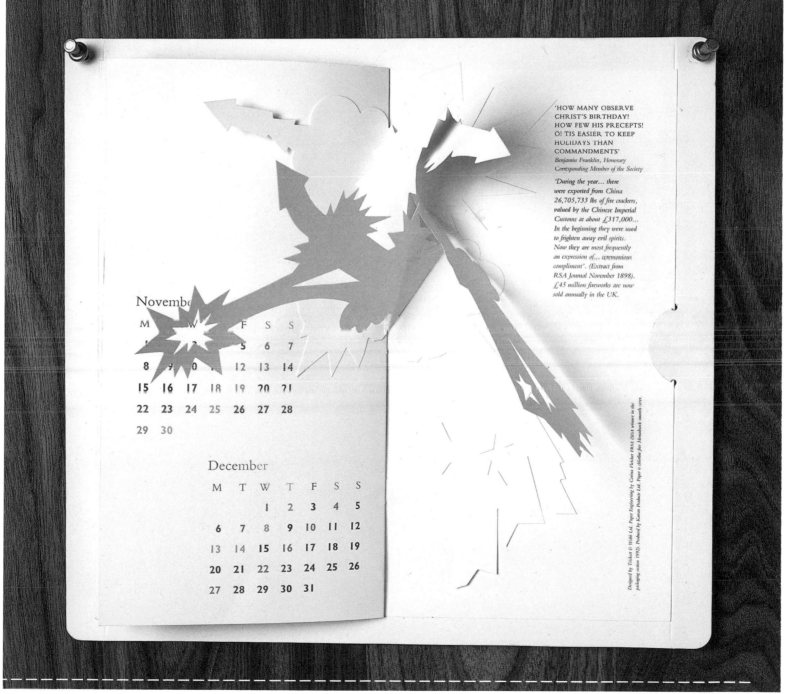

November

M	T	W	T	F	S	S	
					5	6	7
8	9	10	11	12	13	14	
15	16	17	18	19	20	21	
22	23	24	25	26	27	28	
29	30						

December

M	T	W	T	F	S	S
		1	2	3	4	5
6	7	8	9	10	11	12
13	14	15	16	17	18	19
20	21	22	23	24	25	26
27	28	29	30	31		

'HOW MANY OBSERVE CHRIST'S BIRTHDAY! HOW FEW HIS PRECEPTS! O! TIS EASIER TO KEEP HOLIDAYS THAN COMMANDMENTS'
Benjamin Franklin, Honorary Corresponding Member of the Society

'During the year... there were exported from China 26,705,733 lbs of fire crackers, valued by the Chinese Imperial Customs at about £317,000... In the beginning they were used to frighten away evil spirits. Now they are most frequently an expression of... ceremonious compliment'. (Extract from RSA Journal November 1898). £45 million fireworks are now sold annually in the UK.

Designed by Trickett & Webb Ltd. Paper Engineering by Corina Fletcher FRSA (SIA winner in the packaging section 1992). Produced by Kaman Products Ltd. Paper is Mellotex for Monadnock smooth cover.

Design: **WPA Pinfold**
Client: **Die–Set Formes**
Project: **Promotional brochure**

Pop-up ducks, a cut-out spaceship, a skeleton with protruding vertebrae—this brochure designed by WPA Pinfold beats most children's books when it comes to playfulness. The design is geared towards promoting the work of die-cutting specialist Die-Set Formes to the design and print industries, with emphasis on creative potential as well as technical expertise. Each section of the brochure addresses the company's core values—accuracy, speed, innovation—communicated through the use of intricate illustration techniques and simple, modern typography. Ducks on a shooting range, for instance, convey the theme of accuracy. To showcase the company's production methods, a selection of die-cutting, creasing, and folding techniques was used throughout. The brochure was printed by GKK Print with paper supplied by MoDo Merchants Ltd. The plastic cover is Priplak white pearl/sand 800 micron, supplied by The Robert Horne Group.

Design: **SEA**
Client: **GF Smith**
Project: **Colorplan book**

GF Smith certainly cut no corners when it comes to the design, print and production of their promotional material. Of course they would be mad not to—as paper merchants, their sales and reputation depends on the feel of a page and the way the print works upon it. Nevertheless, this book designed by SEA, showcasing the Colorplan range of paper really does go the extra mile. Colorplan consists of 52 colors, 8 weights and 19 embossings, all of which are contained within and make up this book. The available finishings and effects, such as folds and die-cuts, are also shown throughout. As the weights of this paper are heavy—from 120 through to 700 gsm—the book sits like a perfect block, the colors and different thicknesses creating a rainbow effect up the sides with one edge cloth-bound and exposed. Despite the feel and texture of each individual page being unique, together they make a perfect unit. The whole book displays just what can be achieved when paper, printing and design work harmoniously. Text and images are kept to an absolute minimum and all possibilities are expressed by the tactile and visual quality of the paper alone.

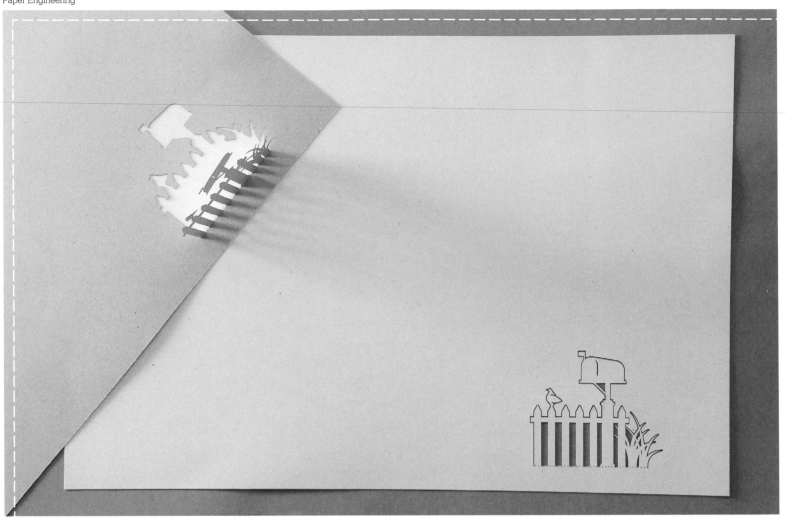

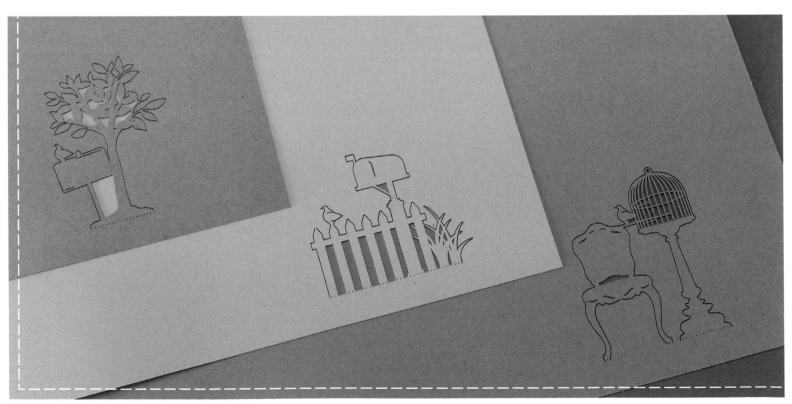

Design: **Publique Living**
Project: **PopMat Paper Placemats**

San Francisco–based design team Publique Living make a number of home decor items, including these fun disposable paper placemats featuring pop-up graphics. Each design incorporates an area that doubles as a name card, such as a chair back, a mailbox, or a birdcage. The placemats are available in packs of ten, with color options including White Sand and Natural Kraft. They are made from 100 percent recycled paper (30 percent postconsumer fiber, 70 percent preconsumer wastepaper). They make a charming addition to any table setting.

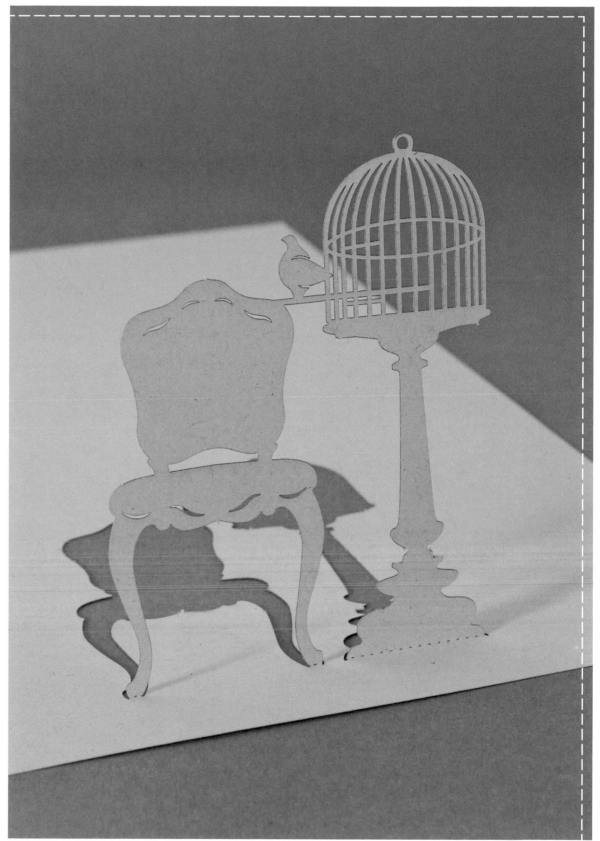

Design: **Corina Fletcher**
Client: **Royal Society of Arts**
Project: **Christmas cards**

In previous years the UK's Royal Society of Arts has approached Corina Fletcher to create its Christmas cards. For Christmas 1999, they wanted the card to highlight the new year which at that time was particularly

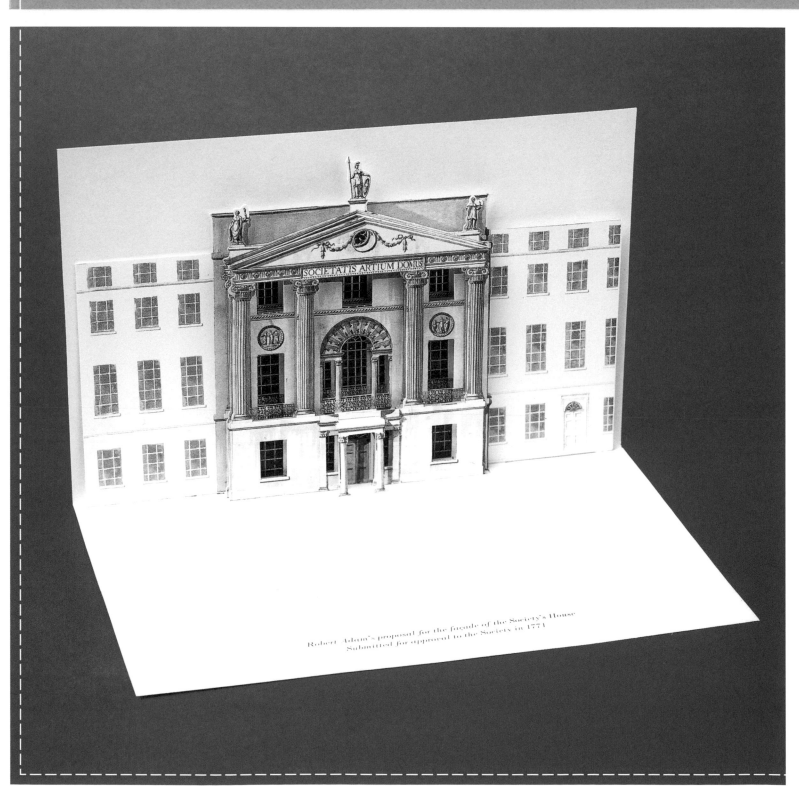

Robert Adam's proposal for the façade of the Society's House
Submitted for approval to the Society in 1771

significant, being the millennium. The solution was a two-sided card featuring a star and a sun. "Originally it was more complex but I had to simplify it a bit to be cost effective," says Fletcher. These special cards were limited to an edition of 100, The following year the RSA approached Fletcher again. "Often we come up with a couple of ideas and then they choose one. But this year they went for both ideas—the Christmas tree and house." The house pop-up is taken from architect Robert Adams' proposal for the façade of the society's house—submitted to the Society for approval in 1771. "The Christmas tree is a particularly easy piece of paper engineering," says Fletcher. "I like the millennium card because it's in white," she says. "Paper engineering always looks best when the surface imagery is limited."

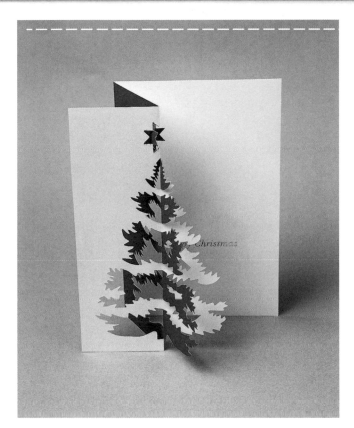

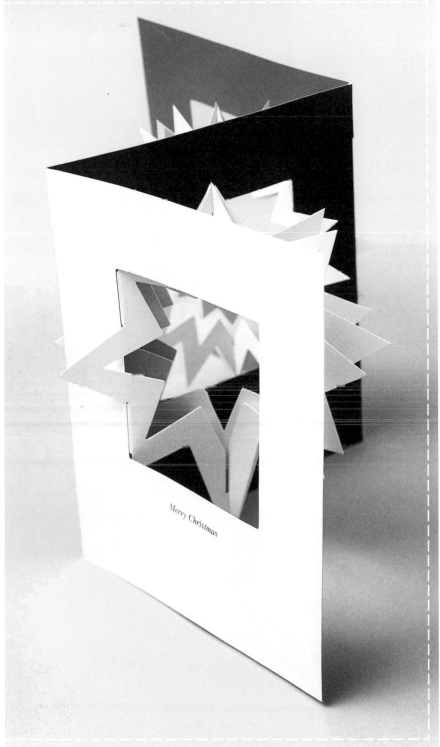

Design: **Robert Sabuda**
Client: **Museum of Modern Art, New York**
Project: **Christmas Cards**

Robert Sabuda is perhaps one of the most imaginative children's pop-up book artists in the United States. For Christmas 2002 he created these beautiful cards for the Museum of Modern Art in New York. One features a fold-out dove, and the pop-up cathedral includes an insert of colored plastic which, when you put fairy lights behind it, looks like a stained-glass window. Sabuda, originally from Michigan, started making

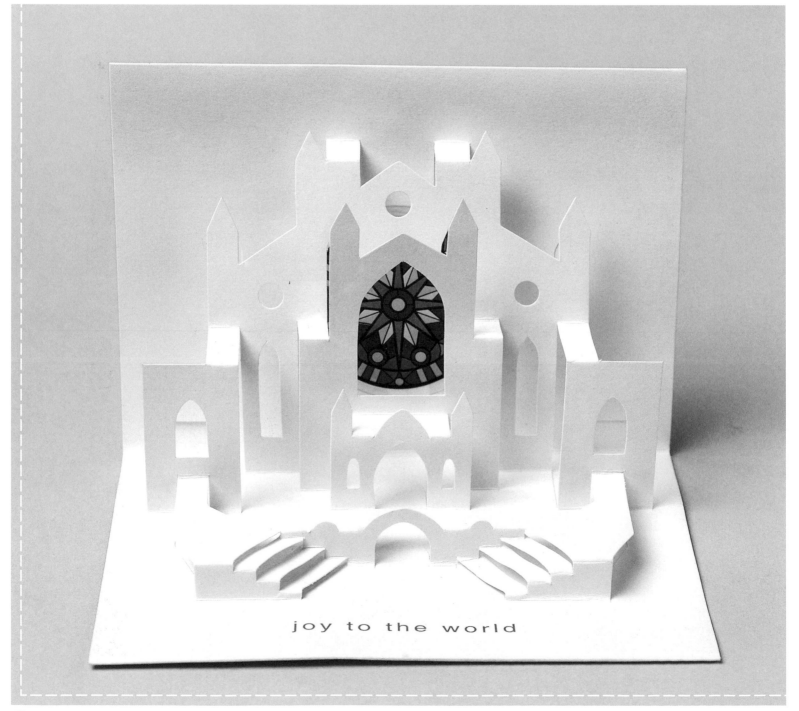

joy to the world

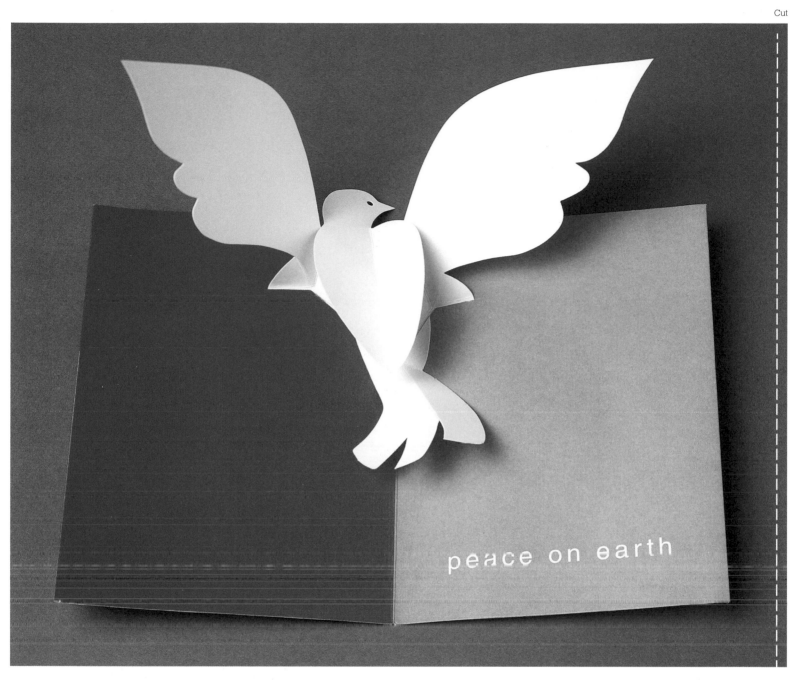

peace on earth

pop-ups from the old, manila filing folders that his mother brought home from Ford Motor Company where she worked as a secretary. He later studied art at the Pratt Institute in New York and during his junior year did an internship at Dial Books for Young Readers where he was very much inspired by the children's book illustrators. When he graduated from Pratt,

Sabuda went from one children's publishing house to another, "showing my work and trying to get an illustrating project and to make money to support myself—I worked as a package designer creating the boxes for ladies panties and bras!" Finally he got small jobs illustrating coloring books (based on popular movie characters like Rambo!) which led to

bigger jobs, and slowly he became a full-time children's book illustrator. He always hoped one day to create a pop-up book, so he pulled out his old pop-up books and taught himself how to make even better ones as a grown up. Today he works in a studio in New York, and his books thrill children throughout the world.

Design: **Penny Baxter and Nicola Gray**
Project: **Conceptual book art**

Penny Baxter, co-director of design agency salterbaxter, and illustrator Nicola Gray worked together on this paper engineering project, Space Hotel, that explores living environments for the 21st century. As the project evolved it became more and more conceptual and each space, with the exceptions of Home's picnic set and brickwork, became abstracted and not restricted by recognizable iconography. The visual language consists

of color, form, and light. Holes, in several of the pieces, allow light to enter and the viewer to look through. In Desert the holes become twinkling stars. Nest, on the other hand, is hermetically sealed and,

once constructed, appears impregnable, a haven protected from the outside world. Depending on your notion of personal space, a space can be seen as a comfort zone or prison. On the outer packaging there

are windows inviting each potential guest to take the first step on a journey that celebrates a book in its conceptual purity. Ironically, in 'making' this book you are destroying it; but Baxter and Gray are happy with this—for

them, the book is there to be used; as much a functional object as an aesthetic adventure.

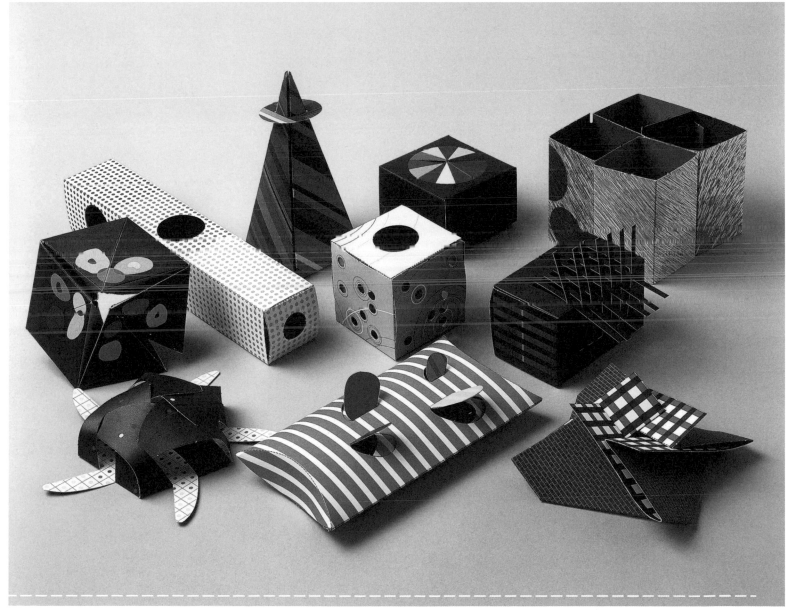

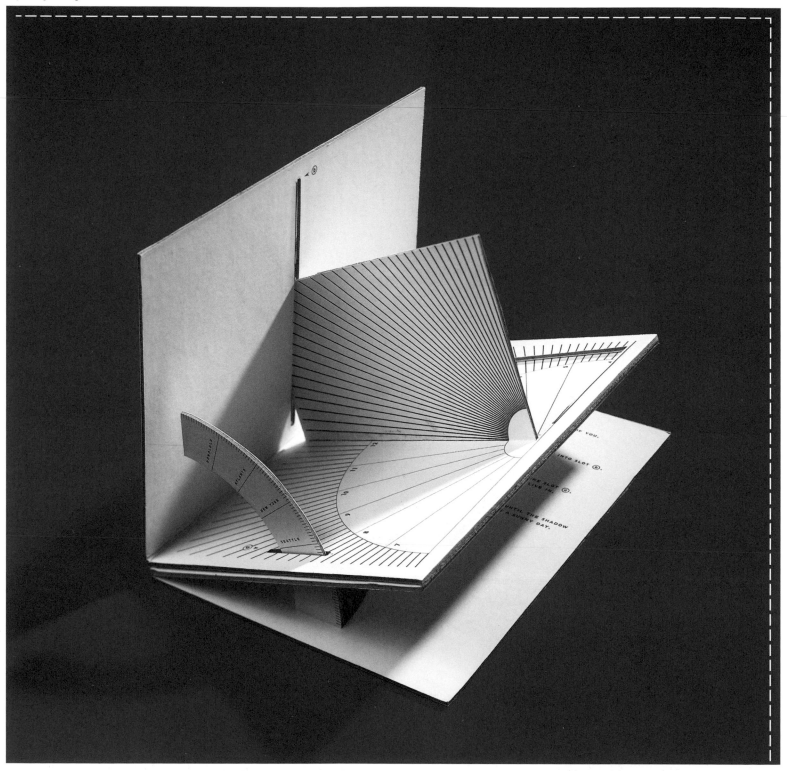

Design: **Sagmeister Inc.**
Project: **Self-promotional card**

With a couple of simple folds, the viewer can turn this card into a working sundial. This card was printed in a limited run of 2000 by Sagmeister Inc. as a self-promotional piece for the studio.

According to Stefan Sagmeister, who designed the piece with Veronica Oh, the sundial gives the correct time anywhere in the US.

Design: **Yorgo Tloupas**
Client: **Intersection**
Project: **Business cards**

Intersection is a car magazine that's photographed like an edgy, sexy fashion mag and designed more like *The Face* (in its glory days) than *Exchange and Mart*. It belongs on a Soho, not commuter-belt, coffee table and is stuff that feeds raunchy youth fantasies rather than the day-dreams of a dad in a carport with a pail and sponge. Yorgo Tloupas, the publisher and creative director of the magazine, designed these business cards for the magazine's staff. The cards are all based on the shape of a Honda mini-van, but there are ten different designs: postal van; police van; security money transfer van; scooby-doo-style van; camouflage van; customized and airbrushed 1980s van; RAC van; TV broadcast van; FedEx van and UPS van. Yorgo Tloupas re-used the cut-out shape to create the invitations for the launch party. "We kept the shape around the card, and people had to push the van out of the postcard-sized flyer," he explains.

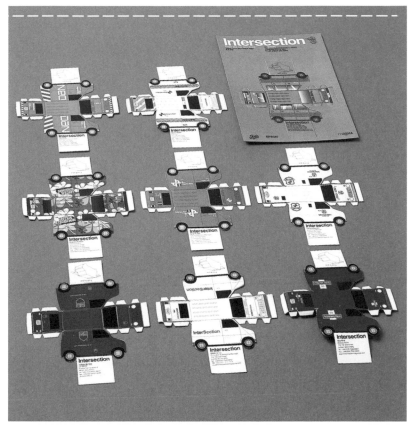

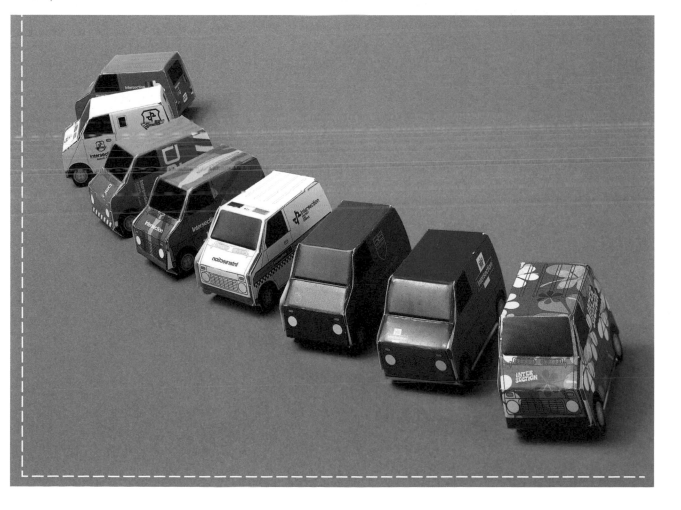

Design: **Zuan Club**

Client: **Tokyo Design Center**

Project: **Promotional material**

This promotional material for the 5th anniversary of the Tokyo Design Center is cut, folded and pasted to create a three-dimensional paper skyline. The sense of perspective is achieved by cutting the edges that constitute the sides at an angle of around 30 degrees. It arrives flat and is made into the rigid structure by folding it into shape and folding up one flap at the bottom to hold the sides firmly in place. At first glance it's easy to think the designers have cut around the skyline intricately, but really the imagery consists of the shapes of office and apartment blocks cut directly onto an oblique aerial view of a dense cityscape.

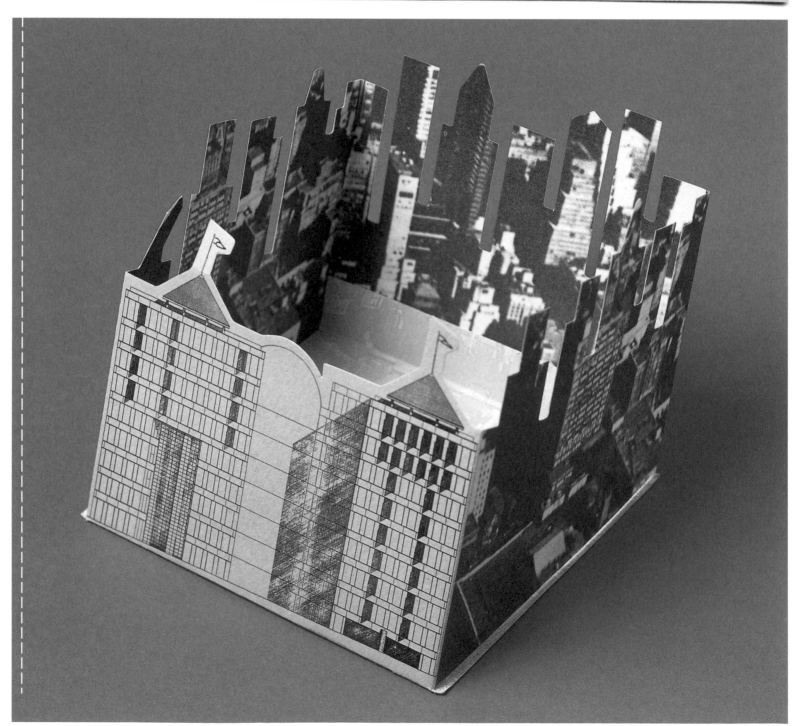

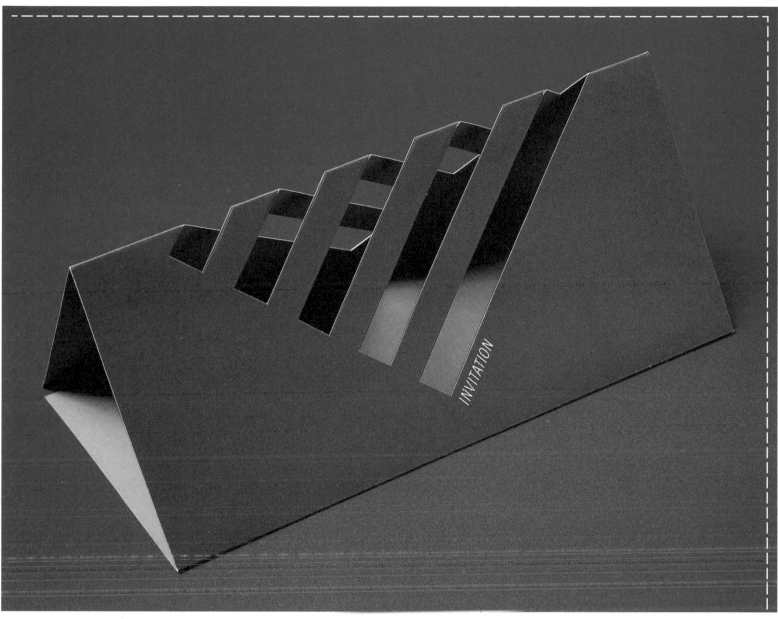

Design: **Zuan Club**
Client: **Sasaki Keori Co. Ltd**
Project: **Invitation**

Opened out flat, this invitation to a fashion show is simply five cut-out strips lined to create a square. It is angled on the page like a diamond and creased through the middle. When this is folded, the die-cut spaces and the strips between them overlap to create this lace-like pattern and effect. It becomes a decorative sculptural object rather than a simple leaflet or card with panels simply to hold information.

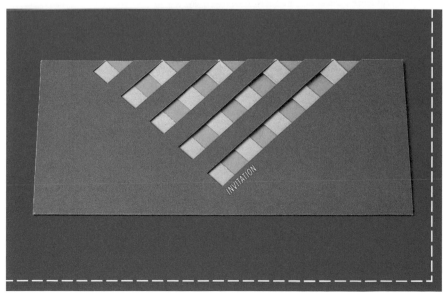

Design: **Gardner Design**
Project: **Invitation**

Bill Gardner describes this card as one of the most complicated folds he has ever been involved with: "It gives a wonderful appearance of an explosion for the firecracker. And it was very easy to design and cut, but the physical folding of this particular cut is a nightmare. Lots of motion in a tight little space and compound angles can make for a real challenge. Just because a fold is possible, doesn't make it practical."

Design: **Angry**
Client: **Monkey Tennis**
Project: **Flyers**

'Things To Make and Do' books from his childhood were at the heart of Scott Burnett's idea for these flyers for Dublin nightclub Monkey Tennis. "The first ones we did were the set of four different characters where you used your own fingers for legs, which I remember from being a kid," explains Burnett. "I always loved the creativity of those types of books, where it was all about making something out of nothing. So we set about

trying to create a series of mild mannered, one-color flyers, that would transform before your very eyes— WITHOUT the aid of sticky backed plastic, OR the supervision of an adult— into something completely different… Oh, and I also thought that if I could get the people in the bars playing with the flyers instead of using them to soak up beer, then maybe, just maybe, we'd have a better chance of filling the club… sneaky,

huh? But it didn't actually work… club promotion is a heartbreaker." The job was a one-color, die-cut job, using 300 gsm strawboard. It was printed by Martin Color print "with much respect to the consistent patience and troubleshooting of Dylan Roche and Conor O'Hare," he says. There were 3500 printed each month.

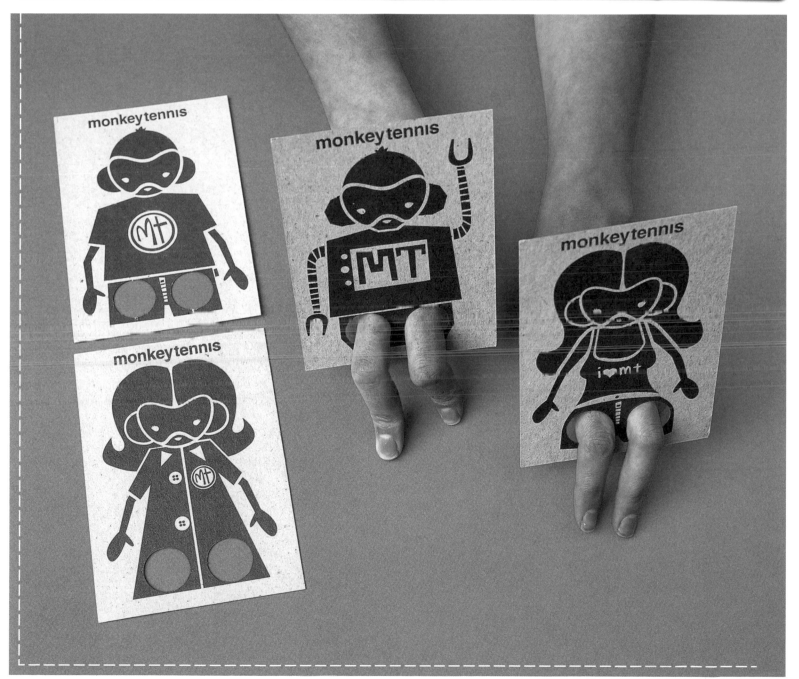

Design: **Trickett & Webb/ Corina Fletcher**
Client: **Renault Espace**
Project: **Mail-out**

Paper engineering was the ideal way to show off the new features of an updated Renault Espace car. It shows how the ventilation system, remote control, safety features and storage all work. The features are viewed as though the car is sliced in half along the middle and the recipient must look in it from above. The seats can be twiddled around showing that in the real car they move in all directions. There are tabs that, when pulled out, change the color that is seen through die-cuts from red to blue, showing how easy it is to control the temperature. Paper engineer Corina Fletcher worked as consultant to design agency Trickett & Webb on this project. "Our original brief from the agency, marketing group WWAV Rapp Collins, was to produce a wooden model but paper engineering seemed a better solution," she says. Brian Webb and Colin Sands were the designers at Trickett & Webb. "A series of paper seemed a more immediate and visual way of describing the features," says Webb. The mailer, printed by Karran Productions, was sent to all potential buyers and proved a huge success.

Design: **Cahan Associates**

Client: **Heartport**

Project: **Annual report**

Designer Craig Bailey took an unconventional approach to what is usually an uninspiring brief—the annual report. "Heartport develops minimally invasive cardiac surgery systems," says Bailey, "Their revolutionary procedure, Port-Access, allows surgeons to perform many procedures through small openings between the ribs without cracking open the chest of the patient." Following an extremely successful year for the company, Cahan Associates proposed a more human approach to the annual report. The book they produced is an examination of a return to normal life through personal photography and recovery stories told by the patients themselves. The company's cardiac theme is carried through the book, quite literally, by two large die-cut holes, cutting cleanly through from front to back cover.

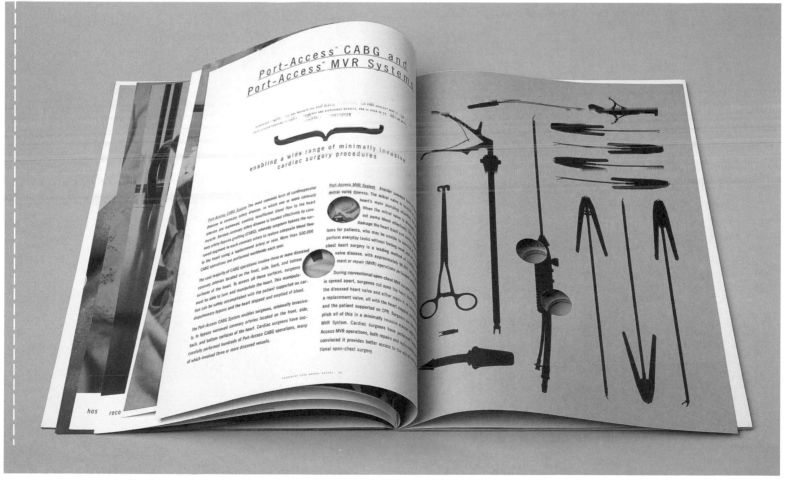

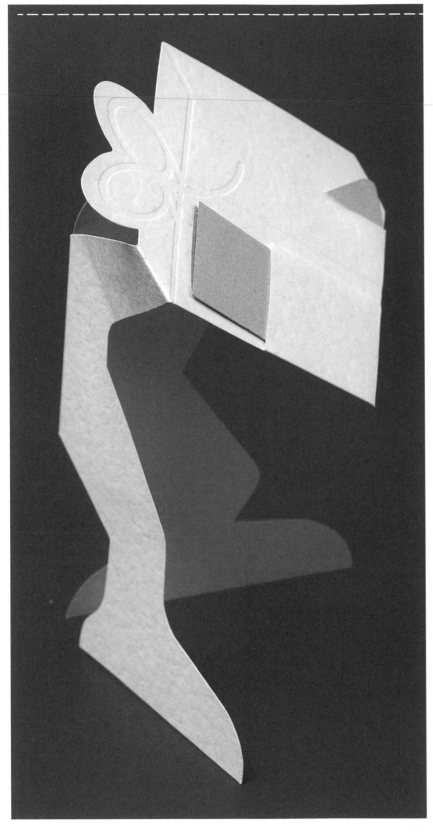

Design: **Zuan Club**
Client: **Arjo Wiggins Japan**
Project: **Greetings card**

Thanks to one crease and a couple of slots, this piece of paper folds into an endearing paper character that stands upright on a surface and holds out a Merry Christmas greeting. The cute little man was designed for paper merchants Arjo Wiggins Japan by Zuan Club and has a dual purpose; working as both a sample of their conqueror range and a greetings card. Even though it is paper, and not card, the piece is a surprisingly strong, sturdy structure when folded into shape.

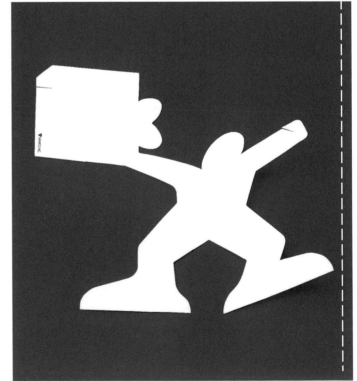

Design: **Stefan Sagmeister**
Project: **Wedding announcement**

Renee and Robert Wong are lucky to have prolific graphic designer Stefan Sagmeister as a good friend. He designed this unique and beautiful wedding announcement for them, featuring "a filigree pop-up with their respective stories on how they first met." The project didn't involve any printing; instead, all of the type was burned out of the paper by laser. Squinting through the delicate lace formed by the cut paper you are able to read stories about how they met and find details of their wedding. The card was manufactured by Joe Freedman of Hestia House/ Sarabande Press in New York.

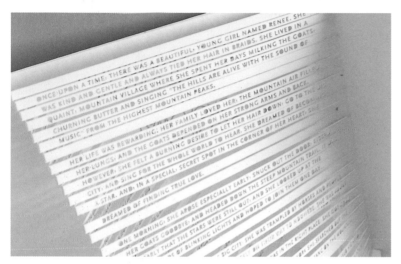

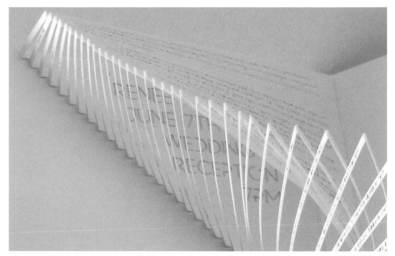

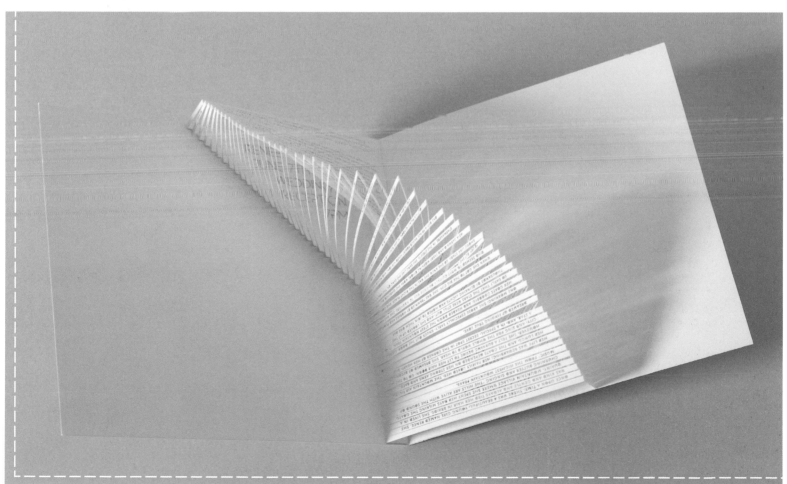

Design: **Joanne Stockham**
Client: **Whitechapel Gallery**
Project: **Children's exhibition guide**

To engage interest and gain the understanding of children visiting a conceptual art exhibition, artist Joanne Stockham created a puzzle that guides them around the gallery and gets them looking at and asking questions about the various pieces of work. Firstly the children are given the template of a box that they must stick into shape using the stickers provided. Each side of the box has a clue that must be unravelled. One side, for instance, has writing that can only be read by putting a mirror against it—this writing tells them to find a particular sculpture. Another contains part of an image and they must find the real thing to match it. A potentially very boring school outing becomes extended play for the children and teaches them that art is as much about exploring their own sense of the world and perceptions as looking at a work by someone else. The exhibition was called Live In Your Head: Concept and Experiment in Britain 1965–1975 and was shown at The Whitechapel Gallery.

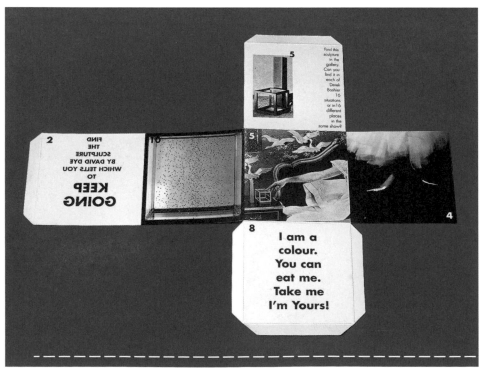

Design: **American Slide Chart and Bozell**
Client: **The Art Directors Club, New York**
Project: **Invitation**

There should be a warning on the envelope of this piece, as it can give you a fright when it snaps sharply into shape. The cube is a rubberband-activated pop-up and was manufactured by American Slide Chart, designers of custom-made dimensional marketing products. Once in shape, the cube is an incredibly strong, solid structure, but one that's very difficult to close up again. The bold, almost inflexible, shape makes it more ornamental than other pieces which means that it certainly won't get lost in a jumble of other envelopes and invites on the recipient's desk. The project was an invitation for the Art Directors Club of New York's 81st Awards Gala and the amusing print design on the panels is by Bozell.

Design: **Akio Okumara**
Client: **amus arts press**
Project: **Book design**

This charming little book *Chinese Star Signs* by Japanese designer Akio Okumara, uses folds and cuts to create the animals of the signs. There's a cow made up of tiny puzzle pieces that can be pushed out from the page and a dragon made from a strip

A rabbit dowels in the full moon.

Where you live is the best in the world.

満月に、兎住む。

of paper with paper clips angled for the eyes. Another strip has a long, upright line up the middle, which clearly determines the ears of a rabbit. These strips are not glued onto the page but are formed by throw outs that have been cut down. There is little print on these white pages: the animals can mostly be determined by the angles of the folds and a couple of simple printed circles or lines. Paper engineering here works harder than the print and, stripped to its simplest visual components, this way of illustrating works perfectly with such clear and simple sayings as "You can never see yourself" and "Others are others. Behave as you wish."

Life is a cow's puzzle

Stick to your own pace by ignoring others.

人生は、牛のパズル。

Design: **Charlie Thomas**
Project: **Paper clothes**

Charlie Thomas is a graphic designer who also creates paper clothes. One of his first forays into paper clothes-making was when he was in Melbourne working on the concept graphics of a Terence Conran store. Here he produced a whole window display for fashion designer Collette Dinnigan, which consisted of a full-sized paper dress, handbag and shoes. He has also designed window displays for Burberry. Such displays were so successful that he was invited to take part in a selling exhibition at Sothebys called Out of the Closet—Clothes of the Unwearable which featured work by, among others, fashion designer and fellow paper-clothes maker Hussein Chalayan. His paper creations were initially flat— a kind of three-dimensional collage—but he has come full circle by making clothes that are wearable, if only for one night. Style queen Isabella Blow commissioned him to make a paper ballgown and foil crepe jacket for her to wear to the couture shows in Paris. The work seen here was created using Keaykolour paper and was exhibited at a Crafts Council Exhibition called On Paper.

Design: **Elisabeth Lecourt**
Project: **Map dresses**

Elisabeth Lecourt created these dresses from maps. The styles of the clothes are linked to the destination on the maps each is made from. "The clothes represent the wearer's habitat and identity," she explains. "Each individual dress tells a story and the title usually gives away slightly more about the person or about the group of people. They can have a dark side to them but this is not voluntary. For example, 'Oh, baby, just you shut your mouth...' is a bridal jacket for an eight-year-old Chinese girl. The dresses are comments and not judgmental. Sometimes the viewer can relate to the dresses or simply be touched. The dresses are usually children's sizes; they are about memories and childhood. Our childhood shapes us for the rest of our life. Where and how we grow up makes us who we will become as an adult." Lecourt says she follows no pattern when making these dresses and that it is more of an instinctive process. "Because I have no idea about sewing, the dresses have a naïve feel to them. They are definitely not wearable."

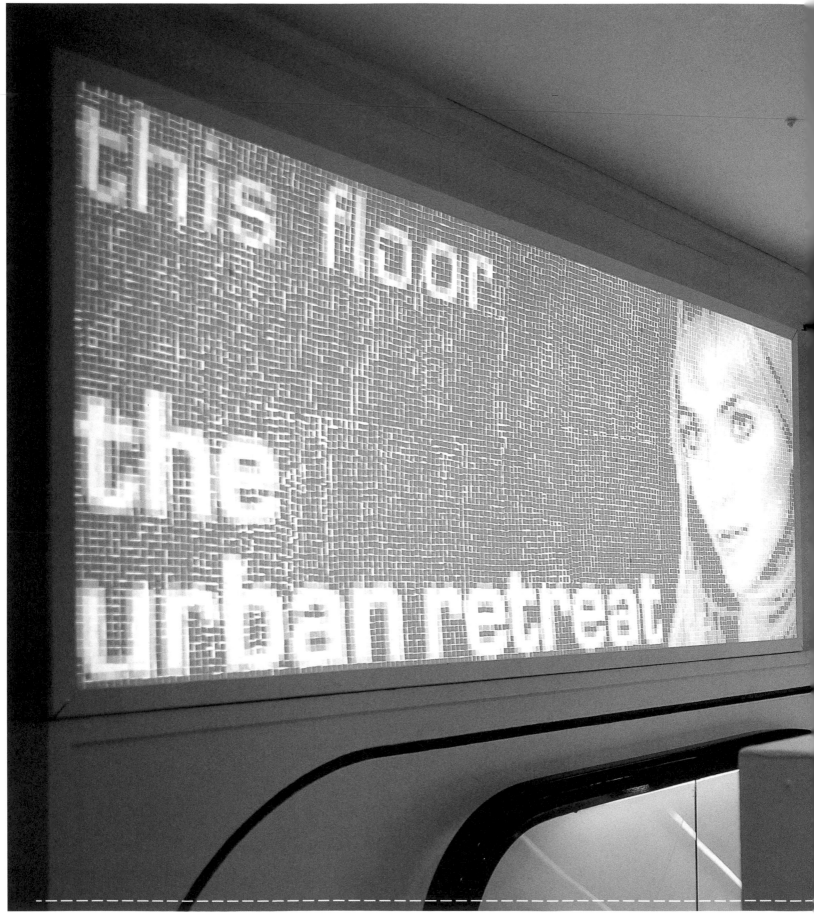

Design: **Multistorey**
Client: **The Urban Retreat, Harvey Nichols**
Project: **Signage**

The Urban Retreat on the fourth floor of swish department store Harvey Nichols in London, was a modern day spa where glamorous ladies went to be pampered. Multistorey designed this sign which was situated by the escalator on the 4th floor and was made from a mosaic of ten different weights of 1in (1.5 cm) squares of white paper on a light box. "The squares range from very thin paper to heavy card, thus producing a grayscale when backlit," explain Multistorey. "From this we formed a bitmapped photographic image. This take on Roman spa mosaics reflects the contemporary look and tranquility of the spa/salon, and stands out from the rest of the cluttered, multi-colored shopfloor." The sign measured $9^{27}/_{32}$ x $4^{59}/_{64}$ft (3 x 1.5m).

Design: **Ogilvy Singapore**
Client: **Northwest Airlines**
Project: **Christmas card**

On this Christmas card for Northwest Airlines, one little airplane unfolds many times out and around to create a snowflake shape. The stock used for the snowflake is a thin, almost tissue-like, paper. It's a witty way of tapping into the festive spirit while also emphasizing the company's commodity. It's particularly reminiscent of Christmas collages made by children to decorate classrooms at this time of year.

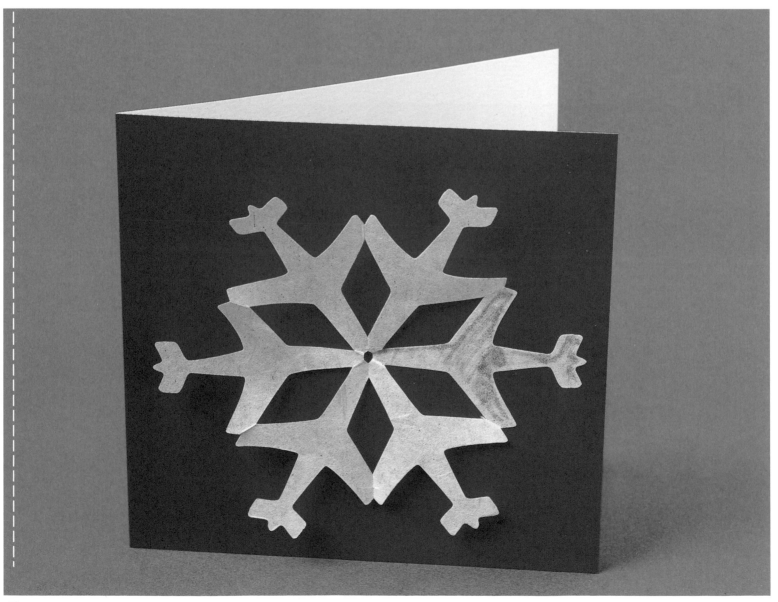

Design: **One Pom**
Client: **Parallel Media Group**
Project: **Invitation**

Each year a wealthy Italian couple who are keen collectors of art and enjoy celebrating (or courting) new talent give a prize—the Parallel Prize—to the most outstanding final year students of Painting and

Communication and Design from London's Royal College of Art. A big dinner party is held for the winners. Being glamorous Italians, the event wasn't held in Hackney or Hoxton, London's current shabby-chic haunts of young

artists, but in Knightsbridge's San Lorenzo, long time watering-hole of the Euro jet-set. The invitation draws upon the Italian spirit of the event. Design agency One Pom, one half of which is one of the Parallel prize invitees,

Elisabeth Lecourt, created an invitation for the hosts which was different from the usual photocopied one that had previously been given out yearly. A poster with a small image of a bowl of spaghetti was sent out and recipients

had to 'rsvp' by completing the drawing. Here are some of the imaginative responses.

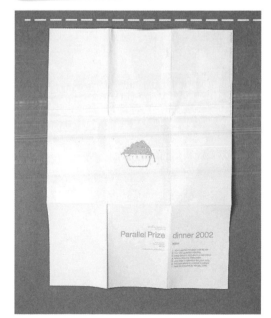

 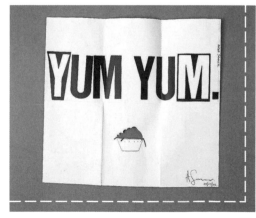

Design: **Roundel**
Client: **Zanders**
Project: **Promotional brochure**

Roundel created this brochure promoting a new range of colored tracing paper by Zanders Spectral. The brochures, to be sent to specifiers, had to be designed to have Pan-European appeal. "Because of the unusual nature of the product, we believed the promotion had to interest and excite designers into ways of using colored trace in their designs," explains Roundel's Mark McConnachie. "Based on the title 'you can' the brochure shows various techniques and effects such as changing colors, creating shapes and moving images." The themes 'move', 'layer', 'add', 'change', 'focus', 'highlight', 'hide' and 'reveal' are used to convey the choice of 18 colors and the two weights (100 and 200 gsm) that can be used. On the first page, for instance, an optical illusion is created; beneath the cherry 200 gsm paper there are three cups and, under the third, a red coin beneath a cup. Lift the paper and the coin moves to the cup on the left. By adding layers of different colored tracing paper the segments of a pie chart can be created and shifted around. The brochure certainly shows how imaginatively not only the color but the weight of a paper can be put to use.

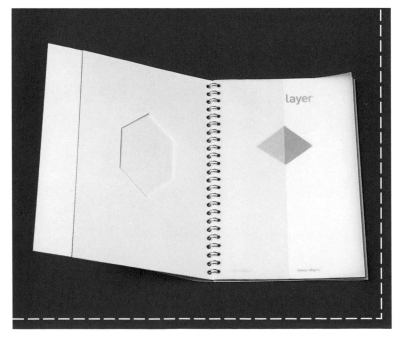

Design: **Warm Rain**

Client: **Surgery PR**

Project: **Invitation**

Recipients of this invitation to a PR company's press open day instantly want to hold it up in the direction of the nearest window. The image, and indeed the whole page, looks lovely when the light shines through it and the transparency of the paper really adds authenticity to the x-ray effect of the hand image. All Surgery PR's clients are listed on the hand. It's an attractive piece that uses paper as an integral part of the design rather than just a surface, and encourages anyone looking at it to absorb the information from a different angle.

Design: **Park Studio**
Client: **British Library**
Project: **Exhibition book**

Color peeps through the die-cut title on the minimal white sleeve of this catalog, designed to accompany a photography exhibition about Creole architecture in Sierra Leone. Turn the cover and you'll find each right hand page is half text and half image divided down the middle by a perforated line. Each photograph can be cut so that you can alter the cover by tearing out the postcards and placing an alternative one behind the typography. The photography, by Tim Hetherington, documents a significant period of West African history and records for posterity the fast disappearing Creole architecture of Freetown.

Design: **NB: Studio**
Client: **D&AD**
Project: **Invitation**

NB: Studio designed the invitations to the silver-themed D&AD annual show. They responded to their brief by using a white folded poster that is stuck by one panel into the left-hand inside panel of a miriboard card. When unfolded from the card the poster reveals all the date and address details of the event and lists the sponsors.

When folded up all you can see on the one exposed panel is a cryptic message that can only be read when reflected into the miriboard. The message reads: "mirror mirror on the wall where's the best creative work of all?" This reference to a fairy tale narcissist is perhaps a tongue-in-cheek hint that entering such a competition

is an act of vanity and that the annual show is a place to be seen as much as see. But then again, maybe there is no 'real' message; perhaps it's just a pretty picture.

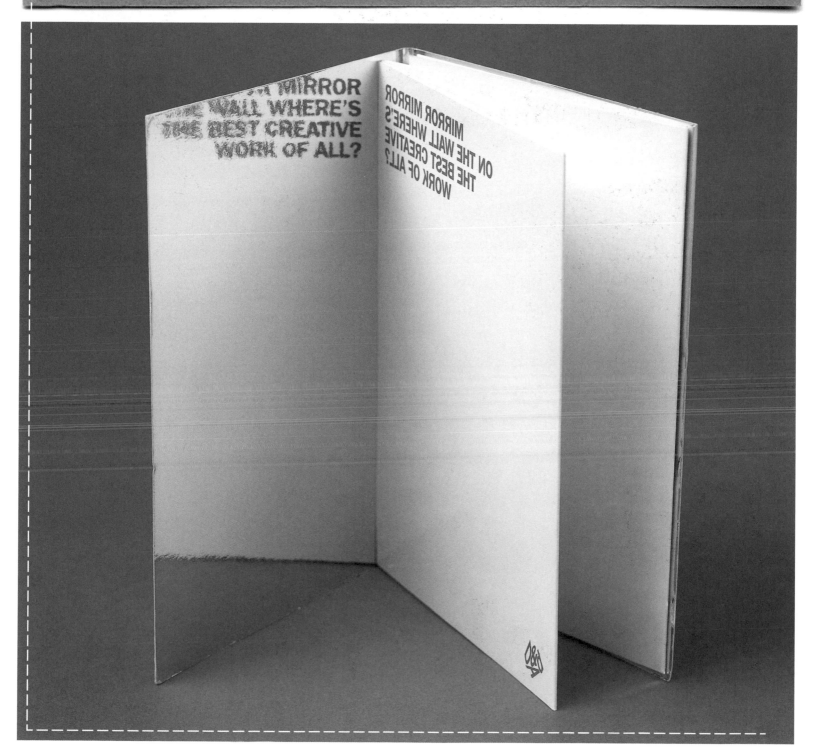

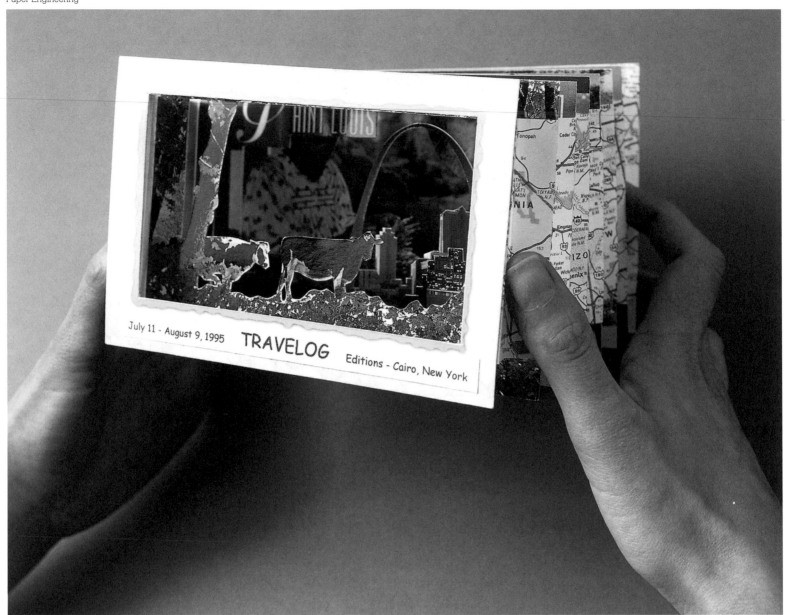

On the postcard: July 11 - August 9, 1995 TRAVELOG Editions - Cairo, New York

Ed Hutchins

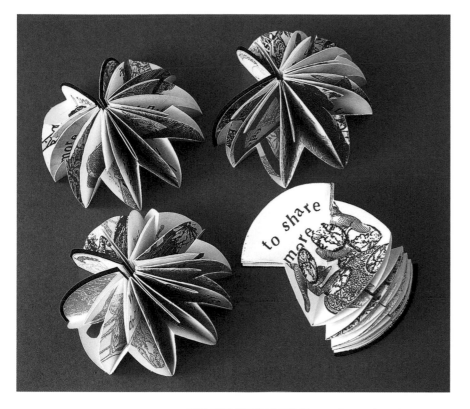

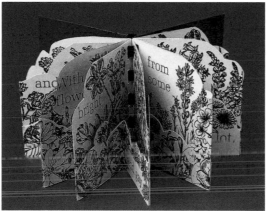

paper and method of printing to do justice to them. You can take a structure and ask—what story does this have to tell? It's not where you start that is important, but that when you are finished all the elements of the book contribute to successful understanding by the reader."

Hutchins believes that the structure and design of a book can play just as important a part in manipulating readers through a narrative than text or illustrations. "When there are fewer, larger words on the page, the reader turns the pages more quickly than when there are smaller, densely packed words. The reader will turn the page faster if there is an unfinished sentence, than when there is a complete sentence. It makes a difference whether the reader turns one page at a time, or can view the entire text in one glance when the pages are spread out concertina fashion. With an illustration on the page the viewer looks at the surface. With a tunnel book [a book constructed from a number of planes with die-cuts through which you look] the viewer enters inside the illustration."

When it comes to printing Hutchins admits that he's tried just about everything. "I've done letterpress-printed books, but since I don't have a letterpress they are few and far between. It's more likely that I will stencil, silk-screen, photocopy, color copy, block print, rubberstamp, gocco print, gum print, soap bubble, marble, collage, Xerox transfer, splatter, or use molded text, hand-carved stamps, matchstick type… most books are a combination of techniques."

There isn't one particular type of paper he returns to again and again. "If you were to summarize my approach to bookmaking it would be to make books using simple skills and materials found close at hand," he says. "As a result I rarely go out to get specific paper. In most cases the paper finds me. I have a flat file with paper I've inherited from different projects and friends and a lot of my books are made with paper from your everyday office supply store. When we put together the Thinking Editions catalog I had to buy full cases of the two types of paper that were used. As a result the Gadzooks catalog and Editions sampler are made out of the same paper. You may think this strange after I said that every part of the book had to be carefully considered but there's no contradiction here. One type of paper doesn't have just one application, it can be used for many projects if it is appropriate… just as one structure can be used for many different books. I'm very conscious of paper grain direction and if the book is offset printed there is usually a battle with the printer over this. In some cases, where there are folds going every which way, the concept is moot. Each project is unique and you come up with the best combination of materials and techniques."

From his studio, based half an hour outside Manhattan, Ed Hutchins creates small, unusual books using a vast array of inventive structures. There isn't one particular structure he favors but he admits to an affinity for using just one sheet: "I have about 50 different structures of books made from one sheet of paper."

To Hutchins, a great book is achieved when every single part of the book—"text, illustrations, paper, the type of printing, binding, covers"—comes together to deliver the message in a unified way. "It's when the parts are so interconnected, so supportive of each other, that the sum of their collectiveness is greater than each individual contribution," he explains. "Because each part has to pull its own share of the load when it comes to getting the message across, it doesn't matter which part you start with. You can take a story and ask what's the best way to illustrate it. You can take illustrations and ask what's the best

As well as possessing many structures, his books carry diverse themes. "Social justice is an important concern and there's no doubt that my books have a certain gay sensibility," he says. Gay Myths, a book on 24 photocopied pages with four fold-outs is, for instance, "a catalog of baseless misconceptions about lesbians and gay men which was inspired by the 1993 march on Washington." Other books are about his travels cross-country and in Mexico with his spouse Steve Warren (their commitment ceremony was in 1994). There's the innovative tunnel book created from postcards collected on a journey cross-country in the

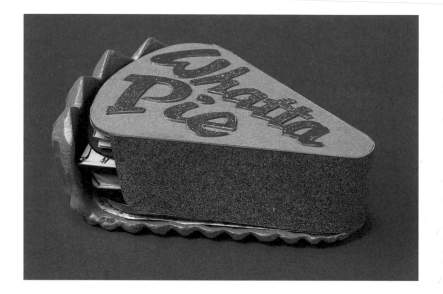

States. This structure, which is reminiscent of Victoriana-style peep-shows, works as a perfect journal/picture book. Hutchins says he dislikes books with themes that are "self-absorbed." "When I was in graduate school my advisor, an unhappy introspective person, kept saying, 'make your books darker, make them darker'. Finally I said, 'get over it, I'm not a dark person.'"

Surprisingly, Hutchins started out on a vocational path that seems very remote to what he is doing now. He originally studied for a B.S. in Government Administration at the University of Arizona, a degree he says his parents encouraged him to take, believing it would one day lead to a secure job. "You know how parents are: they want their children to be happy and most parents can't conceive of their children being successful—and thus happy—as an artist." His parents' drive for him to be more conventional can be absolved though, as, thanks to their involvement in the church, Hutchins was exposed to the mimeograph machine that produced Sunday programs, church

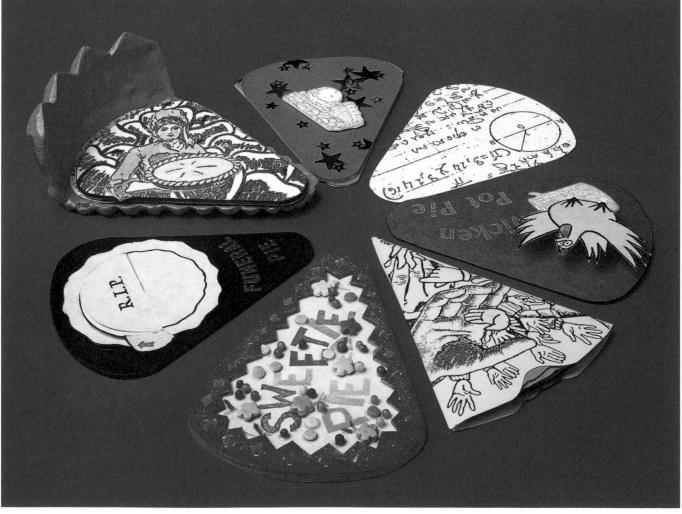

schedules and annual reports. Later in junior college he learned silk-screening and one of his first books, a program for the college musical How to Succeed in Business Without Really Trying, in 1968, had mimeographed pages, a silk-screened acetate cover and comb binding. Decades later he studied at the Center of Book Arts in New York and worked in collaboration with many professional book artists. "Mostly, I've learned by doing and doing and doing. I also teach, and there's nothing like teaching for learning."

One of Hutchins' most prized possessions and biggest influences is a scrapbook by his great-grandmother, Estelle Morehouse, who arrived in the Arizona Territory in 1880 to start the first kindergarten. "She had just graduated from a course in the Freidrich Fröbel [founder of the kindergarten] approach to early childhood education—a system that influenced a generation of artists including Frank Lloyd Wright, Wassily Kandinsky, Paul Klee, Piet Mondrian, Le Corbusier

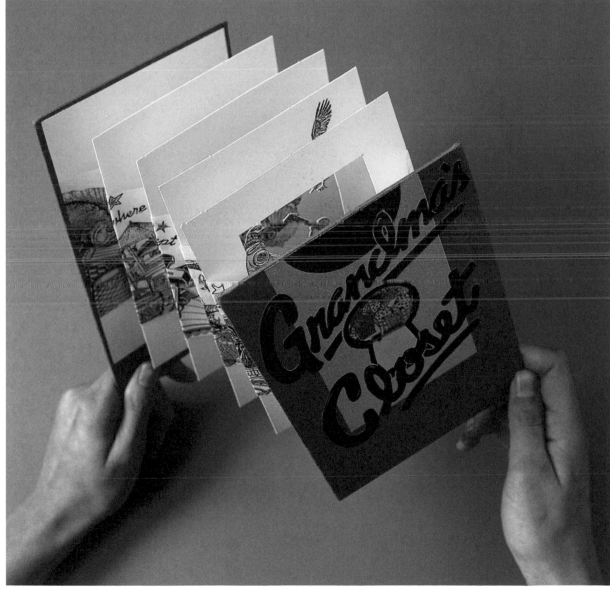

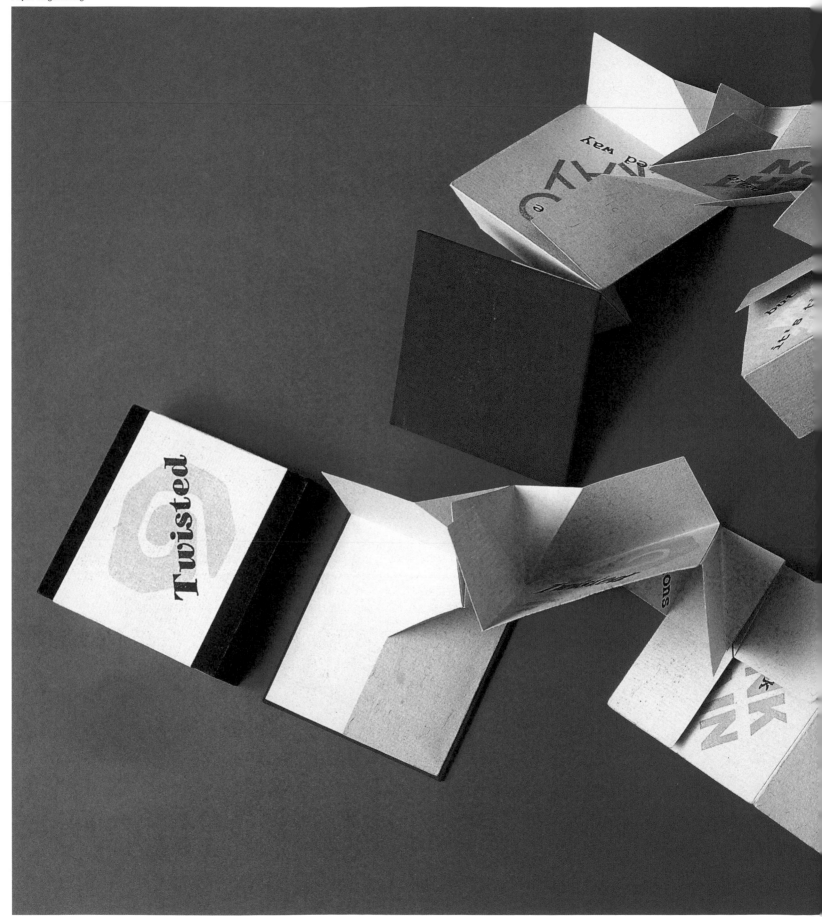

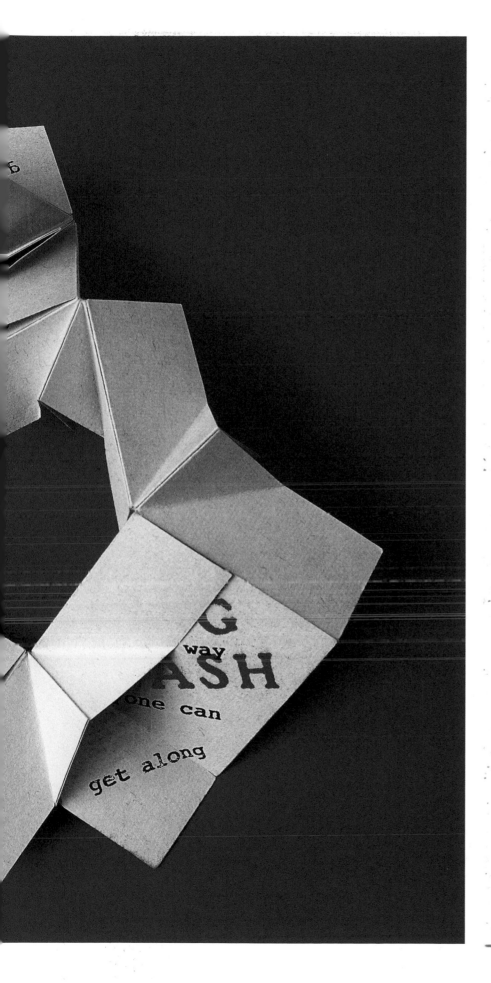

and many others," says Hutchins. Fröbel's philosophy of education was based on four basic ideas: free self-expression; creativity; social participation and motor expression. These ideas, carried out through play, group games, goal-oriented activities and outdoor time, had a huge impact on the US school system. "The system taught children art, design, mathematics and natural history by introducing them to the Fröbel 'gifts'—a series of 20 educational toys," explains Hutchins. "Estelle Morehouse brought with her to Arizona a scrapbook that she filled with samples of the work she presented in class. There may have been more than one scrapbook, but the one I have has pages and pages of samples from gifts—11 pin pricking, 12 sewing, 14 paper weaving and 18 folding—what we now call origami."

Today, instead of pen-pushing in a government department Hutchins is making highly original books in his own studio. His books have been on many touring exhibitions and are held in prestigious university and gallery collections such as the Museum of Modern Art in New York and the Victoria and Albert Museum in London.

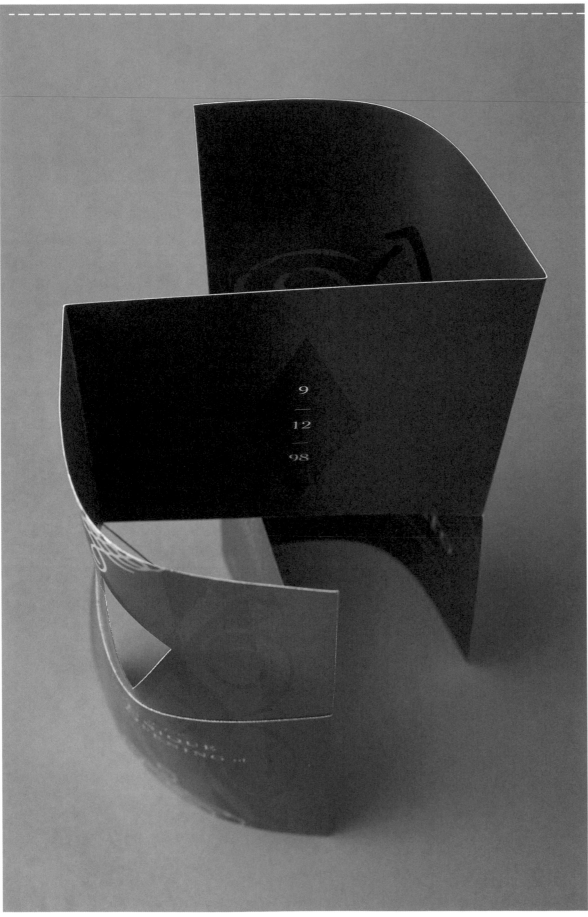

Design: **Vrontikis Design**
Client: **Restaurant Stellato**
Project: **Invitation**

At first this appears to be an ordinary card with a simple die-cut diamond on the front, reminiscent of a menu or wine list on a restaurant table. In fact, when opened, it surprises the recipient by appearing to be 'woven' on the inside; the top half of the right side and the bottom half of the left side are both covered by an extra layer of card. Furthermore, when closed again, the edges of the card join and then reopen in the opposite direction like a hinge. It sounds complicated and it takes a moment to work out. In fact, the construction is relatively simple. The card is constructed from a single piece of card cut into an 'n' shape with a 'tail', the bridge of the 'n' and the tail each forming half the size of the uprights. When the card is folded up, concertina-style, the tail on the right folds inwards through the center to tuck and glue round the upright on the left, that way transforming into the clever hinged invitation that opens both ways.

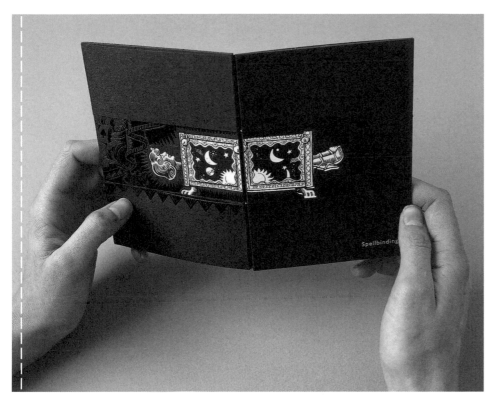

Design: **Williams Murray Hamm**
Client: **Fay Presto**
Project: **Promotional book**

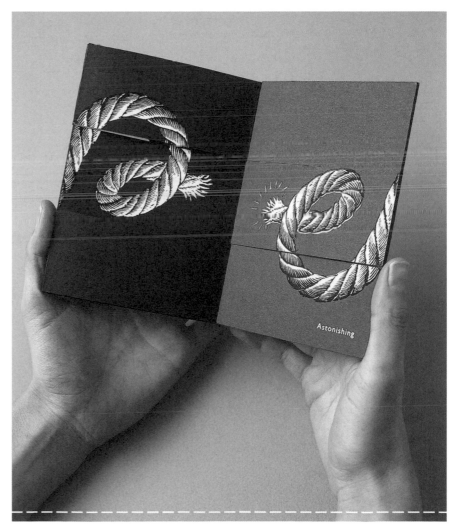

Like a magic act, this ingenious little book is spellbinding, and you could spend a long, long time completely mystified and trying to figure out just how it works. 'The Presto Pack' was designed by Williams Murray Hamm's Stewart Devlin and Richard Johnson (now at Ogilvy Singapore) for magician Fay Presto. You open it on one spread and then continue folding bringing the spine towards you. As you do so, numerous spreads (not just two) reveal themselves. There's a spread with an image of an Ace of Spades, one with a woman in a box and another with a rope, but keep folding on in the opposite direction and the card is torn in two, the woman is cut in half and the rope has been cut in the middle. Geoffrey Appleton was the illustrator and artwork was by Graham Burt. The printer was Artomatic, renowned for creating innovative structures and packaging.

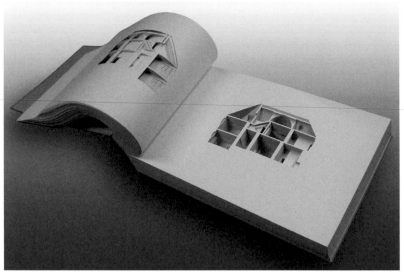

Artist:	**Olafur Eliasson**
Design:	**Michael Heimann and Claudia Baulesch**
Manufacturer:	**Kremo**
Project:	**Your House, commissioned by MoMA, New York**

Conceived by artist Olafur Eliasson and designed by Michael Heimann and Claudia Baulesch in Berlin, this piece of art uses paper engineering to experiment with space—here comparing the experience of reading a book to walking through a house. German company Kremo masterfully laser-cut 454 leaves (908 pages), which were then handbound, to create a negative-space rendering of Eliasson's house in Denmark in 1/85 scale. The book consists of a series of shapes cut into every page, each presenting a vertical cross-section of the building and forming a reverse to the conventional three-dimensional architectural model. There are no words, images, colors, or printing of any kind. This extraordinary artist's book was published for the Library Council of the Museum of Modern Art in an edition of 225 and sold out within a week of its release.

Design: **The Kitchen**
Client: **Levi's®**
Project: **Brochure**

Sent out to art directors and fashion editors, this brochure designed by The Kitchen, emphasizes the Levi's® Red brand's attempt to "breathe new life into accepted forms and functions, setting industry standards in new fabrics with radical design." The shapes of the (very glossy) pages create a spiral effect and works as a metaphor for finding new forms. It looks great when closed but can be quite hard to open because of the amount of glue needed to hold the different shaped pages in place. It certainly won't lie open as a spread.

Design: **NB: Studio**
Client: **Merchant**
Project: **Guide book**

Merchant, experts on annual reporting and related matters, each year bring out *The Merchant Handbook*, as a way of flexing its editorial muscle and proving how knowledgeable it is on reporting. Designed by NB: Studio, the handbook is sent to city analysts, press, financial directors, chairmen and managing directors. "Each year they descend on us with piles of articles, cuttings, charts and sound bites," says NB: Studio's Ben Stott. "Our job is to house them in something memorable. This year it was decided that the current economic climate in the world of reporting required a more serious approach. We decided that we would treat the six separate articles as individual books. This meant we could use different tone, colors and layout to make them individual and thus add interest. We then took the idea to its extreme. Working closely with Fenner paper and Impressions we used different stocks, finishes and formats throughout; we then quite literally stuck them together." Two of the books were illustrated by Tom Gauld and Brett Ryder.

Paper

Specifying paper

The best way of sourcing and discovering what paper is out there is by getting on the mailing list of the many merchants such as GF Smith, Arjo Wiggins, Premier Papers, the Robert Horne Group, McNaughton and Fedrigoni. These merchants are more than happy to supply designers with sample packs. Some specialize in certain types of paper while others offer an incredibly diverse range from international mills. It is worth creating an archival file of paper and even saving paper that has been printed on. Also, when visiting your printer, find out what they have in stock as you may be able to make a deal. Just take into account the possibility of reruns in the future, as you may not be able to obtain that stock again.

Prestigious jobs could provide the rare opportunity to try handmade paper. Visit shops such as Kate's Paperie in New York or Falkiners Fine Papers in London, which hold large collections of handmade papers, and a mere interest could turn into an obsession. These shops are like gold mines for those with a passion for the tactile in design and show just how beautiful paper can be as an object in its own right. Some papers, especially papers from the Far East, are so exquisite and unusual that you feel it would be vandalism to print or draw upon them.

When specifying paper there are many things that need to be taken into account—for instance, opacity, gloss and smoothness. Often the printing process itself will narrow the choice down and it is wise to consult your printer while specifying.

One of the most important considerations to take into account by paper engineers is grain direction. To fully understand grain direction it is important to know about the raw material that paper is made from and about how sheets are manufactured.

Paper qualities

Paper is made from the cellulose fibers of plants or trees. Cellulose is a chemical compound of the elements carbon, hydrogen and oxygen. Tubular in shape, these fibers swell when immersed in water and, when dried in close contact with one another, create their own gelatin "adhesive." Along with the fibrillation—the splitting and fraying of the fibers to produce thread-like hairs that bond together—this produces extremely strong material.

Traditionally paper was made from rag: the cotton off-cuts from textile mills. Cotton contains the purest cellulose and so requires the least processing. As more and more synthetic fibers such as nylon and rayon, and animal fibers such as wool were introduced into textiles, paper mills had to stop using rag, as these new fibers did not bond as well as cellulose and weakened the paper. Sources of rag are limited today (the T-shirt industry is a main source) and so it is not used as much in papermaking. Another source of cotton is from linters. Linters are the fibers left on the seed once the longer fibers for making thread have been removed. Because the fibers are shorter, a linters sheet is soft and not as strong as a rag sheet.

There are many other fibers such as hemp, grass, leaf and jute but these are mainly used in the production of handmade papers. The majority of printing paper today is made from wood pulp of which there are two kinds; mechanical and chemical. Mechanical wood pulp, or groundwood, is made by removing the barks and then grinding logs under a stream of water in order to get them to disintegrate, leaving a pulp. Lignin, a component of the cell walls, remains in the pulp with the cellulose. Lignin rejects water and resists bonding and causes the paper to go yellow quickly. This not very strong pulp produces cheap paper that is used in newsprint and packaging. Chemical wood pulp, (which is, strangely enough, also called 'woodfree'), relies on chemical agents to dissolve the lignin from around the cellulose enabling it to be washed away. Wood pulp varies in cellulose content but the finest can contain up to 93 percent, which means it is almost as pure as cotton pulp. However, this pulp has much shorter fibers and so would never be as strong or have the same character as cotton paper.

How paper is made

Paper is either made by hand or machine produced. There is also moldmade paper, which is made on a machine but has characteristics that resemble a handmade sheet. With handmade paper the grain lies in random directions, a potential problem for paper engineers when folding, as the crease could create a ragged edge. On a papermaking machine, the fibers tend to align themselves in the direction of the paper web and so the strength and look of the folded edge is more predictable. Most graphic designers work with tight budgets, fussy clients and short deadlines, and so the uniformity, cheapness and availability of machine-made paper is almost always the option. Just because it is mass-produced doesn't mean that you cannot get some machine-made papers with wonderful surface textures and finishes.

The Fourdrinier process

The machine responsible for much of the paper made today is the Fourdrinier. It is a continuous process: pulp goes in at one end and rolls of paper come out the other. It is a highly technical, computer-controlled machine that is often run day and night and when producing tissue paper, for instance, can produce as much as 61 feet per minute.

Fibers, whether from cotton linters or woodpulp, are bought by the papermill in the form of dry compressed sheets for ease of handling. These sheets are blended with lots of water to form a slurry. This is pumped into storage towers and then through conical refiners containing rotating bars. This mechanical treatment in water is called beating, and the amount of beating in these refiners determines the length of the fibers and the extent to which they are fibrillated. This, in turn, determines the kind of paper that will be achieved at the end of the process: from highly beaten glassine and tracing paper to soft, bulky blotting paper that is hardly beaten at all. You can tell how much a paper has been beaten by holding it at a corner and shaking it to produce a 'rattle.' The pitch or sound of the 'rattle' is higher if it has gone through a longer or more intense beating or refining process.

After the refiners, the next stage is the internal sizing process. Sizing controls the absorbency (of water, ink, etc.) of the final paper. Here, a non-cellulose material is added. Traditionally the material used was rosin from the gums of pine trees which are attached to the paper fibers using an acidic material called alum. Rosin yellows with age and has more recently been replaced with synthetic sizing materials with more neutral pHs. Other additives such as colored dyes and mineral fillers such as china clay are also introduced at this stage. China clay is a fine white powder that is added to the pulp to reduce shrinkage, increase opacity, and make the surface smooth.

Opacity is the property of paper affecting the show-through. A sheet with 100 percent opacity is completely lightproof. Opacity is influenced by both weight and bulk—the more fibers there are the more light will be blocked out. Fillers added to the paper can enhance this. Printing papers commonly contain up to 30 percent of fillers. Ultimately, the more coating a paper has, the more shine, lift and brightness the printed color will achieve.

As this stage the pulp is still 99 percent water and 1 percent fiber. This mix is called the furnish. The furnish of cover paper or board contains more recycled paper, and is beaten less, to ensure efficient drainage on the wire. The furnish is released onto the conveyor belt of wire mesh and the rate of release and the speed the wire is traveling dictate the resulting weight of the paper. The slower the wire and the greater the amount of furnish, the heavier the paper will be. Here the transformation from creamy pulp to solid white paper takes place.

After forming on the wire, the paper is still around 70 percent water. Water drains through the mesh, and the screen is vibrated from side to side. The fibers tend to align in one direction along the length of the roll, giving machine-made paper its characteristic grain. The pattern of the wire mesh gives the paper its texture. Laid papers have a pattern of mainly horizontal or vertical stripes. Wove papers are created on a woven mesh.

Paper is formed as it lies horizontally on top of the wire. To create texture on the top of the sheet, a hollow dandy roll is located above the wire and presses a pattern onto the top surface of the paper corresponding to the pattern on the wire. From then on most of the length of the Fourdrinier machine is concerned with drying the damp paper. The paper passes through a series of presses that squeeze out most of the water. These presses can also be used to impart surface texture, and the amount of smoothing affects the final bulk (though not the weight) of the stock.

The paper can then be surface coated or sized and is carried on a felt belt between staggered rows of huge steam-heated cylinders. Once dry, the paper is pressed in a vertical row of polished steel calender rolls, or nips. This operation, called calendering, increases the smoothness and degree of gloss. The more calenders, the higher the gloss. From the calender stack the paper is wound into large rolls called webs. Some papers may also require off-machine finishing such as supercalendering (polishing), coating or embossing.

Grain direction and folding

At the end of the process the web of paper is cut into rectangular sheets, either parallel or at right angles to the machine direction. Sheets whose long dimension is parallel to the machine direction have the grain running lengthwise and are called 'long grain'. Sheets cut across the web have the grain running in line with the short side and are called 'short grain'. If you look at a packet label in the US the first dimension of the sheet size indicates the grain direction; for example 450 x 650mm is short grain and 640 x 450mm is long grain. In the UK these dimensions are displayed the other way around. Paper folds more readily and tears more easily along the grain than across it. When producing books, the grain direction usually runs parallel to the spine to facilitate folding. But folding endurance is greatest (the paper is stronger and less likely to tear) across the grain.

The quality of the fold is also influenced by the types of fibers from which the paper is made. Paper with longer fibers are more susceptible to splitting along the crease when folded. Coated papers can also be more susceptible to cracks because the coating layer is not as strong as the base paper. The thicker the coating layer, the greater the danger of the coating cracking.

Good designers will always take into account the printing process during the design process. For instance, with cutting, odd-shaped booklets and posters may seem like a good idea but they can be wasteful on paper, so find out the sizes of stock that the printer can handle, and have a sheet in front of you when you are calculating the size and shape of your layout. An important part of the process of making up a pop-up book is 'nesting' whereby all the different shapes that are to be die-cut are fitted onto a page. The nesting determines how much paper area will be used and is carefully organized so that less paper is wasted and a die can be created.

It is always a good idea to select your paper with the printer. Some printers are reluctant to try out new folds. If this is the case then perhaps it is worthwhile finding another printer. But often printers will understand more about the possibilities or limitations of a particular type of paper than the designer. Sometimes the relationship between designer and printer can be antagonistic but, as with any relationship, flexibility and an open mind is needed so that ultimately both can learn from each other.

Templates

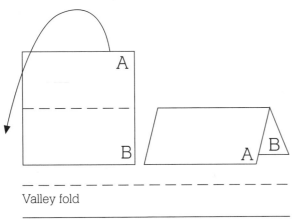

Valley fold

Cut

Mountain fold

Pages: **96–97**
Design: **hat–trick**
Client: **Rabih Hage**
Project: **Identity and promotional items**

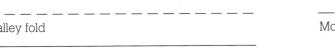

Page: **45**
Design: **Carter Wong Tomlin**
Client: **Capital City Academy**
Project: **Stationery**

Pago: **32**
Design: **salterbaxter**
Client: **Tate Modern**
Project: **Invitation to exhibition party**

Image 1

Image 2

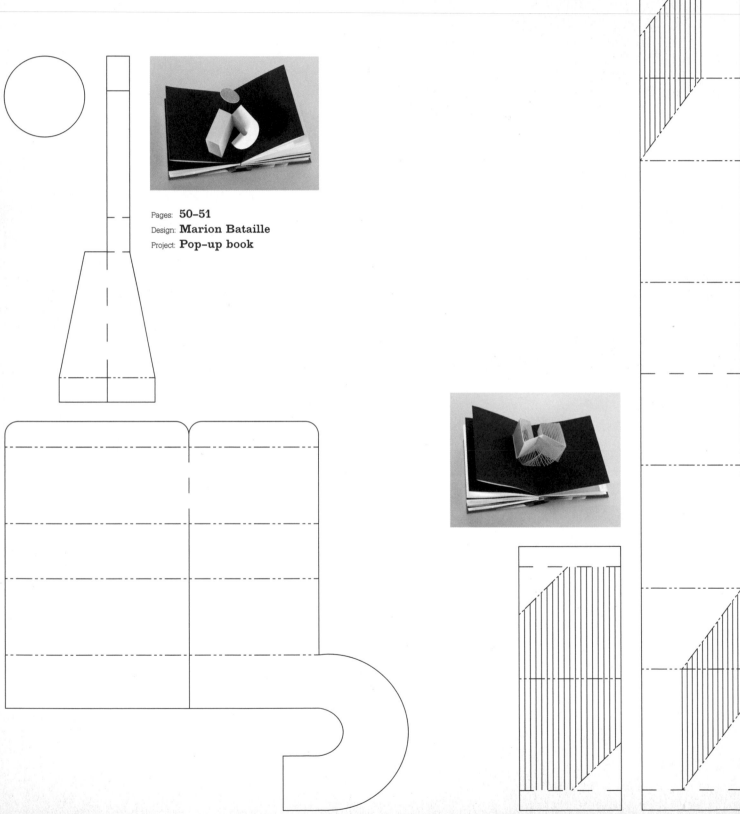

Pages: **50–51**
Design: **Marion Bataille**
Project: **Pop-up book**

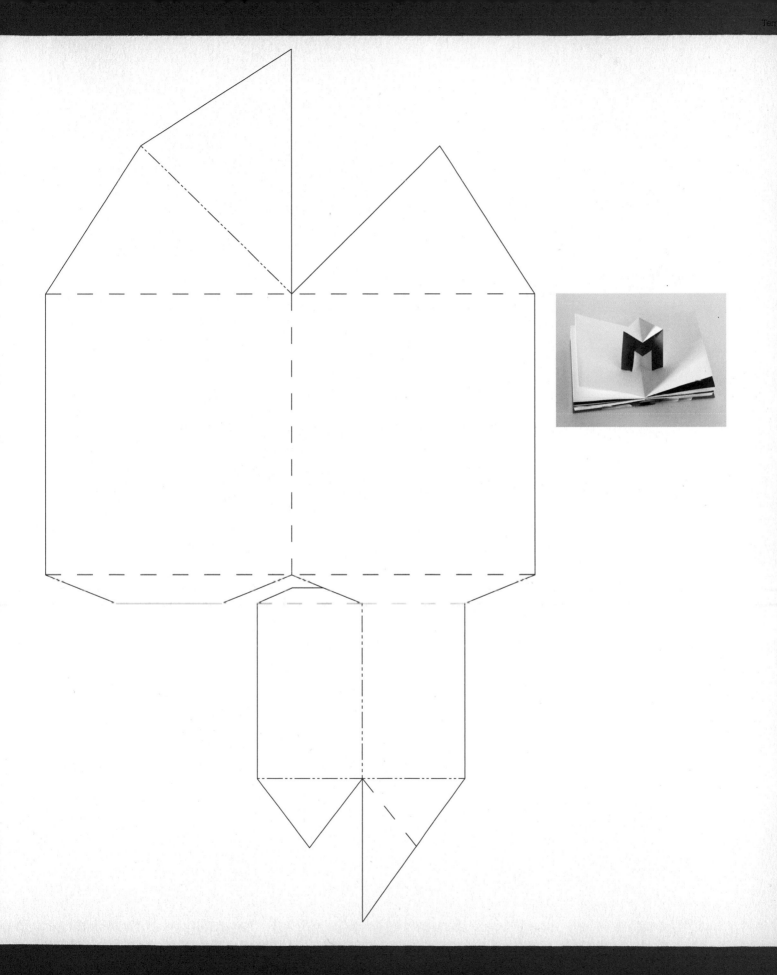

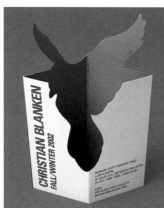

Page: **98**
Design: **Agitprop**
Client: **Christian Blanken**
Project: **Invitation**

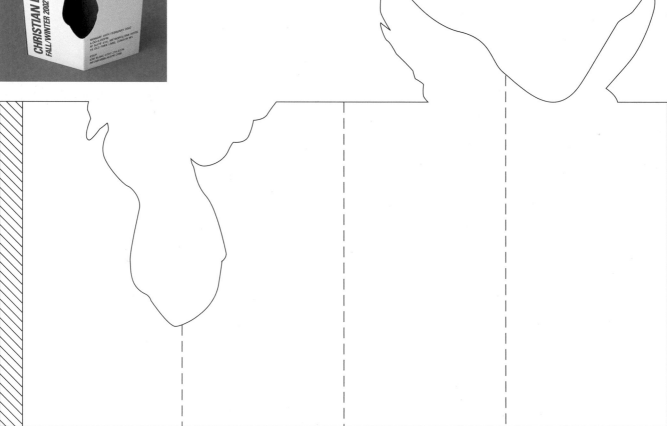

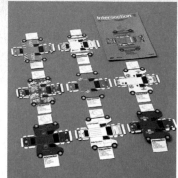

Page: **125**

Design: **Yorgo Tloupas**

Client: **Intersection**

Project: **Business cards**

Page: **21**

Design: **Zuan Club**

Client: **Java Live**

Project: **Invitation**

Glossary

The following glossary contains terms used in the printing and papermaking worlds that are useful to know when embarking on graphic design projects that use paper in a more three-dimensional way.

A-sizes — The ISO range of metric paper sizes designed for stationery. Different formats are used in the US.

Accordion fold — See Concertina fold.

Acid-free — Free from acid-producing chemicals. Acid-free papers are more durable and less prone to yellowing than others.

Against the grain — Folding or marking paper at right angles to the grain. See Grain.

Airmail — Extremely lightweight paper usually below 40 gsm, used for stationery.

Antique — A high quality, bulky paper with a rough finish but good printing surface, used mainly for books and folders.

Apron — Extra white space allowed at the margins of text and illustrations forming a Fold-out.

Art paper — Coated paper with a hard, smooth 'gloss' finish caused by an even coating of china clay compound on one or both sides.

Artwork — Reproduction-quality origination, for making films.

B-sizes — The ISO range of metric paper sizes designed for work such as posters that require a larger format than standard A sizes. B0 is 1000 x 1414mm.

Back up — To print the reverse side of a sheet of paper that has already been printed on the first side.

Banker — An envelope with a diamond flap on the long edge. Depending on the throat this can be described as high-cut or low-cut.

Bond paper — Uncoated paper, generally used as writing paper.

Bolts — The folded edges of a sheet or section that will be trimmed off.

Book block — A book that has been folded, gathered and stitched but has no cover.

Bleed — The printed area that runs over the trimmed edge of a page. Usually $\frac{1}{8}$ to $\frac{1}{4}$in (3 to 5mm).

Blind — An embossing or debossing without foil or ink. Simply an impression is left and the image is visible because of the shadows cast.

Brittleness — The extent to which paper cracks or breaks when bent.

Bristol board — Fine board made in various thicknesses and qualities, usually of smooth finish, used for drawing and printing.

Bursting — A term referring to the separation of perforated sheets.

C-sizes The international ISO range of metric sizes for envelopes, designed to accommodate equivalent A sizes.

Calliper The thickness of a single sheet of paper measured in millimeters, microns or $\frac{1}{1000}$in. A micron is $\frac{1}{1000}$mm. It is also the word for the instrument that can measure such a thickness.

China clay A white refined clay used extensively in loading and coating mixes.

Chromo-coated Usually one-sided coated, high quality gloss paper or board for proofing, inserts etc.

Crease See Score.

Creasing A linear indentation made by machine in thick paper, providing a hinge.

Coated paper Also known as Art paper: gloss paper coated with china clay that can have a gloss, matt or satin finish.

Cockling Wavy edges on paper caused by unstable atmospheric conditions.

Collate To gather sections of printed work in the correct sequence for binding.

Concertina fold A sheet of paper with several parallel, alternating and closely placed folds forming a pleated effect.

Cotton fibers The soft white filaments attached to the seeds of the cotton plant. Cotton fabric is made from the long fibers, leaving behind short fibers, called linters, which can be used for papermaking. Cotton rags can also be turned into pulp for papermaking.

Cover paper Paper for the covers of books, pamphlets, etc.

Crop marks Printed lines beyond the page area that indicate where the page should be trimmed. See also Trim/tick marks.

Debossing An impression which is sunk into a surface (opposite of embossing).

Deckle edge Paper with an untrimmed feathery uneven edge.

Die This intaglio stamp is a metal object crafted from artwork and is used for impressing a design. It is used to create embossing, cut shapes or apply foil.

Die-cutting The process by which shapes are cut from paper or card with a metal die.

Double-coated Paper that has been passed through the coater twice.

Edition The whole number of copies of a book printed and distributed at the same time.

Embossing A raised impression on a surface (opposite of debossing) created by pressing the paper between a male and female metal die. For simple designs the die can be photo-engraved. More complex patterns have to be engraved by hand which can be expensive. The best paper to use, to avoid splitting, is paper with long or random fibers.

Enamel paper High-gloss-coated on one side.

End paper Strong paper used for securing the body of a book to its case.

Feeder Apparatus for feeding and positioning paper sheets in printing presses and paper processing machines.

Fiber A plant cell composed of cellulose used as the basic element of papermaking material.

Fillet An embossed line used as a decorative device on a book cover.

Finish A general term for the surface characteristics of papers and boards.

Finishing Processes that the printed sheet goes through in order to produce the final item; for example, creasing, die-cutting, embossing, binding. In paper-making finishing refers to the practices of drying, sizing and looking over sheets of paper after the papermaking processes are completed.

Foil An extremely thin, flexible metal sheet applied as decoration to a blocked or embossed design.

Foil blocking The process by which foil is applied to a surface using a metal die, heat and pressure.

Fold lines Tick marks that indicate where a sheet is to be folded. Often dotted, to distinguish between folding and trimming.

Fold-out An extension to the leaf of a book, making it wider than the standard page width so it must be folded back onto the page. Also called a throw-out.

Folio The book size formed when a sheet is folded making the pages half the size of the sheet and forming a multiple of four pages. This term also refers to page numbers.

Foot The bottom of a page.

Fourdrinier The name of a type of paper machine in which paper is made at high speed in a continuous web.

French fold A sheet of paper that has been printed on one side only and then folded twice to form an uncut four-page section.

Furnish The ingredients such as pulp and additives from which paper is made.

Gate fold A paper fold in which both sides are folded across the middle of the sheet in overlapping layers.

Gathering Placing the sections of a book in the correct order for binding.

Glassine — Translucent, grease-resistant paper used for window envelopes, photo bags and interleaving books.

Gloss — The shiny and lightly reflective surface of a piece of paper.

Grain — The alignment of fibers in machine- or moldmade paper, sometimes called machine direction. Long grain means that fibers run parallel to the longest side of a sheet; short grain, that they run parallel to the shortest side.

Grayboard — Board made entirely from waste paper, used in bookbinding and packaging.

Grammage — Grams per square meter, used to define stock weights.

Gripper edge — Leading edge of paper as it passes through a printing press.

Gripper margin — Unprintable blank edge of paper which is held by the grippers that control the flow of the sheet as it passes through the printing press.

Guillotine — A machine for cutting paper.

Gutter — The margin on a sheet which will be bound into a book or the gap between multiple images on a sheet.

Head — The top of a page.

Hologram — A three-dimensional image created by the lasers.

Imposition — The arrangement of pages on a flat sheet so that the section will read in the correct order when folded.

India paper — Very thin but strong, opaque paper used for bibles and dictionaries.

ISO sizes — International range of sizes for paper and envelopes (not US). See A, B, and C sizes.

Ivory board — Smooth board commonly used for business cards because of its fine finish.

Jacket — The removable cover of a book/brochure.

Kiss-cut — Usually referring to self-adhesive labels, the cutting of a shape without cutting through the backing paper, enabling the self-adhesive item to be peeled away leaving the sheet intact.

Knock up — To line up the edges of a stack of paper.

Laid paper — Paper with distinctive lines running parallel through the entire sheet. These are the wire marks of the mold used in the manufacturing of the stock.

Lamination — A film applied to printed sheets (commonly matt, satin or gloss) for protection or to achieve a particular finish.

Laser cutting — Very fine cutting by laser, where traditional die cutting cannot achieve the required level of detail.

Mark-up — Instructions written on artwork/proofs for the printer to follow.

Nesting — A term used by pop-up artists and manufacturers that refers to fitting all the shapes for die cutting and printing onto an area of paper.

Newsprint — The cheapest printing paper entirely made of mechanical pulp, used to make newspapers. Has good opacity and bulk, but a poor surface and low brightness.

Opacity — The extent to which printing on the reverse side shows through.

Overprinting — Printing over a previously printed sheet; also specified where colors must not reverse out of each other.

Overs — Additional copies run to the amount specified.

Perforating — Piercing a series of holes into a sheet of paper, usually to enable tearing.

Pocket (envelope) — An envelope with its opening flap on the short edge.

Proof — A copy made before the full job is run, in order to check quality and accuracy of origination and specification.

Pulp — The main ingredient in the papermaking process, usually made from processed wood, cotton linters or rags.

Quantity — The number of finished copies.

Quire (UK) — A British term for 24 or 25 sheets of paper, a twentieth part of a Ream.

Rattle — The sound produced by shaking a piece of paper. In general, the harder the rattle, the better the quality.

Ream (UK) — 500 sheets (although traditionally was 480 sheets).

Reel — A continuous length of paper wound on a core, irrespective of diameter, width or weight.

Register — The positioning of plates correctly to form a composite image.

Score — An impression made into a sheet to enable folding without cracking.

Sheet fed — Printing in sheets as opposed to rolls of paper.

Show-through — Lack of opacity in a sheet causing the image on one side to be visible on the other.

Spot varnish — Varnish applied to a specific area of the printed sheet.

Translucent — The description of materials that transmit light but are not fully transparent, i.e. tracing paper.

Trim/tick marks — Printed lines that fall outside the image area, indicating where the sheet should be cut. Can also be used as register marks if no others appear.

Uncoated	Paper with no china clay coating.
Varnish	Transparent coating applied for protection or effect.
Wallet	An envelope with a square flap on the long edge.
Watermark	An image impressed into the body of a sheet of paper during the manufacturing process.
Wove	Paper without inherent lines (as distinct from laid).
Zig zag book	The name sometimes given to a book made up of a continuous sheet of paper folded in a concertina fold.

Contacts

Agitprop
www.agitprop.co.uk

Airside
www.airside.co.uk

Akio Okumara
www.okumura-akio.com

Allies
www.alliesdesign.com

American Slide Chart
www.americanslidechart.com

Angry Associates
www.angry-associates.com

Bisqit
www.bisqit.co.uk

Bozell
www.bozellthinking.com

Charlie Thomas
www.charliethomas.net

Carter Wong Tomlin
www.carterwongtomlin.com

Cahan Associates
www.cahanassociates.com

Corina Fletcher
www.corinaandco.com

Ed Hutchins
www.artistbooks.com

Elisabeth Lecourt
www.selisabethlecourt.com

Etu Odi Design
www.etuodi.co.uk

Eggers + Diaper
www.eggers-diaper.com

Fibre
www.fibredesign.co.uk

Fl@33
www.flat33.com

Frost Design
www.frostdesign.com.au

Gardner Design
www.gardnerdesign.com

hat–trick
www.hat-trickdesign.co.uk

HGV design
www.hgv.co.uk

Iris Associates
www.irisassociates.com

Kate Farley
www.katefarley.co.uk

Katsumi Komagata
www.formandcolours.com

KesselsKramer
www.kesselskramer.com

The Kitchen
www.thekitchen.co.uk

Marion Bataille
www.albin-michel.fr

Metalli Lindberg
www.metalli-lindberg.com

Multistorey
www.multistorey.net

NB: Studio
www.nbstudio.co.uk

Ogilvy & Mather
www.ogilvy.com

Olafur Eliasson
www.olafureliasson.net

One Pom
www.onepom.com

Origin
www.origincreativedesign.com

Park Studio
www.park-studio.com

Publique Living
www.publiqueliving.com

Riordon Design
www.riordondesign.com

Robert Sabuda
www.robertsabuda.com

Roundel
www.roundel.com

salterbaxter
www.salterbaxter.com

Sagmeister Inc.
www.sagmeister.com

Sayles Graphic Design
www.saylesdesign.com

SEA
www.seadesign.co.uk

StudioThomson
www.studiothomson.com

Rob Ryan
www.misterrob.co.uk

Rodney Fitch
www.fitch.com

Ron van der Meer
www.howmanypopups.com

Vrontikis Design
www.35k.com

Warm Rain
www.warmrain.co.uk

William Hall
www.williamhall.co.uk

Williams Murray Hamm
www.creatingdifference.com

Wink Media
www.winkreative.com

Wood McGrath
www.woodmcgrath.com

WPA Pinfold
www.wpa-pinfold.co.uk

Yorgo Tloupas
www.yorgo.co.uk

Zuan Club
E: zuan@big.or.jp

Book design and art direction: **Multistorey**
Photography: **Xavier Young and Simon Punter**

Acknowledgments

A huge thank you to all the designers who submitted material for this book. Thanks especially to Corina Fletcher—a superb paper engineer who chatted to me about the whole process and to Paul Benwell at Benwell Sebard printers. Many thanks to Andrew for cups of tea and warm slippers and to Zara, Luke, Xavier, Harry and Rhonda for being a pleasure to work with. A big special thanks to Caroline Roberts and Chris Foges.

Further Reading

Artist's Book Yearbook by Sarah Bodman, published by the University of West of England, Bristol, UK

The Book of Fine Paper by Silvie Turner, published by Thames and Hudson, London 1998

Choosing and Using Paper for Great Graphic Design by Mark Hampshire and Keith Stephenson, published by RotoVision, Hove, UK 2007

The Elements of Pop-Up by David A. Carter and James Diaz, published by Little Simon, an imprint of Simon & Schuster's Publishing Division, New York 1999

Non-Adhesive Binding Books Without Paste or Glue by Keith A. Smith, published by Keith Smith Books, New York 2001